ART IDEAS HISTORY

THE ROMANTIC WEST

1789-1850

EUGÉNIE DE KEYSER

TRANSLATED FROM THE FRENCH BY PETER PRICE

★

© 1965 by Editions d'Art Albert Skira, Geneva
Library of Congress Catalog Card Number: 65-16670.

★

Distributed in the United States by
THE WORLD PUBLISHING COMPANY
2231 West 110th Street, Cleveland 2, Ohio

★

PRINTED IN SWITZERLAND

CONTENTS

I
DISRUPTION

II
THE SEATS OF POWER

III
WITHDRAWAL

IV
THE INNER LIFE

V
MAN IN SEARCH OF HIMSELF

I

DISRUPTION

THE CITIZEN
BECOMES MASTER OF THE CITY

On the night of August 4th, 1789 the Nobility and Clergy of France renounced their privileges and handed the keys of power to the Third Estate. At that time no one dreamed that within a hundred years these new men would be supreme in almost every land and would be about to arrogate all the natural forces and all the riches of the earth.

The real power of the middle class lay in their command of a constantly expanding economy; it was no more than ratified by the rights which in France had just been granted to them, which they had won ten years earlier in the United States and which had been theirs in England since the fall of the Stuarts.

Credit was the hallmark of the new men, and this more than any other factor would shape the ethics and taste of their society. The fact that Europe and America lagged behind England was due not so much to their antiquated financial system, which at the beginning of the nineteenth century still rested on gold and land, as to the inadequacy of their parliaments. Men were confronted by swift, ill-defined and unpredictable changes due to the transformation of industry by machinery and new forms of motive power. They had to meet an ever-increasing demand for raw materials and to capture fresh markets as steamships and locomotives opened up trade routes throughout the world. These new economic forces could only be controlled by means of easy, unlimited credit.

There developed a concomitant belief in progress. The industrialist, building empires of iron, cotton or silk, had a rosy vision of his business expanding ad infinitum, bringing such lasting enrichment to the lives of men that whatever upheavals might occur, in social matters for instance, must sooner or later die down of their own accord.

Yet man is a slave to his own power and is transformed by it. Balzac was the supreme portrayer of a society enmeshed in deposit accounts, bills of exchange and legacies. The world of appearances, of the outward signs of wealth or poverty, gave unheard-of significance to possessions, furniture, houses. New desires were born. Credit inevitably became hypertrophied in ostentation, while the placid rentier waxed fat on the fruits of industry. Already men were finding the yoke of plutocracy hard to bear. Trapped by their own cunning, they could no longer tell where creditworthy appearances ended and truthbearing reality began.

It looked as if the triumphant revolutions in France and America at the close of the eighteenth century would usher in a golden age, whose amazing technical advances would in time release Man from every kind of drudgery. The world, it seemed, was his oyster. Yet the new century, far from redeeming its promise of buoyant assurance, proved to be an age of timidity, evasion and misgiving. Man's power rested on no higher principle, such as belief in God or in himself, or even in the bounteousness of Nature. Life could not be justified by credit, nor were artists likely to be inspired by the dividends of industrial growth.

It might well be supposed that a society based mainly on economic motives would be attracted by material values and that its triumph would be marked by a fairly uncompromising realism. In fact this was not so. In painting the still life went out of fashion, while those who commissioned portraits from Ingres or Lawrence were indifferent to physical likeness and psychological detail. What the sitter looked for was not his features but his "image," his status, the figure he hoped to cut in society. While he insisted on accuracy in details that made him appear affluent or cultivated, he delighted above all in a striking pose. Now the realist loves objects and creatures for their own sake, frankly relishing his physical awareness of them. In that sense the nineteenth-century bourgeoisie had no liking for realism.

Credit, of course, relied on future business, but also on a man's mode of life, his sense of decorum, even on the way he dressed. In this sense a portrait was a sort of prospectus. So, for that matter, was behavior. Impropriety might discredit the firm. Loose living was dangerous in so far as its exposure might weaken confidence in a man's business. To a great extent, therefore, the prevailing standards might be summed up in Tartuffe's famous epigram: "Le scandale est ce qui fait l'offense." A man's rights and duties were governed by the impact of his behavior on the economic foundations of society. Ethical values tended therefore to be equated with solvency, integrity in business and the soundness of contracts.

Within the middle class, however, there was a scale of rank based neither on institutions nor on intrinsic criteria, but always on a certain appearance which gave token of success or failure. Status acquired greater value than the merit which enabled a man to climb the ladder of success. It was more important to be something than to be someone. Looks, in fact, mattered more than character. A man's distinction or personality was only esteemed if it explained or facilitated his success. That, not his nature, was what counted.

Such was not the case in regions unaffected by industry or its economic nexus. In northern Europe and the smaller towns of Germany society remained curiously becalmed. Here the gentry retained their ascendancy over the local merchants and craftsmen, whose dealings were confined to the surrounding district, or even to their market town. They were solid and sober citizens, very different from the flashy customers who now ruled the roost in London or Paris. Soon, however, these secluded backwaters would be engulfed in the floodtide of the new century.

The cities of western Europe, likewise, would be adapted to the needs and values of an industrial society. They would have showy, imposing façades but would be made up of modest dwellings that were consonant with the reality of small families and limited means.

In Paris, Rome or London there could be no question of total reconstruction. They merely renovated certain districts in the likeness and for the benefit of the new ruling class. The Americans, however, could conjure up visionary cities and hope one day to build them. When L'Enfant planned Washington, an embryonic capital at the junction of the Potomac and its eastern branch, he gave it a sweep and symmetry answering to the ideal of the period—well-ordered and stately, yet pleasant to live in. This was also the aim of the new districts in Paris, London and Brussels; each house being embedded in a long façade, which undoubtedly gave the streets and squares an air of grandeur. But the spaciousness of the general layout only disguised the cramped and commonplace nature of the actual dwellings. Even the building materials were meretricious. Brick was thought common and was therefore coated with pebble-dash in a light shade that, seen from a distance, might pass for stone. So long as the house looked well its owner showed no desire to be different from others; nor was his taste reflected in either the style or the appointments of his home. Here again one finds true identity masked by rank and status. By himself, of course, a householder would not be able to afford the mansion he longed for as a source not of enjoyment but of prestige. In this as in other forms of business the pooling of capital made possible what no single shareholder could hope to attain—the cornering of a district or a market. Since the town belonged to the business community it developed with a view to their residence and recreation.

The new districts were, indeed, lavishly endowed with parks and gardens, for a palace must have its avenues and vistas. Meanwhile the population of most big centers was being constantly swollen by the growth of industry. This created urgent problems which were never satisfactorily solved. Beyond the residential areas, however, public parks were laid out on the periphery, such as the Pincio in Rome and the Champs-Elysées in Paris. They provided genteel exercise and diversion for a society some of whose members could live on private means. This may account, too, for the proliferation of sideshows and places of entertainment, such as panoramas and cafés, not to mention all kinds of little shops, many of which had undergone a sea-change. The craftsman's workshop and small wholesaler's had been transformed into "salons" for customers who were prepared to go shopping but had expensive tastes. Arcades and galleries were provided for the traffic and amusement of the new privileged class. For privileged they were. "Public" did not mean open to all. Some gardens were reserved to those who lived round them, others to those who wore the right clothes. Just as the property franchise restricted membership of Parliament to the middle class, so their education, money and manner

of dress gave them a monopoly of most of the new public buildings and a large part of the open spaces.

They even turned princely pleasures into a joint-stock company, so that they could all taste the sweets of life in palaces and country houses. Art, music, entertainment, even great demesnes and stately homes became the prerogative of those who, as businessmen and taxpayers, were now entitled to them.

New requirements were met by new buildings. Yet there was no revolution or even modification in architectural forms. Despite full order-books and, in some cases, novel projects, the architects who laid out the residential districts and parks were barren of ideas when it came to designing the structures that were needed. One reason for this deficiency, fundamental to the whole period, may be found in the way the early nineteenth century conceived a town, with its grandiloquent, anonymous façades. On all sides there arose the same frigidly classical structures. Ponderous cubes or rectangles, adorned with pediments and surrounded by Greek or Roman columns, were used to make do for anything—theaters, public libraries, grammar schools, hospitals. Respectability and decorum called for Roman majesty in design. Domes were used for buildings that had to be especially imposing. They were the insignia of Parliaments, the hallmark of political power. Another portentous symbol, the Bank, was dignified in the same way. But these architectural forms were not adapted to genuine needs, or even to the materials used. In public buildings, as in portraits and houses, reality was subordinated to appearance.

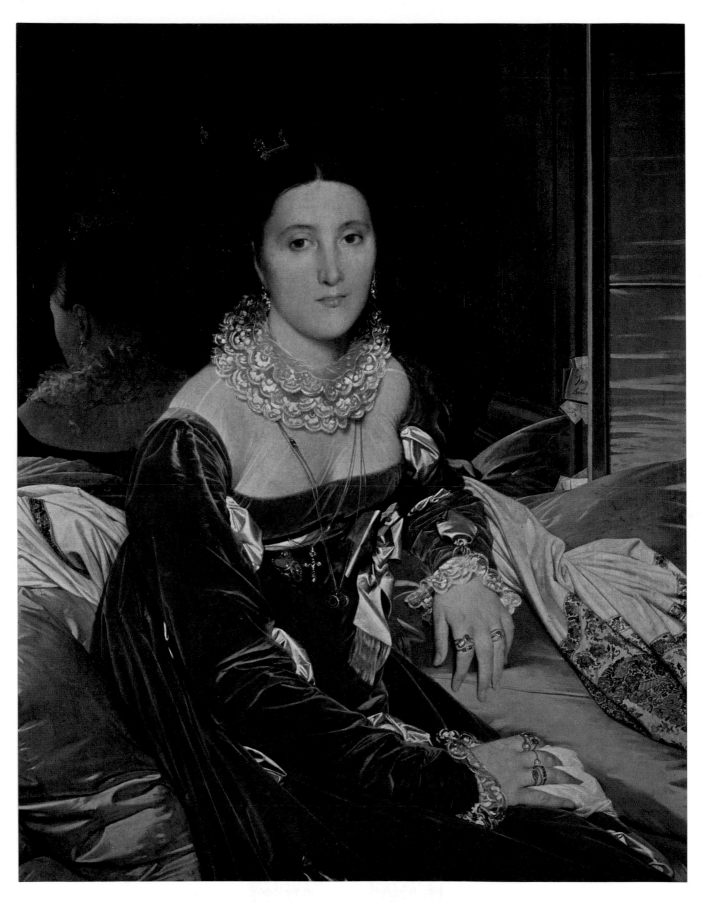

JEAN-DOMINIQUE INGRES (1780-1867). THE VICOMTESSE DE SENONNES, 1816. MUSÉE DES BEAUX-ARTS, NANTES.

Portrait painters tended to exalt their sitters by means of accessories indicative of their status, for this was the type of portrait most in demand among the bourgeoisie now in the ascendant. However lifelike they may seem, the main purpose of these portraits is to communicate a social and political myth. Gestures, attitudes, the entire composition, had to present a worthy image, and one with a moral to it, of a family or individual. Thus David was led to stress the contrast between the bulky figure of the Conventionnel in his shirt-sleeves and the elegant grace of the children grouped around him. Family ties were often indicated in sentimental fashion by a mutual glance or clasped hands. Some symbols acquired particular importance : fine clothes, luxurious furniture, or a book; the latter appears again and again in male portraits as a sign of the intellectual pretensions of a class that wanted to be thought educated and well informed.

Attracted more by externals than by the psychological make-up of his sitter, the portrait painter necessarily concentrated on the richness of the setting and sumptuous materials. The sobriety of David and most French portrait painters of the Revolutionary period gave way to the opulence displayed in so many portraits by Ingres and the Belgian artist Navez. Sometimes the composition was even unbalanced by heavy draperies and ever bolder color schemes. In the portrait of the De Hemptinne family, Navez groups his subjects on a neutral ground and crowds the foreground with details.

Ingres on occasion lingers lovingly over forms and texture. He was fond of contrasting the smooth expanse of velvet, satin and linen with the glitter of elaborate jewelry. But he was adept too, as in the portrait of the Vicomtesse de Senonnes, at subtly balancing the extreme complexity of these secondary elements against the schematic construction of the main part of the picture—here the face and bust; and he carefully avoided those fleeting glances and allusive gestures that serve to link the figure directly with the surrounding accessories. The result is that the young woman, gazing vacantly into space, surprises us by her simplicity. Her reflection in the mirror behind her, larger and darker than her face, repeats insistently the purely formal pattern of rounded volumes. Thus, behind the image of a fashionably dressed society woman, the monumental equilibrium of the figure reappears.

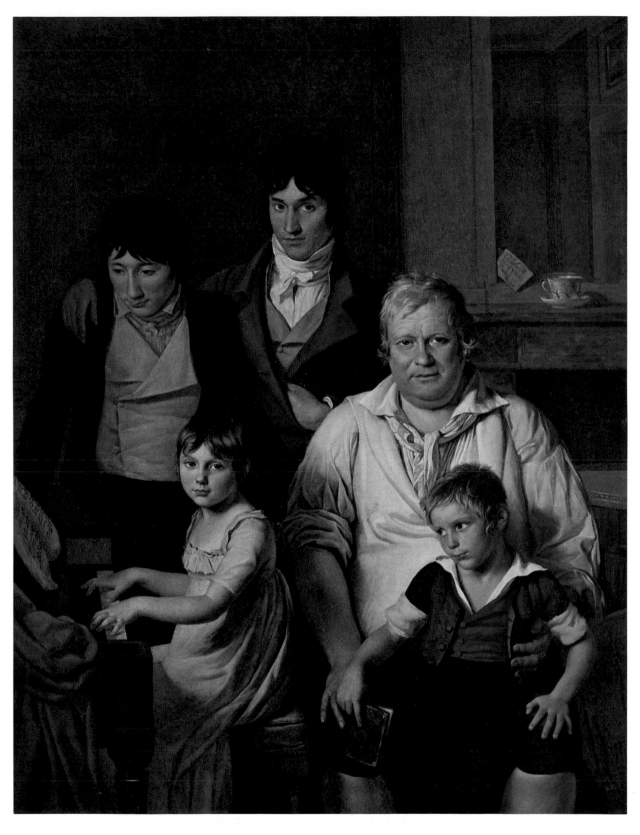

ATTRIBUTED TO JACQUES-LOUIS DAVID (1748–1825). FAMILY PORTRAIT. EARLY 19TH CENTURY. MUSÉE DE TESSÉ, LE MANS.

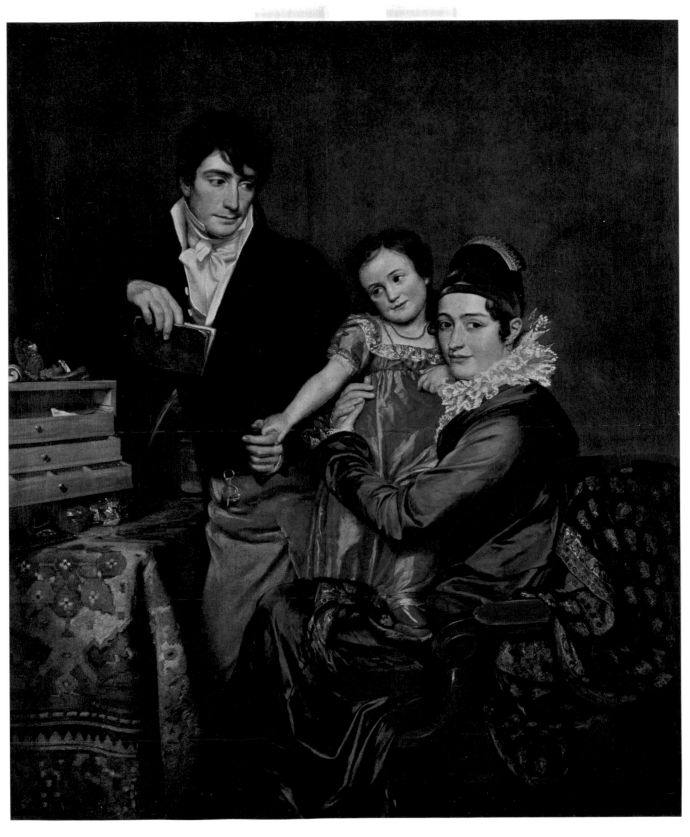

FRANÇOIS-JOSEPH NAVEZ (1787-1869). THE DE HEMPTINNE FAMILY, 1816. MUSÉES ROYAUX DES BEAUX-ARTS, BRUSSELS.

Ingres' first years in Italy, after he had won the Prix de Rome, were a time of freedom and enthusiastic discovery. He had as yet no inkling of the complexity of certain problems with which he later came to grips. He handled his pictures boldly, with spontaneity and even with violence. The studied works of his maturity have none of the dash and simplicity shown in the portraits of this period when he scrutinized his own features and made his friends pose for him. These early self-portraits, and the likenesses of the painter Granet and the architect Desdeban, were working studies made for his own use and instruction; they have a monumental quality that testifies both to his powerful sense of form and design and to his youthful enthusiasm.

Radiant with intelligence and reduced to its essential forms, the half-length figure of Desdeban in the Besançon museum is remarkable for its rigorous construction and manly directness. The sitter's inner life is as vital to the unity of the masses as the vigorous brushstrokes on the dark coat. The forms of the body and clothes are not treated realistically, or even rendered for their own sake; they are simply the support which throws the face into prominence. So true is this that all but the face has remained unfinished. The hand has been placed in an arbitrary, even unnatural position in order to counterbalance the volume of the head, while the triangular opening of the coat, laying bare the white expanse of the shirt, acts as a focus for the light.

There is no sign here of the rich textures and beautiful accessories which tempted Ingres towards the end of his stay in Rome. Our attention is held by the willful glance, the alert face and lucid self-awareness of a figure whose compelling presence far transcends mere realism. The forthright vigor of the execution is proof of the spontaneity of which Ingres was capable in his youth. Everything here bespeaks the joy of discovery and an utter disregard of rhetorical effects. Paying tribute to the life of the mind, a portrait like this, in which there was no room for flourishes, was not meant for the general public. And though the enthusiasm for intellectual endeavor which it reveals was shared by a good many men of the same generation, the glorification of reason is apt to be detrimental to the emotional life unless it is expressed with something of the passionate warmth of the young Ingres.

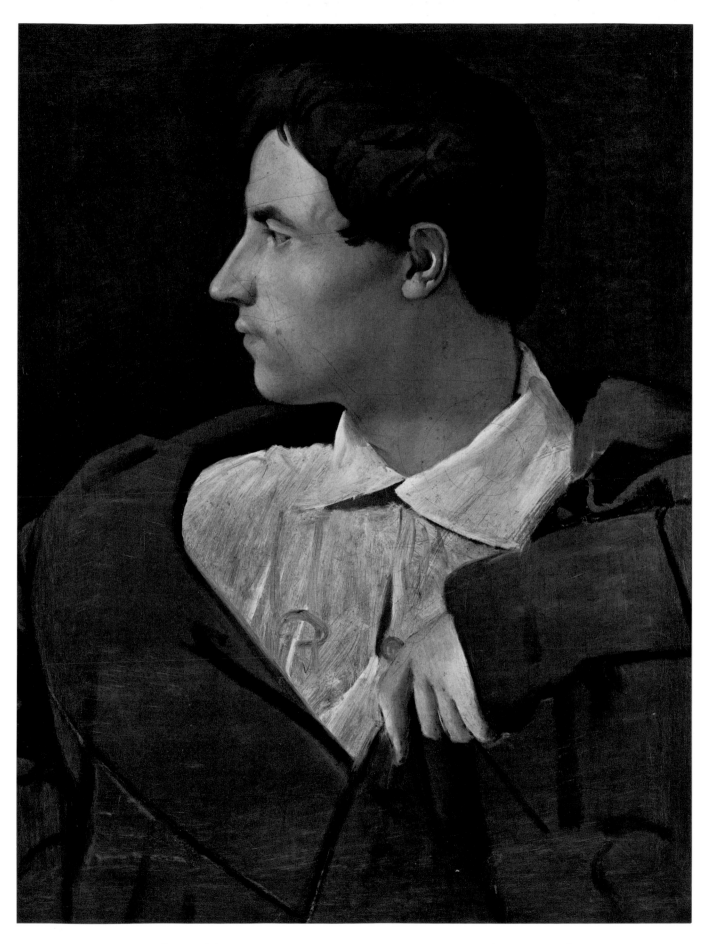

JEAN-DOMINIQUE INGRES (1780-1867). THE ARCHITECT JEAN-BAPTISTE DESDEBAN, 1810. MUSÉE DES ARTS DÉCORATIFS, BESANÇON.

THE SPIRIT OF GEOMETRY

Thanks to their pragmatism the Founding Fathers, in defiance of all theories, made their system of government so elastic that a democracy for ordinary men emerged in the United States after the War of Independence.

This did not happen in Europe. Robespierre and Saint-Just leave one in no doubt that the Convention Nationale intended to establish absolutism in France. Their frequent allusions to Virtue assumed the total sacrifice of the individual to a supposedly perfect polity. In its successes and failures one can see how its advocates repudiated ancient customs and human feelings in their determination to create a compact State, wherein each citizen would become the ideal cog in a society with the same flawless structure, simple and universal, as that of the new system of weights and measures. Since the stability of the ideal republic was considered vastly more important than the well-being or even the lives of a few individuals, there was little anxiety lest it should be baptized in blood.

The ruthless austerity that conceived a world of reason in the teeth of facts is closer than one might imagine to early nineteenth-century thought. A mind like Goethe's may have been led by Kant's theory of the limitations of reason constantly to ponder on the problems of behavior and even, perhaps, to be especially heedful of sensory phenomena. The fact remains that to most writers and thinkers of that period thought was everything, the senses little, the hand nothing.

Once the national assemblies had made Reason supreme, men were unlikely to be attracted by form or color, or to find any symmetry that was not purely rational. Perspicuity of thought and symbol does not reveal the power of the intellect so much as its inability to permeate the senses; it seldom produces a good picture, but it had a certain appeal for the votaries of

Saint-Just or Napoleon. Hence the plastic arts aimed above all at lucid exposition, pleasantly graphic allegory and simple exercises in historical allusion. The main thing was the subject. Painters themselves, from David to Girodet, even Delacroix in his early days, were deluded into believing that eloquent gestures and blatant histrionics could be a substitute for cogency of form.

All the artists of David's school tried to make their works as explicit as speeches. Most of them succeeded, but only by sacrificing beauty of expression. Some, including David himself, held that physical reality was essentially tangible; yet in obedience to reason they felt bound to dematerialize what they considered gross matter.

Hence they gave birth to basilisks and monsters. Being unable to express their feelings, they composed arid, declamatory manifestoes in which exact definition was subordinated to perspicuity. Their works were descriptive or allegorical. Form was reduced to symbol, to mere hieroglyphs.

These, then, are pictures which appeal to the intellect. For them to be understood the events and people portrayed had to be readily recognizable; gestures are accordingly more significant than expressive. David's transfixed warriors are no less symbolic than the personifications of the *Iliad* and the *Odyssey* seated at the feet of Ingres' Homer. Each figure is the embodiment of an idea, and if anything is expected to move us it is the moral relations between one figure and another and the historical allusions they convey. Pictorial expression—color, form, brushwork—counts for nothing. Indeed, any emphasis on expressive qualities was considered harmful, for it might blur the clarity of the subject.

This jejune intellectualism, ignoring the power of aesthetic expression, is bound up with the theories of Kant. For it was he who cast doubt on the sentient

apprehension of phenomena. The scientific method of identifying objects by means of mathematical symbols gave men an incomparable mastery over natural forces; yet it awoke misgiving as well as enthusiasm, for it could not attain any ultimate truth. Man's firmest beliefs were shaken just at the moment when reason seemed to provide him with an instrument of miraculous power. He lost his grip on reality. No wonder the arts reflected the disarray of human knowledge and belief.

The fact remains that men stood amazed at what the intellect could do, and until the beginning of the nineteenth century this amazement, coupled with the conviction that they were guided by reason, was bound to be reflected in art.

Yet the rationalism prevailing, especially in France, at the end of the eighteenth century, hindered the tangible expression of mental attitudes. It favored an abstract and analytical habit of mind, scarcely calculated to discern perfection of line, harmony of color or symmetry of mass. People were prepared to admire reason, but not to have it trumpeted in works of art.

And yet, generations of European painters and sculptors had consistently upheld the pre-eminence of the mental over the visual image, however marvelous, by a form of communication where the existence in the everyday world of consciousness, of order and life, was not disguised by tactile charm or sensuous pleasure. Even so, art had to be Flesh, not Logos; its job was not to demonstrate but to discover.

Cézanne, whose Impressionist background might have led him, even momentarily, to regard the painter's standpoint as purely visual, had less difficulty than Ingres in conceiving and bodying forth a mental vision of the world. In his concern with form and structure he reacted against his environment. In this he showed all the convert's assertiveness, seeking to demonstrate the affinity of the tangible world with the most exquisite forms of geometry. He rejected all external influences and his manner of painting was tantamount to giving his only possible vision of the world. Ingres, on the contrary, always felt compelled to relate his rigorous forms and arabesques to a symbolic, readily intelligible world beyond them.

Yet he and others, by causing an intelligible world to emerge from color and mass, sought to make "what is real and tangible a perfect expression of the mind." Unlike David, such artists as Ingres, Granet, Cotman and even Canova realized that by heightened sympathy the worlds of mind and matter could be organically linked. To them, order and reason were not the writer's province but the painter's or sculptor's. They did not always escape the aridity sometimes found in those who believe that form can only survive if it is kept pure; but at least they did not draw illustrations or hieroglyphs. When they delineated a hill or a body they set out to reveal its very essence, not to make an ideogram of it.

Nothing came of this quest for a harmony of line and mass which, though apprehended by the eye, should appeal rather to the mind. It encountered the blank disapproval of contemporary opinion, to whom form was suspect as soon as it laid claim to exact expression of sensory reality. Any transposal that arose from genuine contact with the sentient world was rejected on grounds of obscurity or distortion—as if the real cause of distortion were not the lifeless symbol that destroyed every link with the visible universe. Indeed the artists of the post-revolutionary generation began to cast doubts on the value of reason itself. The symptoms of Neoclassical dessication reached a paroxysm in denunciation of all rational composition.

Architecture, with its perfectly geometrical use of space, seemed especially endowed for rational expression, and there were indeed several noteworthy attempts to build monuments extolling reason. With its new modes of thought and living, the age needed a distinctive architecture to personify it. Yet these experiments were few and ill received. The imaginativeness of men like Soane, Gilly and Ledoux seems to have isolated them and cost them a number of commissions. Their ideal was an architecture whose beauty should consist in faultless dimensions, elegant planes and balanced proportions. They were concerned less with utility and function than with attaining an impeccable equipoise of mass and space. Bold, mathematical surfaces lent their buildings an authority which, apart from their undoubted beauty, was a categorical statement of order and harmony. The very simplicity of their dimensions seemed a challenge, for it was neither traditional nor pretentious.

The geometry of Ingres or Gilly may well have owed its unpopularity to the fact that it was regarded as pure design, appealing to the eye and nothing else. At a time when reason was expected to be an efficient tool and the spatial arts merely to illustrate moral concepts, there seemed little point in the power of the intellect to create designs in its own image. Indeed there was no awareness of reason as a rising sun, bathing the physical world in its effulgence. On the contrary, it raised doubts about Man's place in the world by hinting at strange affinities which no amount of argument could uncover. It revealed a form of sensory perception wholly unrelated to that of science. Begotten of the hopes and fears of that generation, it was not what they were looking for.

HAND AND BRAIN

The Industrial Revolution was an age that set little store by manual skill, and when Man abjures direct contact with matter and the delight of craftsmanship his creativeness is endangered and he himself diminished. The intellectualism that subordinated form to allegory, when carried to the extreme, hankered after a world without body or substance, where space and feeling would be annihilated. This yearning for the incorporeal was shared by Hegel, whose remorseless logic led him to predict the imminent extinction of art. To him, indeed, art was no more than an instrument enabling the mind to comprehend the universe and recreate it in its own image. Progress consisted in an osmosis whereby the world would cease to be external and become a figment of the mind. Art, as a mere step in the process, could not survive it, being condemned by its own relationship to space and matter, which was that of a mere intermediary. Thus poetry ranks first among the arts because "it is unencumbered by any contact with brute matter . . . it immediately conveys to the mind all that art or the imagination can conceive, and it does so without displaying it to the senses by visible or bodily means."

Music stood only second to poetry, not because it coordinated sounds but because it had the power of "expressing a thought truly." The superiority of painting to sculpture and architecture was due not merely to its ability to express feelings by achieving a degree of inwardness but also to its freedom from the force of gravity, so that it appeared to present no obstacles. Space, the weight and mass of objects—all were illusory and the mind was free to roam. Thus a man who could neither hear nor see might find himself attuned to a perfect world from which the texture of matter had been removed.

The death of art, foretold by Hegel, was not so far off, for the essential dialogue between man and the tangible world was generally ignored. A similar portent could be seen in the widespread contempt for craftsmanship. If the mind was everything, neither hand nor substance had any intrinsic meaning. To be created, art no longer had to take physical shape. Since man could not in any real sense change his surroundings the artist need merely create a mental replica of them, whereby they would be to some extent explained.

Schiller said the same thing when he denied that a sculptor could take any interest in the material he was working. The worst of it was that most sculptors of his day would have agreed with him. The divorce of the artist's hand from his brain, his refusal to come to grips with matter may be seen in the growing habit of making little clay models and leaving an assistant to finish the job in bronze or marble, as the case might be. There was nothing to prevent the use of sculpting-machines, and when one appeared in fact at the 1847 exhibition in the Palais de l'Industrie it does not seem to have caused any aesthetic qualms. By the end of the eighteenth century, in fact, all trace of the artist's hand had been eliminated from his work. Sculpture became glossy, harmonious, slick. Canova reigned supreme in marble perfection, but life and feeling were destroyed by technique. Nothing remained in these polished stones to suggest that they were man's handiwork, they seemed to have neither weight nor texture. The Neoclassical painters went the same way, carefully smoothing out their brushstrokes and blending their lights and shadows—in a word, banishing from their work all trace of their own personality.

Once it became the normal thing for an artist merely to supply a design for completion by a craftsman, he would be all the more inclined to free himself from technical obligations. In this contempt for materials, for their emotive significance, for the eloquence of workmanship, one can see why the whole nineteenth century was marked by decadence in industrial design.

Stained glass, tapestry, then furniture, pottery, jewelry, textiles—all were afflicted with conspicuous poverty in execution and design. Gone was the idea

that the artist who provided the cartoon should co-operate with the weaver or glass painter who carried it out. The designer who refused to obey the behests of his own technique nonetheless required an exact replica of his model. Once more one finds the hand and its materials subordinated to abstract form. While the confusion of paper with wool or glass might not be obviously harmful in conceiving a work of art, when it came to be carried out the effect was to dilute the true resources of craftsmanship, leading inevitably to a futile dilettantism.

Nineteenth-century stained glass and tapestry became painted images and imitation pictures. Nothing took the place of the forgotten skills. As a result of a long process beginning with the Renaissance and now reaching a climax, the arts and crafts were divorced. The sculptor refused to make jewelry, the painter to have any hand in the weaving of his cartoons. The gulf between imagination and application widened. The craftsman helplessly watched the debasement of his craft. Despised as a mere technician, he lost all capacity for daring or inventiveness and was only expected to be the passive, unthinking reproducer of ill-conceived designs or antique models. His hand had to surrender its cunning to the untrained painter. Neglect drained him of that manual inventiveness which in weaving yarn or welding lead tracery had transmuted the drawing into an arras or a pattern of light.

Changes in engraving gave further evidence of this irresistible trend towards the elimination of handicraft. The etcher's needle and the wood-carver's knife cutting along the grain likewise call for physical contact and struggle with the artifact. Once the changes that occurred between the drawing and the finished plate were no longer a source of further inspiration inherent in the process of stippling, etching or carving, but were merely an obstacle that distorted the abstract qualities of the original idea, then the draughtsman sought to dissociate himself from the engraver. While the invention of lithography at the end of the eighteenth century may have been fortuitous, its success was not. No one realized that the apparent removal of an obstacle by drawing on stone instead of engraving actually involved the substitution of a new art form for the old.

The divorce between hand and brain naturally became still more apparent once the worker was himself no more than part of a machine. In a factory, of course, not merely did he have no say in the design of his product—cotton, silk, pottery—but he was even cut off from the raw material. Once the be-all and end-all of manufacture were speed, productivity and turnover, the worker's imagination, deftness and knowledge of his material became superfluous; they might even obstruct the Juggernaut which insisted that the design of a matrix should be determined not by the clay but by the machine that used it, and that the artist's brush should be replaced by the swift accuracy of a transfer. The worker no longer had any active, physical contact with his work, which was reduced to a few automatic movements, leaving no room for his dexterity, his sureness of hand or keenness of eye. The ultimate aim was to replace his last vestige of human activity by a mechanical process. The potter's wheel gave way to the casting-mold; glass was polished by a cylinder. The hand had now no part in the process of manufacture; nor, for that matter, did the mind that determined ornament and design. The industrialist chose his model with a view to productivity rather than to the thing produced.

When Goya designed a tapestry or Delacroix a stained-glass window it did not matter to them how the transmutation was effected. They believed that one substance could be adapted to another and insisted on its being done. By forcing their own design on an unfamiliar material they ignored its intrinsic quality and plundered it, as it were, for themselves. This method was carried much further in industry, which treated machine-made glass and pottery as if design were superfluous. The usual practice was to stylize classical motifs or use patterns that lent themselves to mechanical reproduction, regardless of their suitability to the finished article. Now there was nothing left—neither the play of the craftsman's mind on his material nor that direct contact with the sentient world which the artist obtains from canvas, palette and the rub of charcoal on paper. The manufacturer knew none of this. His textiles or china were almost an abstraction, as remote as the hand of the African or Indian who picked the cotton for his factory. He couldn't even use some exotic design, for he didn't know any. He had no point of contact with the tangible world. Not merely did he take no interest in the qualities of this or that technique; quality in itself meant nothing to him. This was not a case of the craftsman misappropriating his product or making a travesty of his technique; the product itself was a matter of complete indifference.

Technical discovery, by its mastery of a new medium, usually revolutionizes design. This was not the case with industry or with architecture. By the end of the eighteenth century metallurgy had reached a point where girders of great tensile strength could be cast, and it looked as if a new age of design must be imminent. But no. Although iron was used for practical purposes, such as making structures fireproof, no one thought of applying it to design.

That strange paralysis of architecture which, instead of adapting itself to the times, stayed in its Classical, Palladian or Neo-Gothic rut, has been traced back in France to the separation in 1798 of the Ecole des Beaux-Arts for architects from the Ecole des Arts et Métiers which trained engineers. But the divorce of technique from design was so inherent in the conditions of the time that one can hardly distinguish between cause and effect.

The age of Hegel was bound to beget an architecture of the Ideal, indifferent alike to the method employed and the purpose aimed at. Like the decadence in industrial design, it was an expression of abstractness. Small wonder that iron was only put to practical purposes. If it was used to build cantilever and then suspension bridges, this was only done because they solved certain technical problems, regardless of their aesthetic merits. This was even truer of cast-iron for industrial building, which was not regarded as a new concept of space but merely as a cheap way of housing machinery.

On the other hand there was a fondness for graceful, symmetrical plans that could be used for anything. The same courts, the same rotundas, the same interminable galleries were designed in exactly the same way to serve as hospitals, prisons or government offices. In point of fact—unlike the contemporary designs of Gilly and Soane—they were not intended to take actual shape but to be admired as a handsome blueprint. They were paper edifices, just as Goya's tapestries were really paintings.

With glass and iron architecture might have created new spatial entities, as Labrouste proved when he built the Sainte-Geneviève Library in 1845. But there is no evidence that most architects of that day had any desire to give space a definite shape. In fact when they planned a building they seemed to be interested in the façade rather than the fabric, and probably in their blueprints rather than the actual edifice. Exceptions there were, but in the main what the age wanted was an abstract and universally adaptable design in which technical exigencies or the materials used might be disregarded.

1

ARCHITECTURAL PROBLEMS

Architecture, by defining the space and milieu in which we live, generally determines the style of an era. It is naturally bound up with men's aspirations. But the age of the great political and industrial revolutions never seems to have worked out a coherent style of its own for its public buildings, though it had every opportunity to do so thanks to the new materials and techniques at its disposal. The new masters of the city, with culture, amusements and the state all under their control, urgently needed new buildings—spacious buildings, original in design and constructed in large numbers. And if these were to answer the requirements of an age in the throes of profound changes, the urban setting had to be adapted to them. True, architects transformed the cities, but everywhere they erected commonplace façades, plastered and painted over, their decorative motifs borrowed from the Renaissance or from classical Rome.

Town-planners were more successful in laying out new streets and parks, and did not hesitate to design them, even occasionally to carry them out, on a large and complex scale. They relieved the monotony of an unimaginative architecture by giving picturesque curves to streets, by unexpected vistas and splendid parks and gardens. Everywhere a "reasonable" degree of fantasy was combined with strict order, but never with more mastery than by

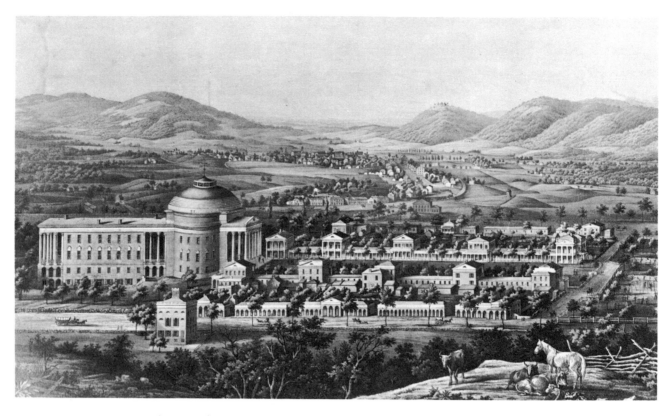

THOMAS JEFFERSON (1743-1826). THE UNIVERSITY OF VIRGINIA, 1817-1826. LITHOGRAPH BY E. E. SACHSE, 1856.
ORIGINAL IN THE ROTUNDA AT THE UNIVERSITY OF VIRGINIA, CHARLOTTESVILLE, VA.

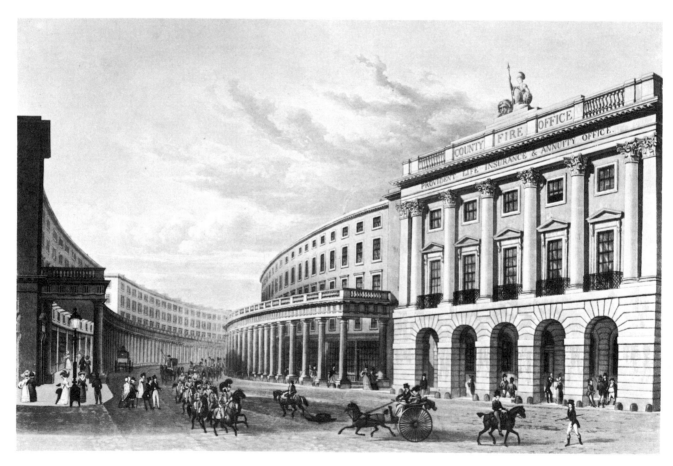

JOHN NASH (1752-1835). REGENT STREET QUADRANT, LONDON, 1819-1820.
PRINT AFTER T.H. SHEPHERD, 1822.

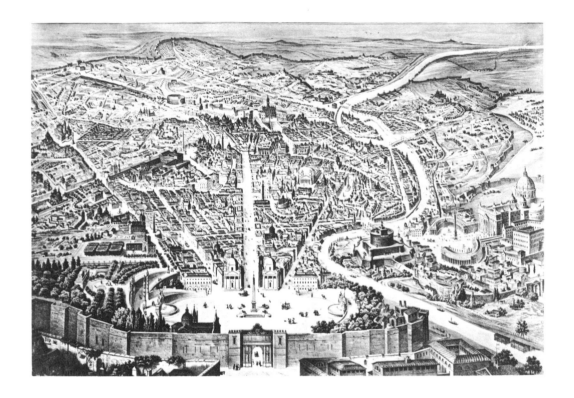

GIUSEPPE VALADIER (1762-1839).
ROME: THE PINCIO
AND THE PIAZZA DEL POPOLO.
NINETEENTH-CENTURY PRINT.

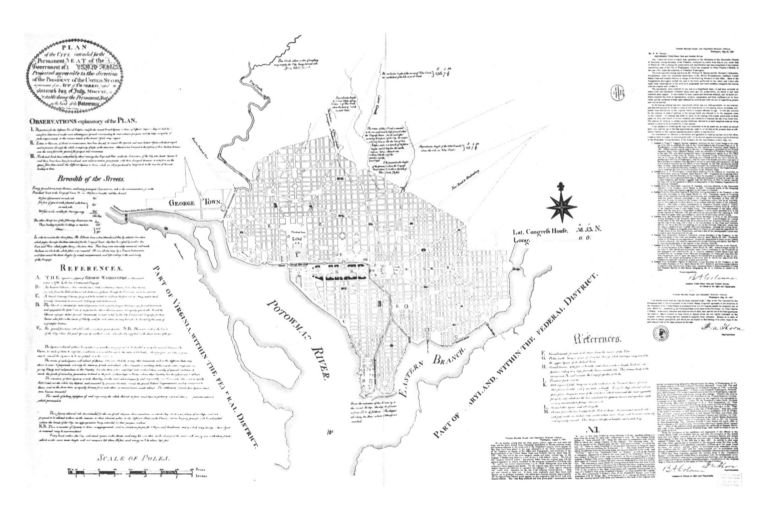

PIERRE-CHARLES L'ENFANT (1775-1825). PLAN OF WASHINGTON, 1791.
REPRODUCED FROM THE FACSIMILE IN THE MAP DIVISION, LIBRARY OF CONGRESS, WASHINGTON, D.C.

L'Enfant. While it is true that the whole of Washington was designed by him as a vast checkerboard, many cross-streets and little tree-lined squares opened up unexpected views that delighted the eye of the passer-by. Above all, two broad parallel drives, following the course of the river, gave breadth and flexibility to the whole plan. The Mall extended from the Capitol to the Washington Monument, linking the opposite ends of the city. Placing a city's most representative buildings in such a prominent position was one of the aesthetic ideals common to most town-planners of the day, who aimed at creating fine prospects by adapting the monuments to the site. The arrangement of the Pincio and the Piazza del Popolo in Rome was motivated by this ideal.

But, strange as it may seem, a monument so treated loses rather than gains in importance. When a building is meant to be no more than the adornment of a crossroads or a symbolic object, then the demands of architecture proper become a liability. The prominence given to the façade since the seventeenth century was now carried to absurd lengths, entire buildings being expressly designed to harmonize with a picturesque setting or to act as a symbol. Their use, the function of their internal space, became irrelevant and, as the building was no more than a sign without concrete meaning, its external space was interchangeable. Thus, at the University of Virginia, Thomas Jefferson devised a plan whereby the professors' houses were modeled after different buildings of antiquity, offering the students a kind of anthology of classical architecture.

Such an idea seems less ridiculous when we remember that, at that time, the exterior of a building gave no indication of its purpose. If a college, a church, a theater or a guardhouse could be identical in design, what was to prevent a house taking the form of a temple or an ancient tomb? All that was expected of the façade was that it should be pleasant to the eye and harmonize with its architectural setting. In the end this principle of town-planning was carried so far that the elegance of a street or public square mattered more than the

beauty of individual buildings; their internal structure was accordingly subordinated to the symmetry of the external setting.

However, in spite of current taste, some architects did design functional buildings. Many of these remained in the planning stage, but some have come down to us in the designs of Gilly and Schinkel. One marvels at these bare surfaces and powerful volumes, the genuine expression of internal space; and one realizes that these architects—going against all the ideas of their time—considered an opera house, a museum, a shop, to have each its own structural and spatial requirements. But there is nothing to show that new techniques had been envisaged. Little use was made of glass and iron, and spatial expression, even where it existed, was partial and incoherent.

Yet, in England as well as France, iron bridges demonstrated the advantage to be gained from metal arches. In 1820 Marc Seguin built the Tournon suspension bridge over the Rhône; its lightness and elegance pointed the way to the architectural revolution made possible by industrial progress. In fact new forms had emerged, large glass windows had been built, and large conservatories like those in the Jardin des Plantes in Paris had been put up without architects realizing the possibilities thus offered to them. The truth is that no really new idea could have any place in the pseudo-classical buildings of the period; indeed it was the persistance of this style that prevented the use of iron in buildings.

It was not until mid-century that genuine innovations were made. At last, in the Bibliothèque Sainte-Geneviève, Labrouste went ahead and used cast-iron columns and arches to good effect, both aesthetically and functionally. There is an enormous difference between these walls reduced to the supports between windows, these slender columns and glass vaulting, and everything constructed hitherto. This is not the logical development of a style, but a sudden and radical departure. Belated and yet quite unexpected, it was architecture's response at last to the age of the great revolutions.

CHARLES ROHAULT DE FLEURY (1801-1875).
THE CONSERVATORIES OF THE
JARDIN DES PLANTES, PARIS, 1833.
DRAWING BY EMILE LABORNE, 1871.

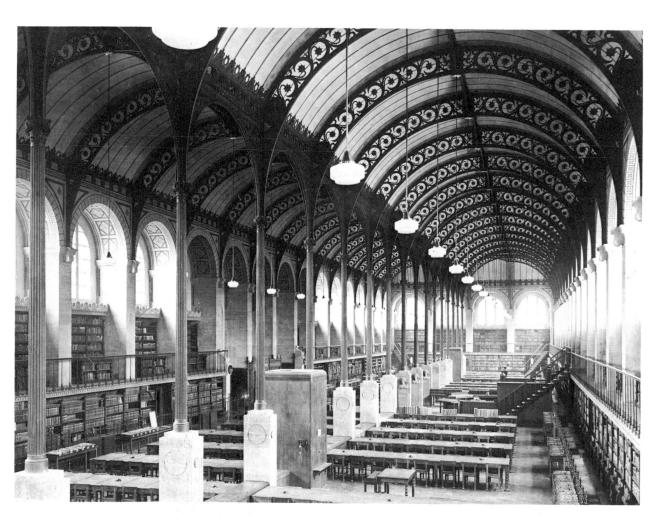

HENRI LABROUSTE (1801-1875).
THE READING ROOM IN THE BIBLIOTHÈQUE SAINTE-GENEVIÈVE, PARIS, 1845-1850.

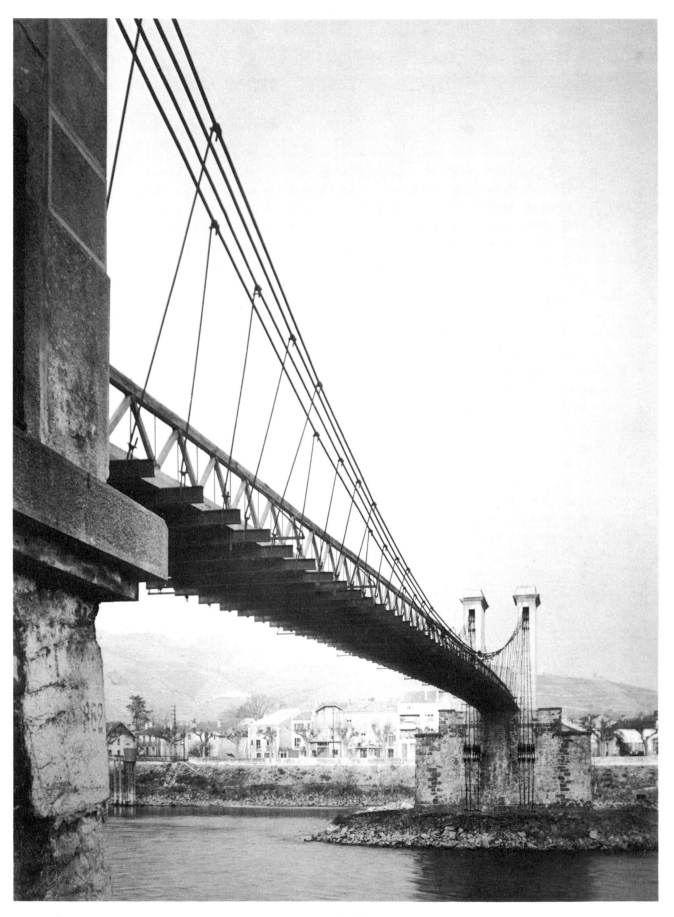

MARC SEGUIN (1786-1875).
THE TOURNON SUSPENSION BRIDGE OVER THE RHONE, 1824.

29

CROSS-PURPOSES

The economy that emerged at the end of the eighteenth century was truly dynamic, governed as it was by technical inventions requiring constant revision of the productive process. Moreover the parliamentary system, which it was hoped would become universal, was likewise capable of endless transformation; for the power of initiating legislation was entrusted to an elective and periodically renewed assembly, which in the last analysis determined the constitution itself. With so much flexibility and movement in politics and economics, one would expect to find the same thirst for progress and innovation in the arts. On the contrary, they would seem to have been drained of all vitality by the great revolutions. The aesthetic turmoil and ferment of barely two generations earlier had subsided. Those who lived through the great days of 1789 seemed to care for nothing but rigid convention, statuesque figures and uncompromising symmetry.

Artistic subjects, however, were highly dramatic, a succession of murders, battles and sacrifices. Such compositions should have momentum, but their dynamic flow is always arrested by symmetry. All energy is stifled by the harmonious gestures of Canova's statues or the balanced groupings in David's or Guérin's canvases. Such nerveless treatment reduces the warrior hurling himself on the foe to a ballet dancer preparing his next *entrechat*. Painters, moreover, outlined their figures with a slight nimbus which cut them off from one another and made it inconceivable that people so carefully segregated should be embroiled in fierce encounter. This clear-cut isolation of every object disrupted the composition and rendered it inert. Besides, the adroit use of perspective in crowding the canvas gave it a stagy effect, completely excluding the beholder from goings-on in which he had no part.

Only with the advent of Romanticism did the plastic arts revive and make some attempt to portray a world in flux and gestation. Had these later works won general acceptance or understanding, one might have said that art had failed to keep up with social conditions; but the works of the Romantic school were disparaged as being laughable, absurd or grotesque. The gulf between artist and public widened.

It is nonetheless certain that the accession to power of the middle class gave rise to the Romantic school in art, which itself epitomized and extolled certain essentially middle-class values, such as freedom and the perpetual onward and upward movement of life. The bourgeois spoke the same language as the poet, who was bourgeois himself. William Tell and Egmont were kith and kin to Washington and the men of the French Convention. Even the most disreputable figures of legend originated in liberal ideology. The bandit or outlaw, living for the morrow and relying solely on his own strength and the right of his cause, is not so far removed from the industrial condottiere, who must also fight the good fight single-handed. Despite first appearances, Hernani, Childe Harold and, above all, Shelley's Prometheus belong to the age of personal responsibility, bills of exchange and debtors' prisons.

The early nineteenth-century bourgeoisie had no use for these characters, whose features they shared. What they loved was the painting of David, the architecture of Chalgrin, the tragedies of Raynouard. They and the poets of 1820 may have paid tribute to the same heroes—the soldiers of Valmy, the members of the Convention Nationale, the Girondins; but the real idol of the middle class was Napoleon Bonaparte. The great enterprise of the Revolution was overshadowed by the order and military prowess of the Empire. The Code Napoléon counted for more than the night of August 4th.

The spirit of adventure was not devoid of prudence. Faith, while essential to credit, must itself be firmly based on well-defined rules, exact laws and stern tribunals to enforce them. The Civil Code, designed

by Napoleon for France and her satellites and imitated throughout the West, did as much as parliamentary representation to consolidate the new social order. It provided a hard, protective shell for the vital organs, such as property and contract, of a society which, however eagerly it sought progress and even adventure, sought them in terms of law and order. Hence the appeal of art that tried to be dramatic without breaking the icy sheath of rules. With its fitful rhythm and convulsive movement, like the writhing of a trapped animal, it truly reflected the rashness and timidity of an age that could not bear genuine enthusiasm if it went too far.

Another restrictive factor was unearned income. The joint-stock system gave birth to a new class of idle rich, who lived on the profits of trade and industry but did not help to run them. They were prone to cold feet. The rentier was even more impressed than the tradesman or factory-owner by the outward signs of success, which were all he could see, and by the seeming dangers of any sensational change. Technical progress enriched him, but since he could only assess it in terms of his pass-book, it also made him nervous. Lacking the imagination and drive of big financiers, he was more careful than they to keep the law and respect a moral code that ranked property as a virtue.

Apart from this love of order as the basis of middle-class power, there was a certain bias against artistic creativeness in itself. The very men who admired progress in science, technology and politics held that any aesthetic change was outrageous and wrong. Art must either obey tradition or imitate nature—in which case the replica must itself conform to traditional standards of verisimilitude, beauty and seemliness. Honor a work of art, by all means, but one must not be upset by it. Strange though it may seem, the bourgeois, the new man, rejected what was new in the very province of inventiveness and innovation.

It was considered further proof of excellence in David and Canova that they echoed Antiquity, whereas Géricault and Delacroix were criticized for their originality. The very people who accepted personal responsibility and risk in business could not see why there should be anything startling in a brand-new picture or composition, or in a play at its first performance. Society might be new, but art was old and should look it.

Consciously or not, the contemporary idea of progress was at variance with the changing view of the world given by painters or poets. That form of progress did not, as a rule, connote either the philosopher's freedom and clarity of belief or the artist's audacity in pursuit of the Absolute, but rather the more tangible goal of worldly success. Characters like Julien Sorel, Dombey or Baron Nucingen had no use for the Absolute.

The new ruling class may have been poor judges of art, but they did not despise it—witness the success of the Salons, drawing ten thousand people to Paris every year. This immense public was neither indifferent nor hostile; it came to admire and be edified. It did not, however, expect art to reveal the unknown, but merely to confirm its own beliefs. That was why people liked best what they best understood—works that appealed to the mind rather than the eye. They came in quest of nobility and earnestness, such as befitted an official occasion like the Salon.

The man in the street was touchy, not merely because the artistic point of view was beyond him, but because his own incomprehension made him fear he was being laughed at. It would never have occurred to a monarch of the old school that an artist might exploit his ignorance to poke fun at him. The visitor to the Salon, however, having no absolute authority, was less sure of himself. Moreover, he was vaguely aware of his inability to judge what he saw and for fear of being hoodwinked he took violent exception to anything unwonted. This was the origin of a compromise. While the success of a painting depended in part on criticism, the actual commission was influenced by popular fancy. A prince could buy what he liked without a qualm. The purchaser's rank guaranteed approval of the picture or statue he chose. Who would have dared cavil at the taste of Louis XIV? But a minister could not order a painting that had shocked ten thousand beholders. That is why Goya had less trouble with Charles IV than Delacroix with John Doe.

The manner of displaying works of art also played a part in the original misconception, whereby they had to conform to a more or less ossified tradition. Most of the pictures shown at the Salon or the Royal Academy were immense compositions, not intended to be hung anywhere in particular. The huge canvases of David and Delacroix had no architectural

setting, unless it were a fairy-tale palace or some vast, empty pantheon. Since they had no setting, such pictures could even be exhibited alone as a traveling peepshow. This was done, for instance, in England with Géricault's *Raft of the "Medusa."* Painting and sculpture were thus completely untrammeled, but at the same time they had no connection with anything else. This meant repudiating not merely the mutual relationship between the arts and space, but also the entire spatial function of painting, sculpture and architecture. If any picture could be hung anywhere—and the higgledy-piggledy arrangement of exhibitions showed how widely this was believed—a picture had nothing to do with the wall behind it and did not transform it. The same was bound to be true of architecture and sculpture, which existed in space but did not affect it. This, of course, denied the very existence of architecture, which must be a shaping of space, and it degraded sculpture to the level of a knick-knack. In fact, as we shall see, the whole trend of the period was in this direction.

Public collections gathered works of art into a sort of limbo where, cut off from life, they acquired an independent existence. The consequences were all of a piece; for this attitude to art was perfectly fulfilled by new galleries designed as a series of immense corridors, along which paintings and sculptures were tediously arrayed. There they remained in crowded exile.

Another factor was the prestige attaching to picture galleries. A painter's ambition was no longer to work hand in hand with sculptors and architects, or to be commissioned to take part in achieving some grand design for the use of living men. What he now wanted was to see his works hung in a gallery beside those of the illustrious dead.

Museums, being exempt from the problems of real life, lacked the dimensions of space and time, thereby confirming the popular belief that Beauty is fixed forever by tradition. There is nothing in Old Masters to affront a man's opinion of himself or of the times he lives in; they cannot disturb the present because they do not belong to it. That is why they are so reassuring. Painters, therefore, were expected to produce hot-house art, divorced from reality and time. Meanwhile the artist, let loose upon the anonymous, non-committal walls of Salons and galleries, was obsessed by his apparent freedom to say what he liked; but what he had to say was determined by his own niche in society. He could only reveal the present. Art can never be coterminous with death; but it may happen that the graveyard lays its silent spell on those who fear the voices of the living.

The divorce between hand and brain was the prime mover, for it marked an age that shrank from grappling with space. No doubt the courage to portray a cause is only found in those with strong roots and unshaken faith. Society in the early nineteenth century was so constructed that liberty became petrified in order, invention declined into industry and industry itself shriveled into credit. No pyramids or cathedrals were likely to spring from such threadbare values. In the end art could only thrive by setting its face against society.

The old quarrel of the Ancients and Moderns broke out with renewed violence at the beginning of the nineteenth century. The accumulated treasures of the past were now on display in the great museums, and their beauty seemed an unanswerable challenge to modern artists. In these masterpieces the public saw an absolute perfection, never stopping to consider that if Phidias had revealed the face of their gods to the Greeks, other artists could, in their turn, give shape to the hopes and beliefs of living men. It was imagined that the artists working under Leo X and Pericles had created the ideal works of art, and that now there was nothing for it but to copy their frescoes and statues. Sculptors and painters themselves fell under the spell of such beautiful models. Canova would polish his delicate marbles till they made people dream of Praxiteles; in doing so he forgot to be himself. Yet his statues do not resemble those of fourth-century Greece. Contrary to current belief, erecting a peripteral temple in the center of Paris did not bring Antonine Rome back to life, nor had the enchanted spaces of the School of Athens *any connection with the labored symmetry of the* Apotheosis of Homer. *No coffered ceilings, pediments, fluted columns or static images of Greek and Trojan heroes could recreate the beauty which came to life at the hands of Phidias and Raphael.*

The genuine tradition was renewed when artists deliberately invented forms of their own. By treating space on the human scale and devising decorations and lighting appropriate to it, Sir John Soane, in the breakfast room of his own house in Lincoln's Inn Fields (now the Soane Museum), offered a fresh solution to the problem of the dome and preserved a cheerful sense of intimacy that is wholly lacking in the pseudo-antique constructions of his contemporaries.

It is one of the paradoxes of Ingres' temperament that, in spite of such pictures as the Apotheosis of Homer, *he should have been capable of the supreme freedom of design that enabled him to compose the* Reclining Odalisque. *The long ivory body owes nothing to the canons of David. This beauty is no copy; it lies in the perfection of the curves subtly drawn out to the furthest point necessary to sustain the almost musical rhythm of the elongated body. The very harshness of the colors is in keeping with the purity of the form. The* Reclining Odalisque *conforms to none of the criteria of the age; it is the aggressive affirmation of an order of beauty discovered by the painter, and intended perhaps for himself alone.*

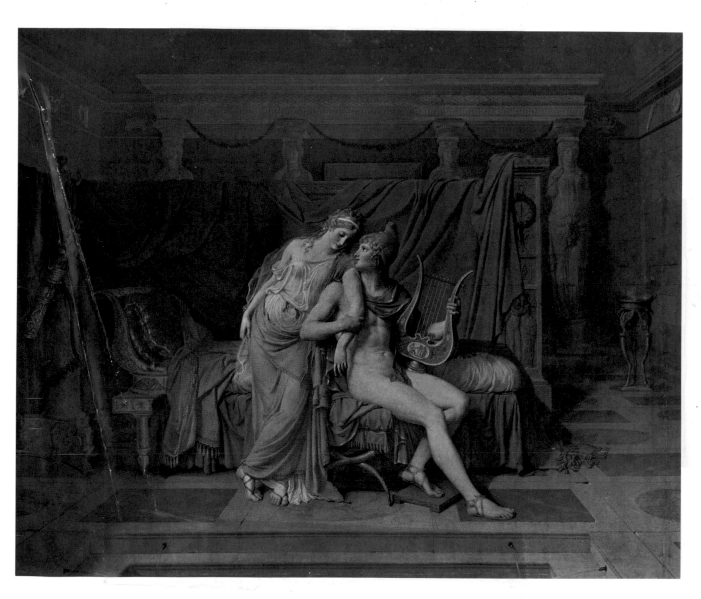

JACQUES-LOUIS DAVID (1748-1825). PARIS AND HELEN, 1788. LOUVRE, PARIS.

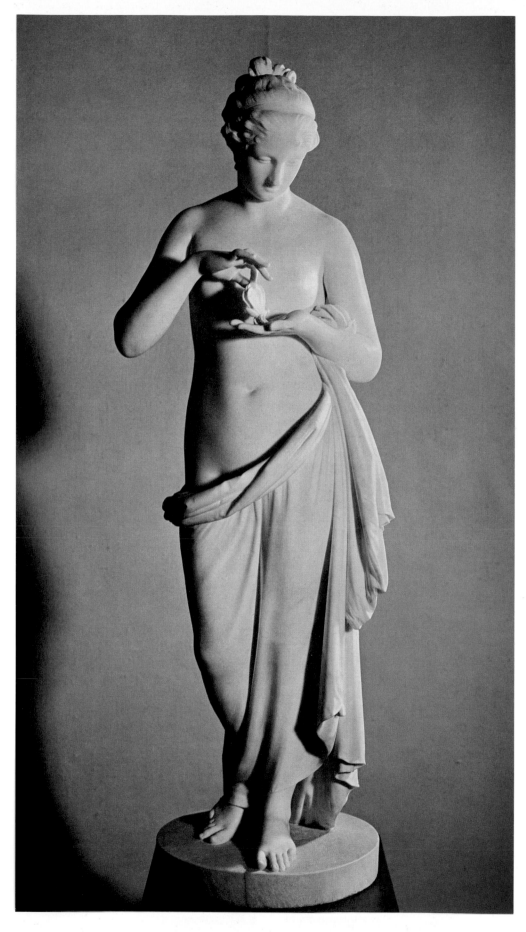

ANTONIO CANOVA (1757-1822). PSYCHE, 1793. MARBLE. KUNSTHALLE, BREMEN.

JEAN-DOMINIQUE INGRES (1780-1867). RECLINING ODALISQUE ("LA GRANDE ODALISQUE"), 1814. LOUVRE, PARIS.

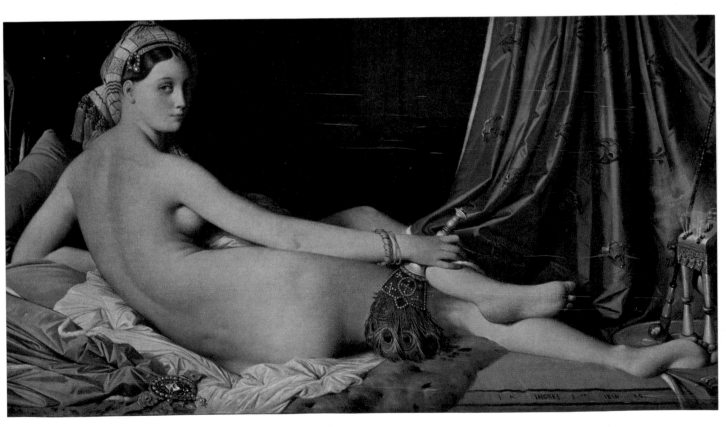

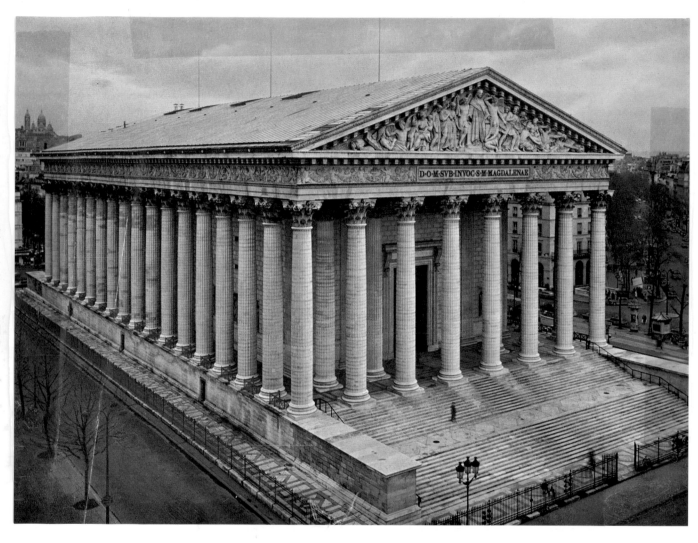

PIERRE VIGNON (1762-1828). THE CHURCH OF THE MADELEINE, PARIS, 1806-1828.

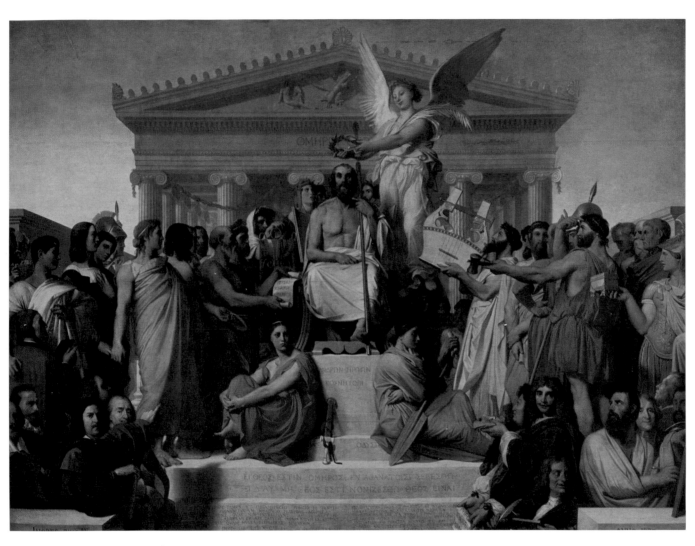

JEAN-DOMINIQUE INGRES (1780-1867). THE APOTHEOSIS OF HOMER, 1827. LOUVRE, PARIS.

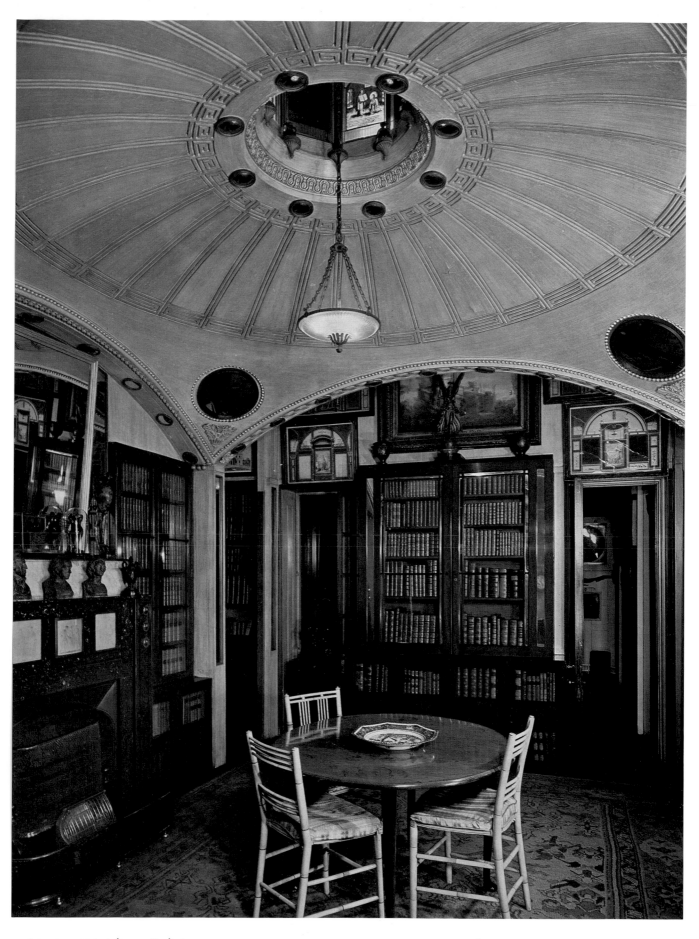

SIR JOHN SOANE (1753-1837). THE BREAKFAST PARLOR IN THE SOANE MUSEUM, LINCOLN'S INN FIELDS, LONDON. 1812-1814.

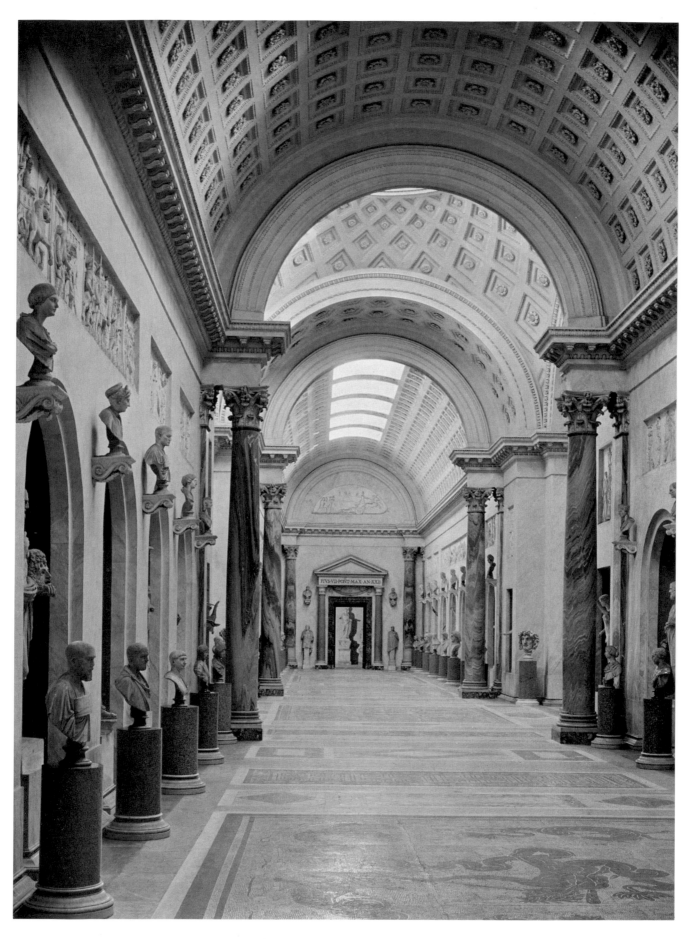

RAFFAELE STERN (1771-1820). THE BRACCIO NUOVO OF THE VATICAN. FINISHED IN 1821.

II

THE SEATS OF POWER

FORCE

Never had men built such huge barracks or prisons as on the day they began to glorify Liberty, just as formerly they had exalted princes or women. These buildings were the ambiguous symbols of an age in which the Rights of Man were proclaimed but force was enthroned. While armies steadily increased in numbers and coercive power, the mercenary gave way to the citizen-soldier who had some awareness of what he was there for. The size of the prisons reflected not only the intention to fill them but also the almost universal substitution of penal servitude for mutilation and flogging. There was a spate of penological works hopefully arguing that a prisoner could be not merely punished but reformed by discipline and solitary confinement.

Just as the new method of shutting men in cells, despite the cruelties it might lead to, was an advance in the administration of justice, so the display of force was a mark of deference to public opinion. After 1789 a despot could only rule with the tacit assent of the people. To retain power over men who believed themselves free the ruler had to display such strength that resistance would be futile, such splendor as to make rebellion a form of blasphemy. This omnipotence was admirably exemplified by the style of the First Empire which, though it was designed to maintain Napoleon's government, spread throughout Europe and even North America, despite many social and political differences. In France the aping of ancient Rome was obviously due to the fact that the Empire could only maintain itself by compelling acquiescence. Autocratic and dictatorial but not gratuitously cruel, it exacted utter obedience and the deepest respect. Men who had danced amid the ruins of the Bastille had to be persuaded that Napoleon stood for all that was good in the Revolution, and that his wisdom and strength ensured the very principles he was destroying. Having stifled opposition by gagging the press, his regime only had to inspire enthusiasm and fear. Building a triumphal arch became an act of State.

The apparatus of power had to assume reasonable guise as the guardian of domestic peace and prosperity. It relied on what were sometimes known as the forces of law and order: the Church, the Civil Code, middle-class morality. Public buildings and institutions were adequately beautified by symmetrical façades and an impressive air of stateliness. Their massive walls and sturdy columns gave token of an indestructible regime. It mattered little that spiritual values and justice might sometimes have been at a discount; the main thing was order. Town planning advanced from the pretentious to the monumental.

The choice of designs was simplified by the infatuation with Antiquity which had been gaining ground since the beginning of the eighteenth century. All the biggest, richest and most impressive features of Rome were laid under contribution. Every façade had to have its columns, and the columns had to be vast and lavishly distributed. Votive pillars and arches of triumph made it possible to outdo even their classical prototypes in size and wealth of ornament. Everything about this uncompromising architecture was inordinate and calculated to impress, as were the heavy velvet coronation robes and the jewelry designed by David or filched from Merovingian tombs.

Even furniture contributed to this exaltation of force. In design it was strictly geometrical, with smooth curves and precise angles; above all it was exceedingly solid, as if to imply that tables and chairs had the same ponderous stability as the Emperor's renown or his arches of triumph. It was all part of the imperial pageant. Materials were robust and costly—mahogany, marble, onyx, gilded bronze; symbols, such as laurel wreaths, Nike and the Sphinx, were displayed in bold relief, blatant and vulgar. Such furniture was not of course intended to be comfortable, but to impress callers and flatter the owner's sense of power.

Politics were not the only inducement to building pediments and colonnades. There was a semblance of logic about these oppressive structures. The intelligence of Robespierre as well as the military prowess of Napoleon was reflected in the severely academic use of entablature, pediment and Roman arch. One has only to look at the churches of that time to see how much better they suited the rites of Robespierre's Supreme Being than the worship of Pascal's Christ. Their enormous size and the use of flamboyant symbols counteracted the subversive element in the puritanism of the Montagnards, whose egalitarian austerity was obstructive to industry and dangerously upsetting to finance. This flamboyance, however absurd, accorded with the ambitions of the middle class. They encouraged it just as they accepted the leading-strings of the Empire, which molested certain liberties but favored industry. They had no reason to be alarmed by the display of force. The high prison walls and lofty columns enabled law-abiding men to live and thrive in security. That pure reason should be reduced to gaudy symbols was all to the good for those whose status depended on appearances.

It was only natural that the imperial style should pervade the Western world, for it ministered both to autocracy and to the new economic system. Little wonder that it spread to the Russia of Alexander I and Nicholas I, whose absolutism, like Napoleon's, was reflected in solid architecture and broad vistas that enhanced the stateliness of great arches, massive stylobates and colonnades. It seemed almost as fitting in the German capitals, especially after 1815 in Berlin, whose vast public buildings might well offer consolation for past humiliations and promise of security.

Politically, it is not so easy to see why the United States adopted a heavily Neo-Greek manner with immense columns, pyramids and pediments. There is no doubt that the founders of the American, as of the French Republic sought to model themselves on the Romans, to whom they ascribed all the virtues they themselves hankered after: austerity, equity, decorum, even a certain manly rusticity. Hence they copied Antiquity, but without its pomp; the Republic of Cincinnatus rather than Hadrian's Empire. After all, the Americans had no Emperor requiring monuments to buttress his power and self-esteem. It was the citizens who opted for the grand manner in their universities and Capitols.

Even here one finds a manifestation of power. As Alexis de Tocqueville rightly observed, the genuine equality attained by the American form of democracy encouraged the citizen to demand of the State a magnificence to which he himself could not aspire. It seems likely that the frowning majesty of American public architecture was designed to assure the citizen of his own legitimate strength, possibly to make him keep the law and finally to prove that the power of the State was none the less secure for being so widely diffused. Infant democracy had to cut a dash in order to gain self-confidence. Nor was it loth to make its presence felt elsewhere. The humblest American, recently the subject of a European monarch and now the avowed master of a continent, might well be fired with imperial ambitions of his own. It was not merely from self-respect but in order to proclaim themselves to the New World and redress the balance of the Old that the United States, after the burning of Washington in 1812, rebuilt the Capitol on a bigger and more imposing scale than before.

COMMITTED ART
AND POPULAR VENERATION

Aesthetically speaking, the use of symbols for propaganda is not much more than a matter of oriflammes and hatchments; but these will not do when design must fulfill the requirements of political power. So long as the pressure applied by government, patronage or public opinion only involved the tendering of obligatory homage, it remained extraneous to works of art and did not emasculate them. In former days, such as the reign of Louis XIV, it had been the normal thing for most writers to tack a laudatory set-piece on to works that had no connection with the royal point of view. It was quite another matter when a poet or painter was asked, as Chateaubriand was by Napoleon, "to employ his talents along the lines indicated."

The astonishing thing about this attitude is not so much the outrage to freedom of expression as the belief that a poet could, even if he wanted to, obey such an order. Moreover its aim was to subjugate the work rather than the man and deliberately to make it the instrument of a specific purpose. The Emperor did not care so much about harnessing the poet to his chariot or being extolled by him; what he wanted was to speak through the poet's mouth. However grotesque this may seem, it was perfectly consonant with the spirit of the times and arose naturally from confusing the work with its subject, the embodiment of an idea with its demonstration. It was all of a piece with the general proneness to rationalism, and for that matter with the American tendency to sermonize.

Even artists succumbed to the belief that their works might be vehicles for publicizing opinions. Hence that extraordinary rhetoric whose sententious harangues were still in vogue long after the Revolution and Empire. The very desire to demonstrate an opinion led to such distortion of form that the work of art, which must needs be fully self-expressive, was utterly vitiated. It followed that praise of freedom could constrain itself to be as artificial as

obeisance to a tyrant. The expository will destroyed precisely what was most significant, the absolute unity of the world that was revealed.

It is not enough to be a good republican in order to extol the republic in a picture or poem; the artist must also stand in such relationship to the world that his republic should in a sense become the only possible form of government. But his work is robbed of its essence by the fact that all forms of government are approximate, especially those which betray their weakness by admitting their need for propaganda. One can thus detect a remarkable analogy between the posturings and empty spaces of David and the hackneyed bombast of the hustings. Neither can be said to have really embodied revolutionary dynamism.

Deliberate effectiveness is self-contradictory. Art can do no more than disclose the inner meaning of things, in so far as the artist has perceived it. It simply makes the unseen visible. While art can portray gods and open the gates of hell, only at its peril can it be deflected to human tasks.

This, no doubt, accounts for the barrenness of art during the First Empire, except in one province that continued to fascinate artists long after the Empire had fallen. It was military renown that enabled Napoleon to triumph even after death. Despite ostracism and banishment his memory remained green, and his inordinate power and downfall underwent an apotheosis in the words of poets and the colors of painters. Once he was no longer a man, an office and a force, he ceased to be limited by his own conduct. Nothing more had to be proved about him. He could become the Conqueror or the Petit Caporal.

When war consisted of gallantry and bloodshed, dashing cavalry charges and brilliant victories, it made a strong appeal to the young, especially as

the conflict, however costly, seemed always to end in triumph. The war might drag on, but every campaign seemed assured of quick success. The people, readily identifying themselves with the ever-victorious leader, came under the spell of cannonades and rearing horses, the cut-and-thrust of sabres and colors streaming in the wind; it more than made up for their lost freedom.

There can be no other explanation for Victor Hugo's nostalgia or the bitterness of Stendhal and de Vigny. Just as every American saw a flattering symbol of himself in his State Capitol, so every Frenchman visualized himself prancing through Europe on his charger.

The Napoleonic legend, cherished by men who for a decade had believed themselves emperors and lords of the continent, compelled the Bourbons and their successors faithfully to complete the monuments of the Empire. It was popularized not only by Béranger and Raffet but later by all the Romantic writers. It gave rise at Versailles to the extraordinary Galerie des Batailles, where every engagement in the history of France is celebrated as a reminder that her military prowess did not begin at Rivoli or end at Waterloo. This composition enabled the Romantic painters, good, bad and indifferent, to keep the battle-flags flying and the guns of Wagram thundering. Yet these vast canvases had lost something of the original glamour, which could still command the respect of Géricault or, much later, of Rude. Delacroix captured admirably the mortification in these scenes of battle recalled after a great defeat. They are dominated as much by flame and smoke as by the bright colors of standards, and one cannot tell whether he is commemorating the disaster of the vanquished or the boundless pride of the victor. War was ceasing to be the inevitable triumph of order and becoming a promiscuous affray. Heroics were giving way to the "darkling plain... where ignorant armies clash by night."

And yet, behind the horsemen in Delacroix's *Battle of Taillebourg* or his *Capture of Constantinople by the Crusaders*, one can always detect, as in Hugo's battle-pieces in the *Châtiments*, the ghostly presence of the victorious commander at Arcola.

the past, and the statues and paintings brought back from Italy were triumphantly paraded around the Champ-de-Mars. Though these glorious relics were nothing more nor less than loot, the French Republicans sincerely believed France to be, as they put it, "the one country in the world which can give inviolable shelter to these masterpieces" of the Renaissance and Antiquity; and by bringing them together in Paris, in their eyes the capital of the world, they hoped to enable the French people to have a share in an illustrious civilization.

The booty of Egypt was also destined for the Louvre, but thanks to Nelson it fell into other hands and ended up in the British Museum. However, the ephemeral glory of Napoleon's Egyptian expedition lost none of its fascination, and it was Egypt, which he had lost, far more than Italy, which he had really subjugated, that fired the imagination of Frenchmen. It was good policy to encourage this tendency and to clothe defeat in all the trappings of triumph. It accordingly became the fashion to raise monuments in a pseudo-Egyptian style, like the column adorning the fountain in the Place du Châtelet.

During the period of the Directory and the Consulate, aspirations to glory found expression in allegories and decorative art remained peaceable. All this was changed under the Empire. Significantly enough, the first monument to be erected by Napoleon after styling himself Emperor of the French was the triumphal arch in the Place du Carrousel; except for the bronze horses taken from St Mark's in Venice which were placed on the top (but which were returned to Venice in 1815), all its adornments refer directly to military exploits. The arch itself is not of particularly impressive dimensions, for its designers, Percier and Fontaine, modeled it on Roman monuments and made a point of not exceeding the proportions of the arches in the Forum. With its great bronze reliefs and marble slabs and columns, it produces a sumptuous rather than a powerful effect.

But as time passed the works commissioned by the Emperor were on an ever larger, more imposing scale. The subtler appeal of fine materials and symbolic figures gave place to new requirements. Colossal proportions became the order of the day, and plans for laying out new streets and squares were extended to include the whole city. First of all

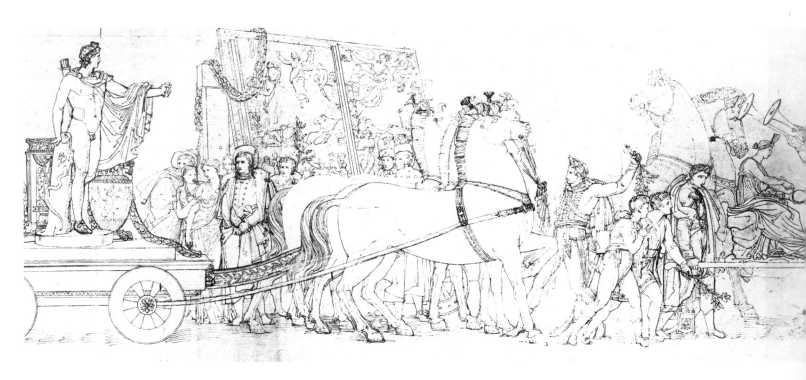

ARRIVAL AT THE MUSÉE NAPOLÉON OF WORKS TAKEN BY THE FRENCH ARMIES IN ITALY. DESIGN FOR A SÈVRES VASE

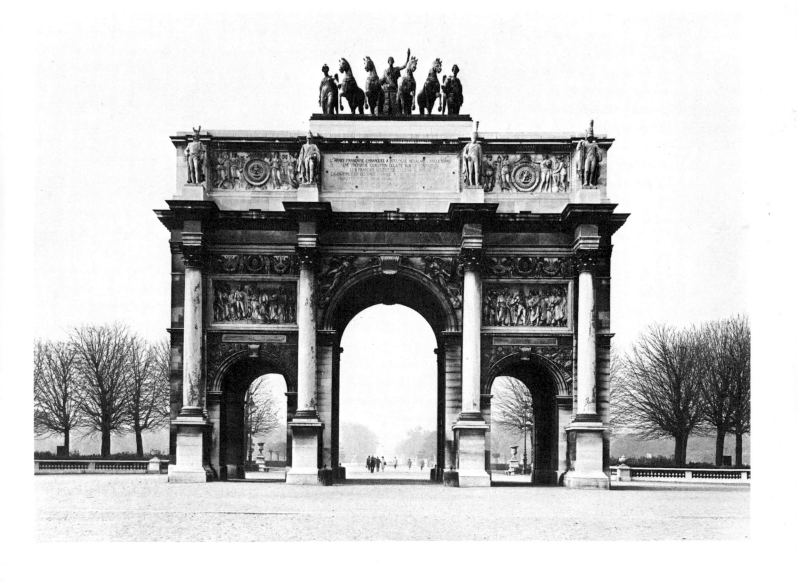

1813, BY A.J.E. VALOIS (1785-1862).

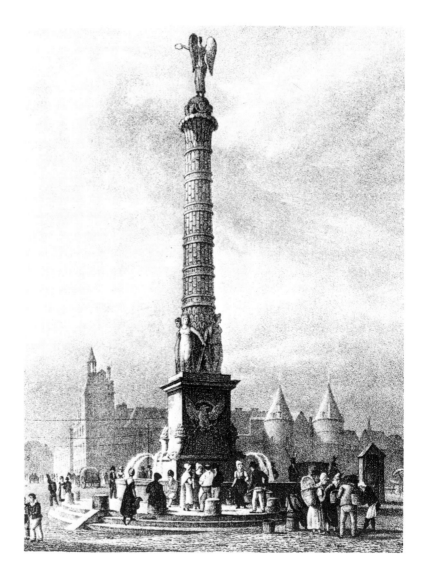

JEAN-ANTOINE ALAVOINE (1776-1834). ELEPHANT FOUNTAIN ▲
DESIGNED FOR THE PLACE DE LA BASTILLE, PARIS, ABOUT 1810-1814.

FOUNTAIN IN THE PLACE DU CHÂTELET, PARIS. ▶
DETAIL OF A LITHOGRAPH BY F. NOEL, ABOUT 1815.
MUSÉE CARNAVALET, PARIS.

TRIUMPHAL ARCH IN THE PLACE DU CARROUSEL, PARIS, 1806-1808,
ERECTED BY CHARLES PERCIER AND PIERRE FONTAINE.

2

LEGEND AND HISTORY

In his early sketches for the *Funeral of Patroclus*, David, who was later to organize the festivities staged by the Convention and the Empire, gave a foretaste of the lavish pageantry offered to the mob by the new rulers of France. Implicit in the Homeric scene are several themes particularly dear to the revolutionaries: the death of the hero, the sacrifice of the enemies of the country, and the pursuit of fame and glory. There is nothing here of the martial spirit, no allusion to the rash exploit of Patroclus or the battle for his body. All we see is the sumptuous funeral and the sacrifice of the Trojan warriors. The emphasis, then, is on ceremony, not on action. Already the young David, like certain of his contemporaries, felt that the presentation of the facts is more important than the facts themselves; a great parade or an eloquent speech can transform defeat into victory. The image of Patroclus, defeated, slain, but glorified, heralded all that was soon to appear in the streets of Paris in the form of solemn celebrations, allegorical pageants, and even buildings.

The Republic, while professing its peaceful intentions, was soon embarked on wars of conquest. Processions were held and monuments erected to convince the people of its triumph and to justify it. The victorious armies of Rivoli and the Battle of the Pyramids thought of themselves as liberators. At the same time they fell heir to the art treasures of

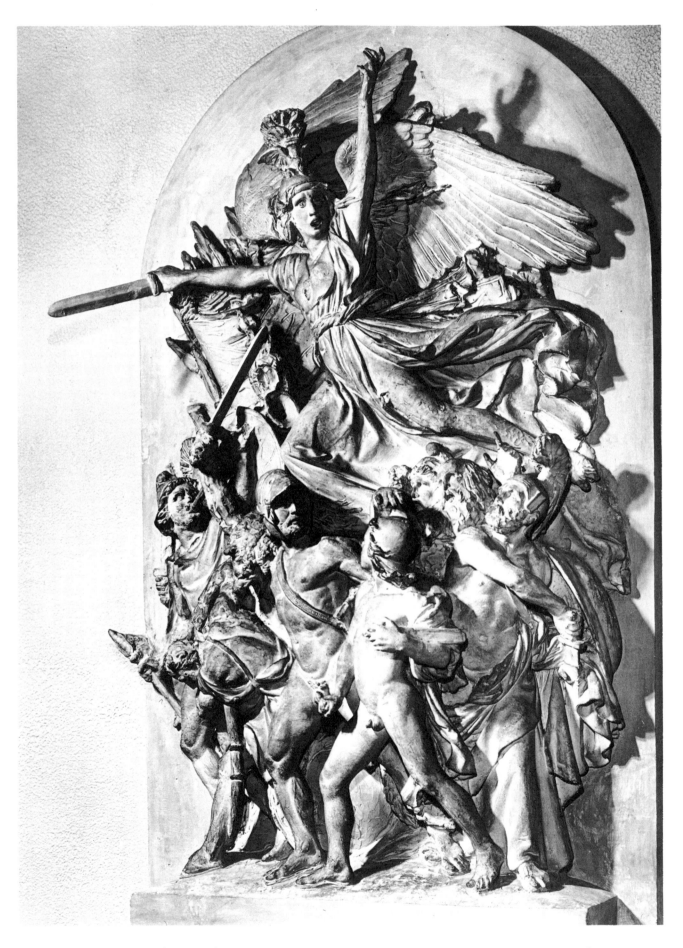

FRANÇOIS RUDE (1784-1855). THE DEPARTURE OF THE VOLUNTEERS OF 1792 OR LA MARSEILLAISE, 1835.
PLASTER MODEL. MUSÉE RUDE, DIJON.

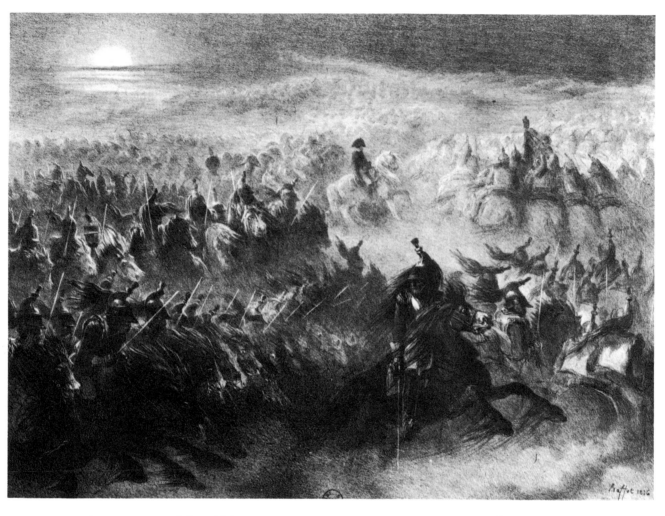

AUGUSTE RAFFET (1804-1860). NAPOLEON REVIEWING HIS TROOPS AT NIGHT, 1836. LITHOGRAPH.

JACQUES-LOUIS DAVID (1748-1825). THE FUNERAL OF PATROCLUS, ABOUT 1778. DRAWING.
CABINET DES DESSINS, LOUVRE, PARIS.

a "triumphal way" was put through from the Etoile to the Bastille. It was to be punctuated by three great monuments symbolizing the wars of ancient times and the victories won by Napoleon: a galley in the Place de la Concorde, the triumphal arch in the Place de l'Etoile, and an elephant forty feet high in the Place de la Bastille. When Napoleon was exiled for good in 1815, none of these grandiose monuments had been completed. The bronze elephant was never cast; a huge wooden model stood in its place for many years, finally being demolished in 1848.

One cannot help being struck by the hieratic character of the works, both large and small, which were executed in France between 1789 and 1815: all are either rhetorical or symbolical. After that heroic age was past and there was no more Emperor to idolize and serve, the Napoleonic epic lived on and the younger generation of Frenchmen dreamed of adventure and derring-do. The Romantics celebrated the glory of the soldiers of Valmy and Austerlitz with an ardor which contemporaries of those events had never known. We need only compare the bas-reliefs on the Carrousel arch with the expressive movement of Rude's figures; the latter gives his *Marseillaise* a passionate intensity which no sculptor of the Revolutionary generation would have ventured to express. Having no political significance and no topical interest, this piece of sculpture has a lyrical power inconceivable thirty years earlier. Of the Empire's ponderous stone façades and colossal bronze figures, of the Republic's spectacular pageantry overloaded with allegory, there remained only the clarion calls to battle and the familiar image of the Petit Caporal. Lithographs and popular songs spread far and wide a nostalgic, sentimental legend which forms a strange contrast with the imperial ambitions. The dream of glory informs that legend as it informs Rude's figure group. Its unreal, dreamlike character is nowhere so well brought out as in Raffet's lithograph showing Napoleon reviewing his troops by night, their serried forms but dimly visible in the fitful glare of torches. No element here stands out above any other; neither force nor ostentation has any place, while even the figure of the Emperor himself is remote—a tiny silhouette wheeling on a white horse, surrounded by ghostly squadrons.

THE IMPERIAL RITUAL

In order to impress upon all beholders the power and glory of the new France, public ceremonies under the First Empire assumed the character of a ritual. They unfolded with the stately formality of a liturgy, each gesture acquiring a symbolic value. There was no scope for any spontaneous expression on the part of the crowd.

During this period, the public image of Napoleon underwent a remarkable change. While he was Consul, Bonaparte differed little from the hero of Arcola as portrayed by Gros. But after he became Emperor the public was confronted with a hieratic image far removed from the heat of battle. Yet the slender, disheveled figure of the conquering general lived on in people's memories, and after 1830 it again came to symbolize the heroic deeds of the Revolutionary armies. Following a wholly Romantic conception of Bonaparte, David d'Angers saw him as the champion of freedom and reverently portrayed a face aglow with the great hopes and promises which the Empire failed to realize. When he was commissioned to evoke the glorious battles of the Napoleonic armies on the pediment of the Pantheon, the sculptor imagined a figure very much like this one. But this ardent, highly-strung Napoleon embodies the very spirit of adventure, disorder and revolution, and it was so little to the liking of Louis-Philippe that he almost refused to accept the bas-relief. Probably the Emperor himself would have rejected this image as being too restless, too unstable and perhaps too human to body forth his glory.

In fact, by the quasi-religious stamp they give to imperial power, the pictures which immortalize the great days of the Empire remind us of the sacred pomp of Roman ceremonial. In David's works, the Emperor's gestures suggest the priest before the altar. Standing in front of the soldiers in the Distribution of the Eagles, *he stretches out his arms in a benediction which halts the sudden onrush of the standard-bearers, who fall back in an attitude of homage. In the* Coronation *he seems to be holding up the crown, symbol of his glory, for the adoration of the faithful.*

The realism so magnificently effective in his portraits here impairs the unity of the general design. In spite of the abundance of gold, the sumptuous setting and the strict simplicity of the composition, the features of individual figures are often vulgar, and some of the attitudes and expressions are so lifeless that they detract from the sacramental atmosphere which the artist has attempted to create. Certain details of gestures and faces are too insistent, with the result that the would-be transcendental image of glory lapses into an empty show. Beneath the gorgeous colors and solemn architecture of all this pageantry, it is difficult to draw the line between theatricality and genuine ritual.

GLORY

At the very time when David was hard at work on his huge compositions glorifying Napoleon and the First Empire, Turner was painting his Battle of Trafalgar. *But though it portrays the fateful battle where England played for high stakes and won, the picture has none of the exultation of triumph. On the contrary, the patch of light in the center fails to dispel the shadows and billowing smoke which darken nearly the whole of the canvas. True, Turner has chosen to show the actual moment of Nelson's death, but the little figures swarming at the foot of the mainmast are dominated by sails and rigging. The men are so inconspicuous that the struggle might almost appear to have been waged between ships, sea and wind alone.*

Depicting the event in terms of these dramatic contrasts, the picture must have touched the hearts of Turner's contemporaries. The death of Nelson at the very moment when well over half the Franco-Spanish fleet had been destroyed and the outcome of the battle was no longer in doubt, brought home to the English a side of glory far more tragic than any that was experienced in France at the same time. The frailty of man and the irony of fate embittered a victory where triumph and sorrow were inextricably mingled. A conception like this speaks with a deeper, more human note than any brash optimism; but politically it is valueless for it shows vulnerable heroes and a double-edged glory.

In his early thirties, when he painted this picture, Turner was still treating his subjects in the classical manner. He was less concerned with the great expanses of water and sky that were to be his sole preoccupation at the end of his life than with the movement of ships and the disorder of the crew massed together on the deck. But already he had ceased to be interested in either a documentary or an anecdotal portrayal of the event. With passionate intensity he expresses the tragedy of the situation through the burst of light around the mainmast, the broken rhythm of the yard-arms and the alternately limp and bellying sails. Even though the picture celebrates a specific event, it goes beyond mere reporting. Through the story of Nelson it suggests the constantly menaced destiny of mankind.

PIERRE-JEAN DAVID D'ANGERS (1788-1856). BONAPARTE, 1838. BRONZE MEDALLION, DETAIL.
MUSÉE DES BEAUX-ARTS, ANGERS. (SLIGHTLY ENLARGED IN REPRODUCTION)

JACQUES-LOUIS DAVID (1748-1825).
THE DISTRIBUTION OF THE EAGLES, 1810. MUSÉE NATIONAL, VERSAILLES.
THE CORONATION OF THE EMPEROR NAPOLEON, 1806-1807. LOUVRE, PARIS.

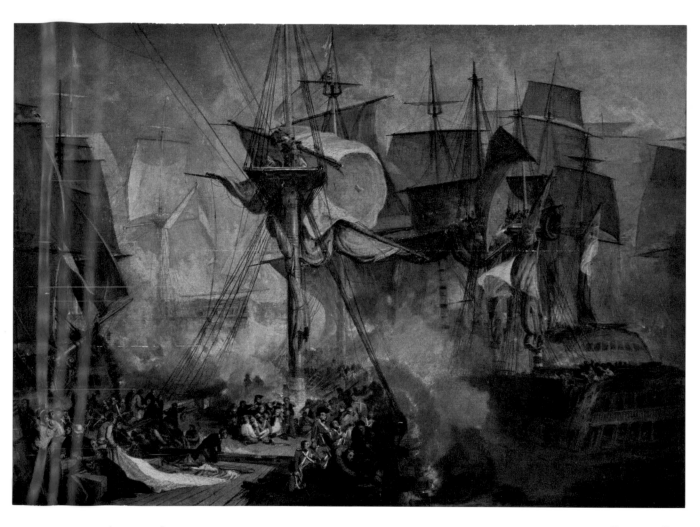

J.M.W. TURNER (1775-1851). THE BATTLE OF TRAFALGAR AS SEEN FROM THE MIZEN STARBOARD SHROUDS OF THE "VICTORY," 1806-1808. BY COURTESY OF THE TRUSTEES, TATE GALLERY, LONDON.

The great military campaigns of the Revolutionary and Napoleonic armies were long a matter of national pride in France. To glorify their triumphs was to render a useful service to the State, and for the artists themselves it was also a means of escaping from the straitjacket of classical rules. Battle scenes offered them scope for the free expression of fervent hopes and aspirations and for a lavish display of gorgeous colors. This freedom, however, found a better outlet in sketches than in finished pictures. In the latter painters were unable to avoid a certain rigidity and fragmentation, either because they shrank from breaking up the outlines enclosing figures or because they had to conform to the stipulations laid down by a sitter who wanted to be immediately recognizable.

Gros's preliminary sketch for the Battle of Nazareth *preserves all the vivacity of his initial inspiration. Although he made a point of portraying some individual deeds of valor, setting them out in an interlocking series of circular groups of combatants, the painter was so carried away by the heat of battle that he succeeded in imparting a single sweeping movement to the whole picture. The figures struggling in the foreground are hardly distinguishable from the furious background turmoil of men and horses. We are plunged into the thick of a battle that seems to have neither beginning nor end.*

The enthusiasm that surges through such works as this must have influenced the young Géricault. His Cavalry Officer of the Imperial Guard Charging *owes a clear debt to Gros's pictures. Here, too, spirited movement and shimmering colors are used to evoke the warlike ardor and furious onrush which had so often carried the French armies to victory. There is nothing to indicate that the picture was painted in 1812. The young painter seems to have been unaware of the disasters of the Russian campaign.*

After Waterloo Géricault showed a sharper sense of the hazards of war in the Artillery Train, *one of his most expressive paintings. Though the troops represented are only on maneuvers, the picture points the way to some of Delacroix's most dramatic compositions. The gulf of shadow in the center and the broken rhythm of the movement give the dashing horses in the foreground, caught in a lurid shaft of light, a tragic aspect that was completely new in French painting. Here, as with Turner, violence and death are suggested solely by the contrast between smoke, light and shadowy masses.*

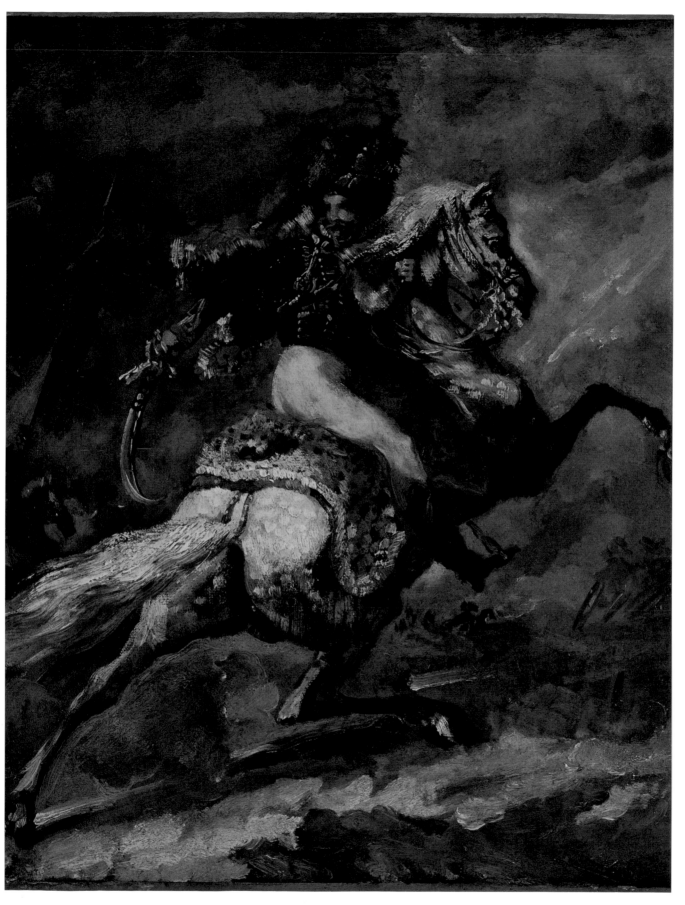

THÉODORE GÉRICAULT (1791-1824). CAVALRY OFFICER OF THE IMPERIAL GUARD CHARGING, 1812.
PAINTED SKETCH. MUSÉE DES BEAUX-ARTS, ROUEN.

JEAN-ANTOINE GROS (1771-1835). THE BATTLE OF NAZARETH, 1801. PAINTED SKETCH. MUSÉE DES BEAUX-ARTS, NANTES.

THÉODORE GÉRICAULT (1791-1824). THE ARTILLERY TRAIN. UNDATED. BAYERISCHE STAATSGEMÄLDESAMMLUNGEN, MUNICH.

REVOLT

The salient emotion behind the noble façades and within the fine, tree-shaded suburbs was a sense of failure. This was true not only in France, whose dreams of empire had been shattered at Waterloo, but throughout Europe, where great hopes had come to naught.

It was obvious that the dreadful butchery of the Napoleonic campaigns had been futile barbarity. Even before the enterprise of 1812 European literature and painting had begun to dwell on the horrors of the battlefield, in antithesis to military glory. Nor was that all. 1815 found the peoples of Europe as subjugated as they had been in 1808 or 1789, only more aware of their condition. Freedom, no sooner won, was endangered by the heavy hand of government and finance, even by justice itself when it became the instrument of power. The high-minded decorum of the middle class concealed rank abuses. The lawfulness of paternal and marital despotism gave rise to discrepancies of obligation that were the more obnoxious for being no longer based on the honor of the clan but on material factors such as property, credit or inheritance.

Law and order, while they benefited some, were opprobrious to others, for it seemed they were not the custodians of eternal values but merely the guarantors of *de facto* situations and vested interests. Government had no real meaning for those whom it misgoverned, being regarded by them as mere bumbledom. Liberalism and nationalism, crushed by authority, won many adherents, and the peoples of Europe, despite their chains, had powerful advocates. Invocations to liberty abounded under such disguises as William Tell, Egmont or Pelayo.

The poet, as so often, was Shelley's "unacknowledged legislator of the world." Candide and Figaro anticipated Robespierre. The nationalism that swept Europe after Napoleon's downfall was intensified by Herder's use of folk-songs to discover purely German traditions and by his exaltation of the vernacular. When Goethe and Schiller were seeking in their early days how Man might attain the fullness of his stature they did not speak merely in terms of passion and truth but wrote of the contest waged by Schiller's "Räuber" or Goethe's Götz von Berlichingen against social injustice, or by Fiesco or Don Carlos against political and religious tyranny.

The Sturm und Drang movement led to a mingling of politics and literature. Writers felt a direct concern for the freedom of the individual, since any abridgement of it by external force diminished the capacity for self-expression. The whole Romantic movement was torn between the need for personal freedom and the desire to bestow moral redemption, between the demands of conscious evangelism and those of unfettered self-expression.

There are some things that cannot be expressed in conventional language, and then the infraction of rules and traditions, whether laid down by Aristotle or by Raphael, leads to the subversion of all arbitrary enforcement of laws.

In *Hernani* Victor Hugo used irregular meters and a deliberately offensive style to uphold Justice against the Law, love against marriage, the dramatist's freedom against all the rules of classical tragedy. He did so in broad daylight and with the clear intention of using every means to win converts. Here, as in many other works of literature, painting or music, one is aware of evangelical zeal. When there is so much tyranny to be overthrown the act of doing so overshadows everything else.

While this desire to make an effect clearly accounts for a certain stridency in the Romantics, one must remember that they always had one eye on the public. The phrase "bataille d'Hernani" is correct inasmuch as Victor Hugo deliberately tried to make

his voice carry beyond the walls of the theater. As each of his verbal enormities led the Traditionalist "vieilles barbes" to exchange blows and insults with the Romantic "gilets rouges" in the audience, he knew he could rely on the newspapers to make them reverberate the length and breadth of France.

The press was now strong enough to dethrone a king or carry the fiery cross of revolution through the capitals of Europe. It provided poets and painters with an ever-growing public whose reactions they could observe or influence. Formerly a work might have given offense by chance or inadvertence; now the scandal was deliberate. Certain lines in *Hernani*, certain figures painted by Delacroix were calculated affronts. Once more the artist's vision was subordinated to the effect he wanted to produce. More and more he was betrayed by his own convictions into lending himself to press campaigns with their inevitable gush and blatant allusions to current events. The integrity of his work was bound to suffer. One even finds painters resorting to allegory in pictures where, being unable to incorporate shame, anger or rebellion in their composition, they betray their own lack of inspiration by using some obvious symbol.

Thus painters, poets and composers mounted the rostrum and started playing to the gallery. They became in a sense spectators of their own works, whose inner harmony and significance in some cases suffered unmistakable damage. Such was the inevitable result of this unholy alliance between the arts, the public and the press.

Only a few, like Goya, put expression before effect and created compositions in which the symbol was snuffed out by the tempest of color, movement and mass. For Goya did not merely believe in his cause; he identified himself with it, so that he could not have painted anything else or painted in any other way.

In most cases however, and especially in the figurative arts, subjects depicting the defense of freedom tended to impair its expression, which made far greater impact when it was not associated with stock images, such as massacres and barricades. While art forms became more and more a manifesto of the absolute self-sufficiency of the individual,

there was no systematic attempt to lay down new rules in place of those which were discarded. The innovations of men like Turner, Corot or Delacroix seem at first sight to share only the negative feature of upsetting the established order. Whatever they put in its place was for themselves alone. The same anarchic tendency is apparent in poetry and in music, which was so completely revolutionized by rich, complex orchestration, melodic eccentricities and the constant use of bizarre or incongruous harmonies that it is hard, for instance, to compare Berlioz with Schumann. One is almost driven to conclude that there was no Romantic school, rather an anti-school voicing the Romantic mood.

The fact remains that there was something behind all this iconoclasm. From being analytical, descriptive and objective, art was clearly moving towards a whole gamut of forms, all of which, however, sought to express a universal, subjective vision. In the first place art was forsaking the clear definition imparted to spatial structure by its perspective, which created a frame for the orderly disposition of well-defined objects. This vision of the world assumed both an existing order and a rational link between the mind and the various phenomena it sought to analyze, isolate and comprehend. The painter's aim was not self-revelation but the discovery of an order.

A cosmic vision of space, whatever form it might take, was bound to disrupt this relationship. Objects lost their definition, the world its outlines. All rational order dissolved in a subjective vision which might be physically or emotionally inspired. There could be no analysis because no factor could any longer be isolated. Nothing was precisely located in space because everything was being used to create the effect of space. Outlines were fragmented by brushstrokes, and in the same way tricks of lighting were used to break up the composition or to connect objects that, seen objectively, would have been disparate. There was nothing preordained about the world on the artist's canvas, for it was not objects themselves, now bereft of identity, that conveyed his message but the way in which they were related.

This was where the trouble began. These new compositions were in effect incompatible with any form of declamation. They could give voice to passion and the utmost violence, but they went

beyond the bounds of reasoned explanation. That is why the personification of liberty has never succeeded in being much more than a purely isolated and personal expression; it has never been the cry of a people.

Political theories, whether liberal or nationalist, encouraged this tendency to individualism. The struggle to enfranchise, as it was thought, the whole people was in fact closely bound up with the right of self-expression. The principle that laws should be debated and enacted by the people was adopted in the fear that otherwise they might be restrictive of thought and speech. A man's loyalty to his nation sprang from his awareness of his own roots in it. He took special pride in his own language and culture because they enabled him to display his individuality. Again and again one is confronted by the liberation of the individual, not of the masses. Since the aim of political reform was to confer self-expression on the individual it was only natural that he, too, should use art for self-aggrandizement.

Works like these cast a sinister light on the human condition, but because they stand outside time they strike the spectator less forcibly than Goya's terrifying indictments.

When, like Blake's Urizen, denunciations of evil exist outside any concrete situation, they run the risk of leaving the spectator indifferent. If force is always triumphant, if law is hateful just because it is law, and if man is by nature a wolf to his fellow men, then western civilization is no more to blame than any other, nor are nineteenth-century social and political institutions. Rather, like a nightmare vision, the tortured victim loses all reality and becomes but a vague menace. If he fails to strike us as a compelling presence, we may believe he never existed. A symbol of all possible acts of cruelty, he represents none in particular. Once we realize that our own age is responsible for this hanged man, and therefore for all miscarriages of justice, then we can no longer look the other way. The reality, actual and immediate, of the figure reminds us that evil is reborn in the men of each generation; even if the image is of the past, what it represents is ever present.

Yet a minutely detailed picture of an event as it actually happens equally lacks force. We tend to linger over details, to see things in too clear a light to generalize from them. The circumstances bulk so large that the human implications of any particular episode are lost on us. For this reason realistic images are even less effective than mythical creations, but there were a few nineteenth-century artists who were particularly well fitted to find a solution to this problem.

"I have seen these things," wrote Goya under the worst horrors in his *Disasters of War*. On one level, he records the actual experiences of a few wretched individuals caught up in the storm that swept over Spain with the Napoleonic invasion; on another, he cries out against the evil fate that eternally dogs mankind. The cruelty always smoldering in the hearts of men flares up in the murderous gesture of a soldier or guerrilla. Thus laid bare, the worst atrocities are not a thing of the past; the evil still stalks among us. Mute and terrified spectators, we

No haber escrito para tontos

FRANCISCO DE GOYA (1746-1828). THE PRISONER (NO HABER ESCRITO PARA TONTOS),
1814-1823. INK WASH HEIGHTENED WITH SEPIA. PRADO, MADRID.

3

THE JUSTICE OF MAN

Blake's tremendous figure of God the lawgiver symbolizes the revolt against all authority. Urizen has fixed the limits of the world in time and space, introduced measurement and established laws. Henceforth man is crippled, his deepest impulses and loftiest yearnings are checked. For Blake mankind has passed from the *Songs of Innocence* to the *Songs of Experience*, from a free world under the eye of God to a city oppressed by rules and dogmas. The Ancient of Days, circumscribing the universe with the golden compasses or floating in the slough of materialism, is not only a symbol of religious orthodoxy; he signifies all oppressive power. The rather turgid accents of Blake's deliberately sketchy technique are here triumphantly effective, conveying all the sinister force and fascination of the mythical creator. Outside space and time, eternal embodiment of evil, Urizen has from the beginning weighed heavy on the destiny of the world.

How strange it is that another poet and visionary, Victor Hugo, should also have drawn and painted pictures without any indication of terrestial space or time, or any concern for perspective, like his *Hanged Man* swaying in the night. No doubt the author of *Le Dernier Jour d'un Condamné* had in mind a victim of the judicial system he denounced in his pamphlets; but his *Hanged Man*, half swallowed up in shadows, is in our eyes the specter of all the gallows in history.

WILLIAM BLAKE (1757-1827). THE BOOK OF URIZEN: URIZEN SUNK IN THE WATERS OF MATERIALISM, 1794.
RELIEF ETCHING. REPRODUCED FROM THE COLLECTIONS OF THE LIBRARY OF CONGRESS, WASHINGTON, D.C.

ECCE

VICTOR HUGO (1802-1885). THE HANGED MAN, 1859.
DRAWING. MAISON DE VICTOR HUGO, PARIS.

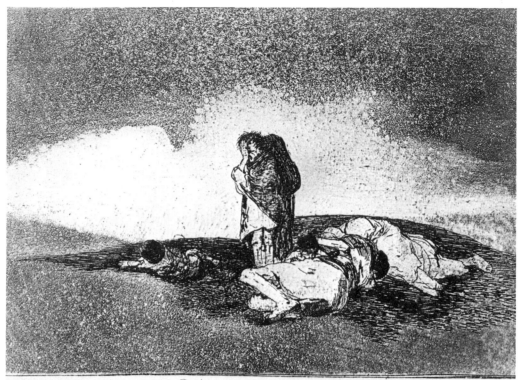

No hay quien los socorra.

FRANCISCO DE GOYA (1746-1828). THE DISASTERS OF WAR, NO. 60:
NO HAY QUIEN LOS SOCORRA (NOBODY TO HELP THEM), ABOUT 1810. ETCHING.

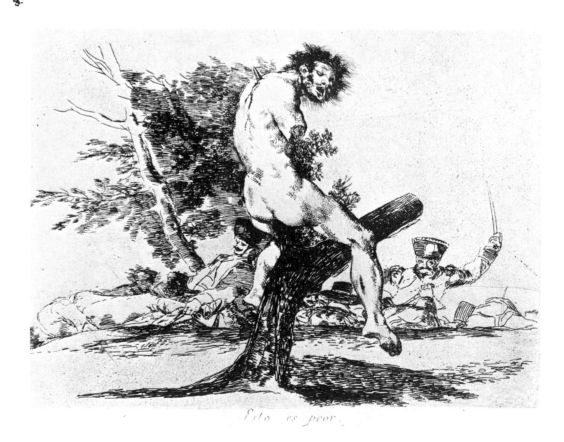

Esto es peor.

FRANCISCO DE GOYA (1746-1828). THE DISASTERS OF WAR, NO. 37: ESTO ES PEOR
(THIS IS WORSE), ABOUT 1810. ETCHING.

are confronted by what is, not by what might be. The forceful composition and slashing linework reflect the very violence of war which they indict. The brutality of some of the scenes makes the horror of war disturbingly real. In one etching—inscribed *Esto es peor*—a body impaled on a tree stands out in the central foreground against the dark trunk and leafage, as if thrust in the spectator's face; behind it, their features roughly sketched in, the grotesque silhouettes of soldiers bob up like cruel puppets. Embodying the force of evil, the soldier lives only for the crime he commits. The victim alone is a man.

In other plates of the *Disasters of War*, the plight of the starving populace is more tellingly conveyed than in any description of the famine that ravaged Spain during the French occupation. Here Goya uses aquatint to create his gaunt, indistinct forms, lost in open country under the pitiless glare of a dawn which reveals only the certainty of abandonment and death. There is no indication of time or place, no allusion to any particular incident. Yet something remains of the persuasive force of direct observation. A strip of ground suggests the dead-weight of these prostrate bodies and their convulsive movements remind us that this ordeal was actually experienced by men of flesh and blood.

Sometimes injustice and cruelty can touch us more poignantly when they are represented without violence. Excess can reassure us by impressing on us the extraordinary nature of the event portrayed; it reduces that event—just as a picturesque interpretation would reduce it—to an episode of history, something that is finished once and for all. But the eternal, ever re-enacted story of oppression is told in the most stark and direct terms in Goya's *Prisoner*, crouching in a cell that might be in Spain or anywhere, yesterday or today. Brushed in with the utmost simplicity, this prostrate figure is even more haunting than those of hanged men or impaled bodies. The masses faintly suggested by broad ink washes, the dim light, the white tortured face glimpsed through the half-open door of the cell, evoke the fate of all those who, in Goya's time and all times, have been gagged and fettered.

THE MASSES

An entirely new feature of towns in the nineteenth century was a huge, poverty-stricken proletariat which had arisen from the fact that the homogeneity of older communities, even the slave-owning society of America, had been destroyed. The industrialist had no responsibility for his workers, yet his authority over them was greater than if he had owned them. The Negro's enthralment by the planter preserved his own identity; he might be maltreated, but his master was responsible for him, for his food, care and livelihood. However degraded the man-master relationship might be, it was not wholly depersonalized. This was not so in an industrial society, with its entirely different nexus. The employer had no responsibility since his workers were not regarded as living beings but as pieces of equipment. They were spare parts that could be replaced at will, less valuable, in fact, than machinery in which capital had been sunk. The worker was only an expense in so far as he was used, and even that overhead could be reduced in a market economy. Consequently there was no longer any human affinity between worker and employer, the one being merely the chattel of the other.

It is impossible to identify oneself with a state that one cannot examine from within. This accounts for the astonishing inadequacy of artists when confronted with conditions whose horror they could sometimes glimpse but never fully apprehend. Laborers, inmates of workhouses, children employed in mines and factories—none of these could make their voice heard, for they were dumb and faceless. Bourgeois painters were remote from them in a way that Velazquez or Van der Goes had never been from their working-class models. Since they could only be inspected from a distance it was the least typical effects of industrial serfdom, such as pauperism and delinquency, that first appeared in works of art. The people themselves and their estrangement from society were hardly ever revealed, even by those who had seen them close at hand. Michelet's

words might have been echoed by any poet, painter or writer: "I was sprung from the people and my heart warmed to them... but their speech, ah, that I could neither comprehend nor record."

Painters were dimly aware of this estrangement, which caused them unnaturally to magnify and isolate their model. Since they could only observe his outward aspect they were prone to seize on whatever was odd about it. In literature one finds the more sophisticated legend of Ishmael, the Odd Man Out. It takes innumerable forms, from Dickens's oft-repeated tale of the child, pure in heart and lovely of countenance, an exile among his fellows, to those characters larger than life whom Victor Hugo summoned from an almost mythical world. The fact is that artists, at a loss to identify themselves with what they wanted to portray, imposed themselves on their characters and, far from seeking what they had in common with the urban proletariat, emphasized the points at which they differed from it.

Often they were actuated solely by pity. They diagnosed sufferings which they neither shared nor understood, and which unconsciously strengthened their belief that they were fundamentally different from the "unfortunate." Moreover the artist's individualism, while it enabled him to withstand oppression, denied him all comprehension of the masses. Although he found them a fascinating subject for his pictures he always remained aloof and regarded them as a powerful but alien and amorphous mass. Instinctively he sought to dissipate this force, which to him was both undiscerning and unpredictable, just as the parliaments elected on the property franchise strove to suppress workers' combinations.

Many social theories of the time had a like bias. Not only were they reactionary in that they tried to evade the economic consequences of capitalism

by turning a blind eye to the factory system, but even at their most constructive they swam against the current of industrial concentration. The aim of reformers like Feargus O'Connor, Charles Fourier and Robert Owen was to set up small communities of peasants and craftsmen. It was only in the middle of the century that the masses, whose existence as an effective force had hitherto been ignored, began to organize in a political labor movement. Only then did the lower classes come to life in novels, pictures and plays. Daumier was the first to portray them, not as picturesque or pitiful curiosities, but as fellow-men of flesh and blood.

Where literature and painting were inarticulate, architecture was dumb. Ancient cities like Paris and London had been thoroughly and systematically replanned, and handsome districts had been laid out with an eye to the taste and comfort of the middle class; but no one had given thought to the hard facts of overpopulation. It was typical that Owen and Fourier should harp on the need to provide industrial towns with attractive estates and should actually do so on an experimental scale; but that where the problem was most acute nothing was done at all. There was no design, no planning, none of the elegant layout that characterized middle-class housing, when it came to crowding the poorer townsfolk into the unhealthy, jerry-built, antiquated rows of back-to-backs that were run up by the mile in every conurbation. The boss washed his hands of his wage-slave, who had no proper habitation because no one bothered about his existence or allowed him to assert it.

In this cancer of the great towns, this squalid, amorphous huddle of slums hidden away behind the tree-shaded avenues of the fashionable districts, one can see the actual, three-dimensional shape of that nameless multitude which, until the middle of the century, no painting could portray nor any poem embody.

THE OUTCASTS

Goya's genius, and later Daumier's, lay in opening up an entirely new view of social and political satire in order to express their revolt against oppressive institutions.

The Tribunal of the Inquisition *is a harsh indictment of an odious judicial process, but it is more than that. By stigmatizing religious intolerance the painter also condemns all infringements of human rights and liberties. Both in style and subject matter, this sharp attack on the Inquisition surpasses anything that Goya had ever painted before. Indifferent to elegance of expression and the ingenious constructions of his contemporaries, he speaks out with extreme violence. The lighting is particularly effective. Space is determined solely by the light that throws pillars and various figures into relief and by the deep shadows that darken the area under the vaults. The absence of any opening on to the outside world creates a stifling atmosphere. In this formless place a featureless crowd is gathered together; only a few faces are lit up in the foreground; their simple, expressive volumes, which fail to emerge completely from the dark crowd behind them, seem to reflect the leering faces of the whole assembly. Against this strange background the figures of the accused and their judge stand out sharply. The thick contour lines, the compact yet massive proportions, and the very colors, now dull and gray, now suddenly vivid, make it clear that the painter, regardless of harmony of any kind, was intent on a forceful denunciation of the cruel absurdity of a tribunal which condemned prisoners without any right of appeal. His treatment of space, forms and colors was imposed on Goya by the violence of his emotion; for him there was no other way of painting this mockery of justice, which he equated with disorder and lawlessness.*

Daumier's rude and simple masses are the outcome of a still more brutal mode of expression because the means he employs are more elementary. The Emigrants *and* The Fugitives *are probably connected with the events that followed the failure of the 1848 revolution in Paris, but they no doubt echo all the bloody repressions that ended the uprisings of that same year throughout central and southern Europe. These windswept figures have the same massive forms and heavy outlines that we find in Goya, and the lighting effects too are similar. But facial features have disappeared, and with them the proud dignity of Goya's solitary captives. The roughly sketched landscape and pressing sense of movement suggest an endless road, an irremediable affliction and a mute submission to suffering that are perhaps more moving than Goya's desperate revolt.*

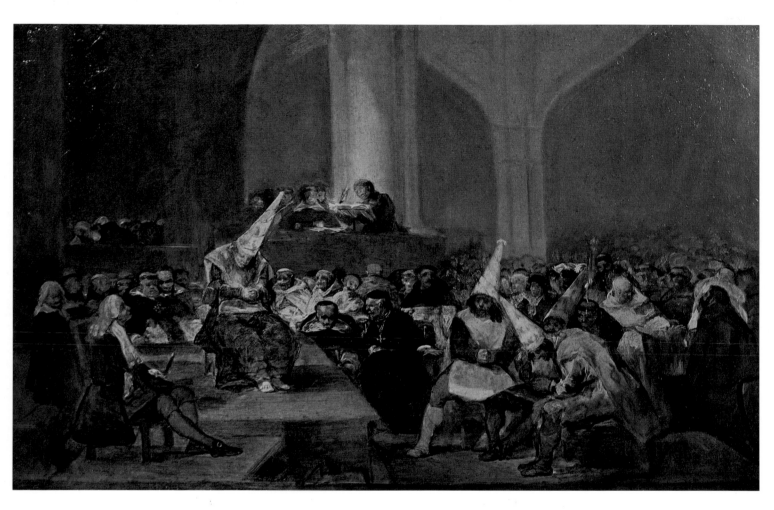

FRANCISCO DE GOYA (1746-1828). THE TRIBUNAL OF THE HOLY INQUISITION, 1808-1815 (?).
ACADEMIA DE SAN FERNANDO, MADRID.

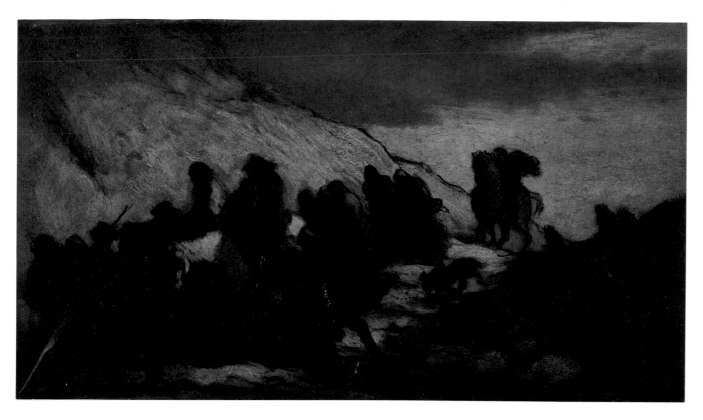

HONORÉ DAUMIER (1808-1879). THE EMIGRANTS, 1850-1855. MUSÉE DU PETIT-PALAIS, PARIS.

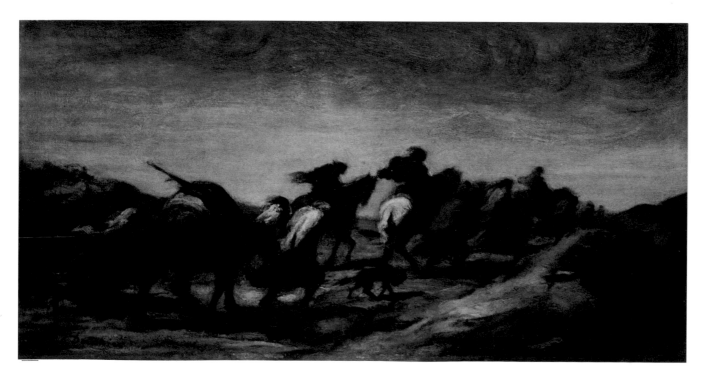

HONORÉ DAUMIER (1808-1879). THE FUGITIVES, ABOUT 1848-1849. COLLECTION OF MRS WILLIAM VAN HORNE, MONTREAL.

III

WITHDRAWAL

HISTORY

The period when Man discovered his mastery of the physical world and realized that by harnessing certain forces he could apparently command unlimited energy, this was also the period when he became aware that history was not a mere sequence of cause and effect but an irreversible evolution. For the past was only a phase contributing to the present which, being itself the outcome of all that had gone before, was utterly different from any moment in the past. History was a state of continuous growth and flux, and therefore could never be lived twice over. The future, moreover, was a fulfillment of the past and present, but was incommensurate with either. It was seen by some thinkers, such as Lamarck or Michelet, as a mystery comparable to germination; or even, in the case of Hegel, as a task to be accomplished by the conscious will, with all the hazards that involved. No one any longer regarded the future as having the comfortable precision of the solution to a problem in geometry.

This concept of time gave immense significance to the technical discoveries and political innovations at the end of the eighteenth century. A new dawn was breaking.

When this world, as yet inchoate and inexplicable, swam into their ken, men's eyes were dazzled as by the rising sun. They awaited a second Adam to give the unknown a name. Instead there took place what Plato described in the *Republic*, in his parable of the prisoner taken from the cave where he had sat in darkness and led into sunlight: "If he were compelled to face the light of day, do you not think that his eyes would ache and he would turn away, back to the things which he could descry, and that these would be more real to him than what he had been shown?" Few indeed were those who dared to leave their cave and confront the times they lived in. The majority clung to bygone customs, and the men who invented the locomotive delighted in dressing up as Louis XI or Julius Caesar.

The burden of a universe which was still wrapped in mystery must have seemed inordinate to those who had to bear it. Industrialism and mechanization are largely ignored in their literature, as if this emergent world could find neither a habitation nor a name.

And yet the very men who had denied birthright and rejected hereditary office found themselves forebears and took refuge in the past, for fear of going they knew not whither. The French and American revolutionaries disguised themselves as Romans and played at being Brutus or Cincinnatus. The speeches of Camille Desmoulins were ghost-written by Tacitus. Napoleon dubbed himself Consul, then Emperor. The fear of coping with the unpredictable and answering for the unexpected caused men to retreat from progress just when it was taking shape in their minds. By speech and dress they strove to misrepresent what was happening. They sought comfort in history, trying to believe that there was nothing new under the sun and that understanding of things present and future could be found in books. They hoped to keep up with the present by consulting the records of the past and by reconstructing Roman temples and Gothic cathedrals.

In fact, when people grew tired of rigid, Neo-Greek decorum and it was found that liberal ideas accorded ill with stiff colonnades and pompous pediments, Medieval Picturesque came to the rescue and spared architects and their clients the effort of taxing their imagination.

Architectural studies were dominated by history, and the archaeological propriety of a building would be earnestly debated before the mortar was dry. Not only were the new techniques unproductive but they helped to realize those immense archaeological designs which have continued almost to the present day to perform their weird function as monuments of no particular epoch.

The Middle Ages were, of course, the great standby of these nostalgic dreamers. History, from the fall of the Roman Empire to the sixteenth century, was their happy hunting-ground, for there they found the epitome of the Western world, with its saints and heroes, its local peculiarities and hectic feuds. There were obvious advantages in the fact that the period had been almost completely forgotten. It was so little known that almost anything could be said about it, and its wealth of legend, chronicles and folklore went far beyond anything the imagination or the pages of Pliny and Livy could offer. Moreover, resurrection of the Middle Ages combined all the kudos of discovery with none of its risks, since its disclosures were of the dim past and held neither dangers nor pitfalls.

Naturally this longing to go back into former times could not be satisfied by mere documentary analysis, and the art of that enviable past, a Golden Age which could be observed without being experienced, had great popular appeal, especially as much of it was still extant. Hence the vogue for prints of medieval monuments. Fortunately the factitiousness of this revival could not impair or diminish what was already a mummified relic, so that architecture became wholly, and sculpture to a great extent, branches of archaeology.

Painters, composers and writers did not fare so badly. Apart from some of the smaller fry they were attracted more by externals than by style, and their medievalism was largely put on. Nothing could be more up-to-date than the argument, structure and language of such works as *Faust* or *Egmont*. Yet the former conjures up a world of witchcraft, love-philtres and devil-raising to which the protagonists' medieval costume lends verisimilitude; while the latter reproduces the sports, dress and manners of the sixteenth century in relating an actual historical event. In *Faust* as in *Egmont* neither the thought nor the speech, still less the dramatic structure, is in any way medieval. Only the setting, the visual image is deceptive.

Only a few poets imitated archaic forms. Many painters, however, showed a fondness for the bright colors, precise outlines and naive expression of fifteenth-century painting, although they rarely imitated it outright, and when they did the resemblance usually remained very superficial. The experiment of the

Nazarenes, who came to Italy from Germany and tried to revive the way of life and the religious art of Quattrocento monks in the cloisters of Sant'Isidoro in Rome, was quite exceptional. Nevertheless, it is significant, for the aim of Overbeck and his friends was to steep themselves completely in the past; instead of studying history they made every effort to abolish time—to set the clock back. The weakness of their paintings is ample evidence of the failure of the enterprise.

Apart from a few eccentrics like the Nazarenes, it is obvious that painters, like writers, were only affected outwardly by the prevailing nostalgia for the past. In fact, medieval garb was sometimes used to introduce daring innovations which otherwise might have raised a storm of protest. Just as it was easier to make the Marquis of Posa rather than a German burgher the vehicle for subversive opinions, so a painter could take far greater liberties if his subject had an antiquarian air. To a public that insisted on clean-cut finish it was difficult to convey unspoken hints by means of highlights, delicate brushstrokes or uneven drawing. Therefore, to avoid blemishes of style, painters hit on the idea of putting their most novel and outspoken works in fancy dress. And they found the pretext of some historical scene still more convenient when they saw that the true meaning of their work would offend accepted canons of behavior. Distress and violence were easily borne in the past tense. History provided a ready-made disguise for eroticism, cruelty and terror.

The public was readily taken in. Reassured by the remoteness of the characters portrayed, by slick and graphic symbolism, by the almost fairy-tale nature of the events depicted, it took a fancy to works that it would surely have condemned had they been presented in modern dress.

In such paintings the imitative veneer is so thin that the desire to counterfeit and contrive leaps to the eye. Far from revealing any deep harmony or intellectual affinity with the men of former times, the carnival finery of these historical set-pieces usually conceals a vacuum. The attitude of their makers is a far cry from the fervor of the Renaissance artists who rediscovered the spirit of Greece through a study of Roman statues. The insight of a Donatello presupposes a common ground of thought with the Ancients which is absent in Delaroche and Cornelius. In fact there was

no affinity of any kind between the latter and the men whose faces and clothes they tried to revive, but whose spirit they had no conception of.

In so far as they are not mere waxworks these productions have no connection with their subject and are strictly allegorical. In literature the link with the past lies right outside the actual text, whereas in painting the clue is given by the way in which the characters are dressed. Indeed, in the more jejune works one finds nothing of the depth, color or draftsmanship of a Titian or a Memling, merely an illustration for a play that might have been written by Victor Hugo or Schiller.

The fact is that in nineteenth-century painting there was no real, fruitful discovery of the past, for that would have introduced a whole system of aesthetics, supplying a key to the present and making it meaningful and acceptable. Instead one finds little more than a picture-book, divorced from the realities of life.

4

JOURNEYS IN TIME AND SPACE

In spite of improvements in the road system, traveling was difficult before the opening of the railways. People did not travel much, but though they would probably never visit them, they were curious to know what foreign countries looked like and took pride in being familiar with the most celebrated beauty spots in their native land. Those who could not take the stage coach bought prints. Many monuments illustrated in them seemed strange at first, but people became fond of the sights and scenes which they could contemplate at leisure in the leaves of their print collection.

To begin with, curiosity had to be satisfied and the most sought-after prints were those which represented monuments and views with documentary accuracy. Catering for the taste of the public, publishers commissioned artists to travel through the provinces of France and England and make accurate drawings of a great number of buildings. Bonington's *Clock Tower at Evreux* is characteristic of the resulting productions. The young artist has scrupulously rendered the structure of the tower and every detail of its period style. He took good care to add some picturesque figures to please the eye, but they are only a minor element. Such prints and pictures certainly gave a strong impetus to the revival of interest in the Middle Ages, perhaps even more so than the writings of Goethe and Chateaubriand.

RICHARD PARKES BONINGTON (1801-1828). THE CLOCK TOWER AT EVREUX, 1824. LITHOGRAPH.

DESCRIPTION DE L'EGYPTE (VOL. I, PLATE 38, PARIS 1809): THE MOSQUE OF SULTAN HASSAN IN CAIRO.

95

half a century, through many a view of the banks of the Seine and the English countryside, seemed to be achieved: not just the discovery of a new theme, but the revelation of a strange world, familiar yet fantastic, outside time.

But the engravers who depicted more distant places held their imagination in check and tried to give a faithful picture of the Orient and the southern Mediterranean lands. It was the thirst for knowledge that ensured the success of travel books and sets of plates which showed the Moslem world in a new light and destroyed the old image of a fancied East, quaint or cruel as the case might be. The great illustrated volumes of the *Description de l'Egypte*, produced as a result of Napoleon's expedition to Egypt, showed actual views of the sphinxes, the pyramids, and the mosques of Cairo. They revealed the contrast between the busy streets of Cairo and desert life, between the picturesque traffic of the Nile and the great crags lining the river in places. They pictured Arab craftsmen at work, camel-drivers and peasants. The novelty and variety of these scenes came as a surprise, but it was their truthfulness, the realization that these people and this life actually existed, that made them more fascinating than any product of the imagination. People were so eager to know more about this world that engravers could dispense with merely picturesque effects.

In spite of the interest they aroused, neither Gothic nor Moslem art had much effect on the graphic arts and there are very few signs of any direct influence. Most engravers and painters showed no interest in the technical lessons to be learned from such sources. Cotman is quite exceptional in having used in his *Château Gaillard* some of the compositional devices of Chinese or Persian art; for example, their precise definition of objects in a two-dimensional space which gains a certain depth from the play of overlapping planes. But this particular influence only emphasizes Cotman's isolation from the main trends of his period.

DESCRIPTION DE L'EGYPTE (VOL. II, PLATE 100, PARIS 1817): THE ARABIAN DESERTS. VIEW OF GEBEL GHAREB.

JOHN SELL COTMAN (1782-1842). ARCHITECTURAL ANTIQUITIES OF NORMANDY (LONDON 1822):
THE CHÂTEAU GAILLARD AT LES ANDÉLYS, SOUTH-WEST VIEW. ETCHING.

CHARLES MERYON (1821-1868). LA POMPE NOTRE-DAME, PARIS, 1852. ETCHING.

Merely to read admiring descriptions of Gothic cathedrals, belfries and keeps would not have been enough to make anyone prefer these forms to the fashionable colonnades and pediments. But popular prints opened people's eyes to the elegance, beauty and fantasy of Gothic monuments, and soon they were delightedly discovering in their own town the same fretwork and pointed arches which they had hitherto ignored.

But as time went on the public wearied of the archaeological detail which had at first struck its imagination. Perhaps it had become blasé; the original monuments lost their fascination when new buildings began to be erected in imitation Gothic. Most of all, however, literature was responsible for the change of feelings. In the hands of writers like Victor Hugo, the Middle Ages took on a fierce and picturesque character which no topographical engraving could possibly convey. There was no less enthusiasm for the past, but now it was a slightly different past.

Henceforth prints had to show a strange, populous, animated world, one much closer in spirit to the Middle Ages which men were trying to bring back to life than the buildings whose forms had grown familiar. Now artists took to picturing narrow, ill-paved streets, lean-to houses and rough walls. What was merely ornamental detail for Bonington became Hervier's main preoccupation. Veiling parts of the picture in mysterious shadows, he highlights the odd tilt of a crumbling wall, a sagging roof, and dilapidated doors and windows. Documentary accuracy gives way to dramatic effect. This style reached its peak with Meryon, who found in the old quarters of Paris endless pretexts for striking contrasts between crisscrossing lines, shapeless masses of deepest black and the sudden bare expanse of smooth surfaces. The intensity of his vision led him to adopt a more demanding medium than lithography and his views of Paris prove him a master of the art of etching. With him, the aim pursued for

THE GOTHIC REVIVAL

Medievalism inflicted greater damage on sacred art than on any other; for it was no mere disguise such as could be stripped away by the vitality of works like *Faust* or Delacroix's *Murder of the Bishop of Liège*. The sham was complete; nothing lay behind the mask.

Yet after the French Revolution the ceremonies were renewed, churches were restored and the priesthood recovered their place in the world. One might have expected a sudden flowering of religious art rather than its general decline. Commissioned works were stiffly conventional and artists modeled themselves on Raphael and the Baroque masters. Religious iconography became a slavish imitation of the past. Before long the obsession grew so strong that everything ecclesiastical had to be exclusively Gothic. In fact, some time before the first Neo-Gothic buildings appeared the contemporaries of Hegel and Michelet had started to equate Christianity with the Middle Ages. When one reads Chateaubriand or even Schlegel one seems to be witnessing a form of ancestor-worship whose significance is purely historical. It was fashionable to speak of "the religion of our fathers," which had no apparent connection with the human or divine personality of Christ. This inconsistency may not have affected theologians, but it had such firm hold on everyday life that even anticlerical works had to don doublet and hose, adopting such titles as Hugo's *Notre-Dame de Paris*. Hegel's indictment of art and religion seems to be conclusively borne out by the epidemic of Neo-Gothic churches, buildings so misbegotten they could only belong to a Dark Age.

The arrant philistinism of these renovated temples gives evidence of a far deeper and more serious spiritual malaise than might have been inferred from the proscriptions and blasphemous ceremonies of the French Revolution. The Gothic Revival made the Church an anachronism. It ceased to be the abode of a living faith and became a ritualistic show-case.

Moreover this deliberate antiquarianism in images and architecture was reflected in certain social attitudes. To the middle classes religion was only respectable so long as it evaded the facts of life and was thus suitable for the employment of women and the instruction of children. It strengthened morality, discouraged impropriety and gave a tasteful and necessary touch of pomp to marriages, funerals and baptisms. It also provided a desirable observance for the masses, in whom it inculcated long-suffering and respect for property. At this rate religious life had about as much artistic merit as the proceedings of a law-court; for where the spirit is wanting art languishes.

The nineteenth-century Church was in no way identified with the community as a whole; rather it was made captive by a single class, to whom it was not so much a master as a watchdog or stalking-horse. Religious obligations were turned inside out. There was no sacred art because most believers did not regard their religion as a means of approaching God but as the custodian of certain traditions which they wanted to uphold.

While the Churches went Gothic and were emasculated by their hidebound followers, there were signs of restlessness among the really devout. These upheavals, though violent, were short-lived, perhaps because they did not reach a sufficiently influential group. They usually took the form of radical opposition to clerical orthodoxy and the excessive worldliness of the priesthood; but it cannot be said that the official churches took much notice of them.

Many of these rebels were actuated by social motives. Shocked by an economic system in which the wealthy ground the faces of the poor, they wanted charity to be exalted and religion to serve the people in a spirit of true justice. This may have prompted the Assemblée Constituante in 1791 to propose that parish priests should be elected by their

flock. It was certainly what Lamennais fought for and what Blake implored in his angriest jeremiads. These impassioned voices found expression in many ways, meeting constant opposition and replying to it with mounting violence. In savage terms they attacked the pallid hierarchy of the Church, hurling anathema at those who tolerated the intolerable. There is a deliberate irreverence in all these works, whether by Blake, Goya or Daumier, that reveals the anguish of men to whom it was an insufferable outrage that Love should serve Mammon. Too weak to hope for acceptance, yet too convinced of the rightness of their cause not to proclaim it to the world, these lonely rebels portrayed Christ "despised and rejected of men," or even the Antichrist.

They dreamed of a living church, wholly identified with the people, that should remedy all the ills of the age, heal the wounds inflicted by industry and strike off the gags and fetters of those who were struggling to be free. But this was not the only religious attitude that conflicted with orthodoxy. The individualism apparent in all intellectual activities also tended to favor a quietist mysticism. This is found at its most extreme in Kierkegaard: "By pertaining to itself and seeking its own identity the Ego pierces its envelope to reach the Power that originated it." Likewise: "Love has its secret and unfathomable life in the very core of our being." There could be no sect or formal worship here. Reverence might still be put into words, but it could not assume tangible shape. Blake or Daumier could readily give outward form to his execration of a certain image of God, for it implied a summons to others as well as the despairing conviction that he was but a voice crying in the wilderness. The faith of a Kierkegaard, though also hostile to the churchgoers, sought no external aid. It was not a summons but a rebuff to the world and could therefore be given neither likeness nor bulk.

At the beginning of the nineteenth century, the growth of the fashionable quarters in Bath, as in other towns, led to the construction of new churches. Near the Royal Crescent, one of the most original pieces of urban architecture of the previous century, a church was erected in a style completely foreign to the nineteenth century. Like many other English churches built about that time, St Mary's has the hard, spiritless purity of a reconstruction. In spite of all their reading, the men who built these churches were powerless to revive the spirit of the master-architects of the Gothic cathedrals. St Mary's stands a silent witness to an age which could build houses of prayer but was incapable of creating a style and forms of its own.

Religious fervor is often linked with nostalgia for the past. German artists loved to paint old cloisters buried in snow and ruined churches in the middle of frozen forests. When Caspar David Friedrich sought to link up his thoughts with more expressive symbols than the sea or a tree, he chose Gothic arches and windows or a cross standing alone in an inaccessible wilderness. The Cross and the Cathedral in the Mountains *is typical of his favorite themes. Isolated from the world, the church and the image of Christ rise up in a desolate landscape where the only signs of life are the fir trees clustering round the cathedral as if to protect and screen it from our gaze. In the foreground a spring flows into a pool surrounded by rocks and dead branches. This wild landscape hemmed in by mountains evokes a sense of mystery and secrecy, but also self-communion and fear of life.*

In pictures that are meant to excite fear, the devil reappears in much the same guise as in the Last Judgments on Gothic tympana. For nineteenth-century painters and poets, however, the devil, as the incarnation of evil, is not bound up with personal sin, but rather with the revolt against society. Associated with nocturnal spirits, with Hecate and nightmares, he represents the powers of darkness and the demons of violence and folly that lurk in the hearts of men. In his quasi-human shape, he became the focus and pretext for a new mythology devised by painters like Blake and illustrators like Delacroix in his Faust *lithographs. But unlike the demons who contended with angels for the souls of men, this devil is too obviously a creation of the past to convince us of his existence. It was in poetry and music, after archaic forms had gone by the board, that Satan regained his malevolent power.*

JOHN PINCH (1770-1827). ST MARY'S CHURCH, BATHWICK, BATH, 1814-1820.

CASPAR DAVID FRIEDRICH (1774-1840). THE CROSS AND THE CATHEDRAL IN THE MOUNTAINS. KUNSTMUSEUM, DÜSSELDORF.

EUGÈNE DELACROIX (1798-1863). MEPHISTOPHELES FLYING OVER THE CITY, 1828.
LITHOGRAPH. MARTIN BODMER COLLECTION, COLOGNY, GENEVA.

WILLIAM BLAKE (1757-1827). THE GHOST OF A FLEA, ABOUT 1820. TEMPERA.
BY COURTESY OF THE TRUSTEES, TATE GALLERY, LONDON.

EXOTICISM

Just as the past may serve as a refuge from one's own time or as a pretext for dismissing it, so also may distant lands—anything, in fact, that has no connection with "the common round, the daily task." At the beginning of the century everything tended to awaken interest in overseas countries. Many people traveled in the Mediterranean and the Indian Ocean, although it was not much easier to do so than it had been a hundred years earlier. Even when steamships became common there were few Europeans and hardly any Americans who went to Algiers or India. Nonetheless sea travel was encouraged by the leisure of those with private means who, unlike the recipients of royal annuities before the Revolution, did not have to remain at the fount of their wealth. Moreover the economic expansion and vast output of Europe made it necessary to develop new markets and sources of raw materials. Yet there was more in this longing to leave the beaten track than the mere desire to make money or kill time. Globe-trotting was not just another excuse for dressing up; it represented a genuine discovery.

Although Oriental brass and pottery were all the rage and ladies wore turbans and men went in for yataghans and Turkish slippers and tried to smoke hubble-bubbles, these were only symptoms of the enthusiasm awakened by the sudden discovery of ancient civilizations and strange customs. The *Description de l'Egypte* electrified its readers, for the hundreds of illustrations done by Bonaparte's colleagues revealed to them the mystery not only of a bygone culture but of an Oriental race, complex, inscrutable and still living. No less startling was the discovery of Greece during the Wars of Independence. To the Philhellenes in Paris and London, Kanaris and the men who fought at Missolonghi were incarnations of the statues in the Louvre. But when peace came and pilgrims went to commune with Pallas Athene and her sculptured retinue, they found a race and a land that had nothing in common with the marble relics enshrined in Greek grammars.

Greece and Egypt, to be followed shortly by Algeria and Morocco, were not disembodied history, offering a selection of heroes and events; they were a living present, full of surprises and enigmas. These foreigners who suddenly burst upon the West had to be taken as they were, even if they did not quite come up to expectations—witness the disappointment of Byron in *Childe Harold* at his first journey in Greece. The world of private myth and self-expression had to give way to an entirely different universe, with its inevitable commotions, conflicts and disquieting contrasts. Closer acquaintance forced a man to recognize that a foreigner was not a projection of himself but a person in his own right.

The extent and impact of this discovery can be grasped if one follows the ups and downs of Delacroix's relations with the Moslem world. Before crossing the Mediterranean he had been fascinated by Islam as he had visualized it from Byron's poems or descriptions in periodicals and reviews; but this was an imaginary world which, like history, could be used as a setting for his private obsessions—rapine, bloodshed, precious gems and mettlesome steeds. It was the Orient of the *Arabian Nights*, where figures in exotic garb moved like puppets. When Delacroix went to Africa he found what no book or object had been able to show him, the fulfillment of the unknown. The hidden, changeless world that he encountered was mysterious beyond anything he had imagined, yet it was real. So violent was the shock that he had to devise an entirely new style of painting.

Even when they lacked the power to reproduce another world, all these artists imparted to their works, however trite, something of the wonder that had been revealed to them on their travels. When they dwelt on racial characteristics, the appearance of villages, the color of the earth, the unwontedness of even the most ordinary objects, they disclosed a strange, fascinating, undreamed-of existence. The

European, despite the innumerable barriers that lay between him and this world, beheld it with nostalgia. He fondly believed its inhabitants, so different from himself, to be better and happier men.

What the early nineteenth century saw was not the Noble Savage, attracting civilized men by the mere fact of his dissimilarity; it was rather the product of another civilization with its own history and complex social order, its own culture, which might be more or less advanced than that of the West, but whose problems were not those of Englishmen, Frenchmen or Americans. This accounts for the awakening of interest in the Indians, now regarded as sages rather than aboriginals. The place of the ferocious Sardanapalus in romantic iconography was taken not by some defenseless simpleton but by Sultan Abd-er-Rahman, a calm, noble figure on horseback in a cloud of gray and gold, with his dignitaries around him and the walls of his city behind. Happy indeed was the lot of a man who could delight in poetry, lead an army in battle, decree laws, take his ease in gardens with fountains playing, and yet, though living in the present, could stand aloof from the fume and fret of Europe.

What really accounts for the fascination of lands far off but no longer legendary is the longing to be someone else, to be released from one's daily burden by assuming another existence. The knowledge that such a wish could be fulfilled made it a living and concrete reality. It may have been escapism but it was not a sham. However remote the other world might be, it was not unattainable. The gulf that divided one from its inhabitants, though wide, could be bridged, for they were not figments from the past or the *Thousand and One Nights* but living men and women. The ineffable charm of exoticism was that one really could live with Abd-er-Rahman or one of his kind, whereas no one could retrace the path of history and "provoke the silent dust" of Lorenzo de' Medici or Don Carlos. One really

could—and some did—settle in Morocco or Egypt, learn the language and go native. Even those who fondly saw themselves as expatriates, knowing quite well they would eventually return to London or Paris, were not merely weaving ropes of sand.

So real were these distant lands, so genuine was the impact of their discovery that they gave substance to all works of art inspired by wanderlust, even to those dreamy rhapsodies in which the poet or painter, for whom the rise and fall of the tide was seafaring enough, conjured up visions of countries he had no intention of visiting. Tales of the past had never produced such an effect. After all, to plan an imaginary journey one must believe in its destination. Those who thought they could smell the African desert at Venice or Cordoba were not wholly mistaken. The ships standing out into the Adriatic were an argosy, and the mosques of Islam could be glimpsed in the domes of Santa Maria della Salute or St Mark's. Venice, so buoyant that she seemed to be floating beside the Grand Canal, adrift on her lagoons, was anchored to the dreams of those who never left her quays; yet she pointed to real lands beyond the horizon, and the dreamers need only bestir themselves to reach them. Even without Venice the vagrant mood might be awakened. The smell of spices in Dutch harbors was enough for Baudelaire to feel the exquisite torments of the wayfarer who never leaves home.

The same pangs of a distracted soul may be felt in Baudelaire's motionless ships, in Turner's diaphanous Venice, in the harem of Delacroix's *Algerian Women*. The European's yearning for another life came from his awareness that a world existed where he could live without remaining wholly himself. Delacroix gloated over the possibility of escape and secretly built his imaginary house at Meknes. Baudelaire knew there could be no escape, yet he too turned towards the silent ships to shut out the din of the streets.

Disembarking in Africa or Asia Minor, the nineteenth-century traveler was impressed most of all by the astonishing novelty of everything he saw. Later, back in Europe, he imagined himself to have met with fabulous adventures, to have seen strange sights, and by way of his actual experiences he thus satisfied some of his innermost yearnings.

One of the most fascinating records of an Oriental journey is to be found in the sketchbooks in which, day by day, Delacroix jotted down all that struck him in Morocco: landscapes sketched in with a few touches of watercolor, dancers reduced to a pattern of rhythmic movements, and horsemen outlined with long strokes of the brush or pencil. Low houses, shady byways and the yellowish walls of fortresses are all seen with a fresh and wondering eye, as if the painter were eager to capture and record everything within his reach. The first pictures Delacroix painted after his return to Europe were still full of this sense of wonder. Like him, other artists such as Decamps and Marilhat traveled in the East and discovered the singular light of the marketplaces and village squares, the beauty of great bare walls glowing in the sun and palmtrees with thin, gnarled trunks.

As they observed life in the narrow streets of Meknes and on the reddish or golden sands of the desert, painters made significant changes in their palette, taking to pure whites, to pearly tones, to limpid reds and yellows. Delacroix was soon going in for bolder contrasts. By isolating figures and stepping up the vivacity of movements, he transformed his compositions; they became more tumultuous the further he moved away from a direct portrayal of the men and women walking through the dusty streets of Moroccan towns.

Later on, dreams mingled with memories. The stirring visions of big-game hunting, to which Delacroix returned again and again, owe little to his travels, though they glow with the heightened colors he discovered in Africa. Oriental in their inspiration, like the wild animals carved by Barye, what they really represent is the eruption of instinctive forces. Elemental ferocity and the savage beauty of rippling muscles are as essential a part of Delacroix's Lion Hunts *as they are of Barye's animal studies (all of which were made, not in Africa, but in front of the cages of wild beasts at the Jardin des Plantes in Paris). What chiefly interested both artists was the dramatic expression of movement, the furious clash of twisting bodies engaged in a life and death struggle.*

ALEXANDRE-GABRIEL DECAMPS (1803-1860). TURKISH MERCHANT SMOKING IN HIS SHOP, 1844. LOUVRE, PARIS.

EUGÈNE DELACROIX (1798-1863). MEKNES, APRIL 1, 1832 (LEFTHAND PAGE). PEN AND WATERCOLOR.
FROM THE NOTEBOOKS OF THE JOURNEY TO MOROCCO. LOUVRE, PARIS.

EUGÈNE DELACROIX (1798-1863). MEKNES, APRIL 1, 1832 (RIGHTHAND PAGE). PEN AND WATERCOLOR.
FROM THE NOTEBOOKS OF THE JOURNEY TO MOROCCO. LOUVRE, PARIS.

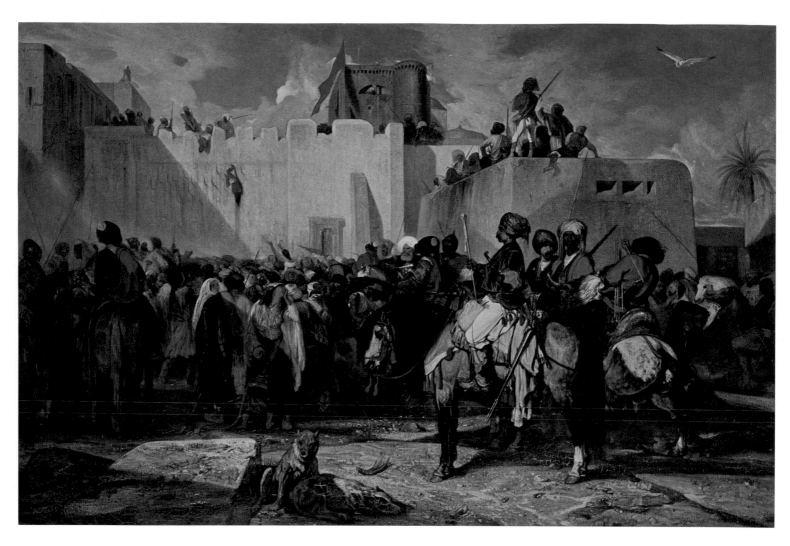

ALEXANDRE-GABRIEL DECAMPS (1803-1860). THE PUNISHMENT OF THE HOOKS, 1837. WALLACE COLLECTION, LONDON.

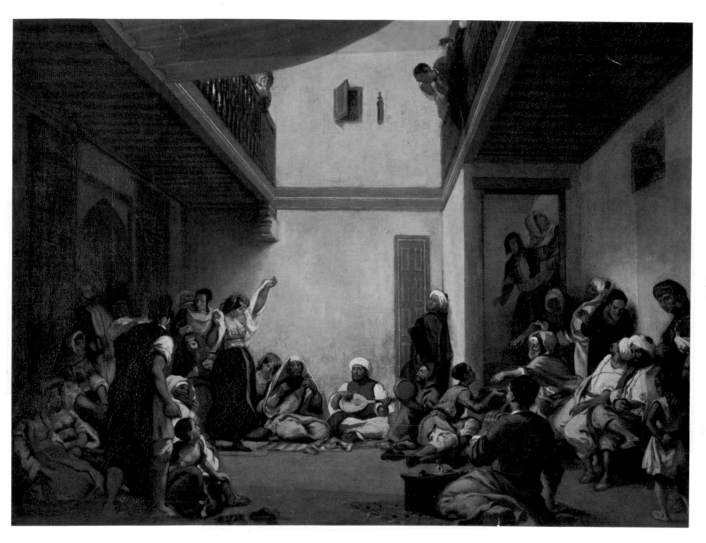

EUGÈNE DELACROIX (1798-1863). JEWISH WEDDING IN MOROCCO, 1839. LOUVRE, PARIS.

EUGÈNE DELACROIX (1798-1863). LION HUNT, 1855. PRIVATE COLLECTION, SWEDEN.

ANTOINE-LOUIS BARYE (1796-1875). JAGUAR DEVOURING A HARE, 1851-1852. BRONZE. LOUVRE, PARIS.

COUNTRY LIFE

Before the Industrial Revolution and its political upheavals, there was a revolution in the European landscape. About the middle of the eighteenth century, new fashions from England and China banished the geometrical paths and pools and pleached bowers, all the symmetry of parks in the French or Italian manner. Thereafter gardeners sought to copy nature instead of confining it. They turned the pools into waterfalls and laid out artificial streams whose banks were overgrown with iris and rushes; they dug lakes and constructed islands. Laboriously and at great expense they obliterated all evidence of man-made order. For the first time in thousands of years the European gardener refrained from imposing his will on the earth and allowed it to have its own way. So deferential was he to nature that he tried to make his own domain part and parcel of it. This resulted in the disappearance of the walls and hedges by which gardens were previously enclosed and their replacement by water, shrubberies or ha-has. The park no longer had visible boundaries and was completely incorporated in its natural setting.

This spontaneous return to the virgin wilderness went hand in hand with a yearning for rural life and the cycle of the seasons, natural enough in townsfolk who, by the end of the eighteenth century, were chafing at the urban sprawl and its surrounding factories, pushing the green belt further and further from the center of the town.

People longed once more to walk between trees and earth, to resume their proper share in the life of animals and plants, from which they seemed to be cut off by the artificial barriers of urban civilization. It was to meet this need that spacious city parks were laid out, especially on the picturesque pattern adopted in England.

So strong was the appeal of rustic life that it led to the building of farms, dairies and windmills, in order not merely to recapture the noiseless tenor of the countryside but to commune more deeply with the earth and its elemental forces. The ready acceptance of simple tasks, those of the cowherd driving his cattle or the dairymaid churning her milk, enabled people to feel the very roots of their existence and to enjoy the luxury of hard work and weariness without responsibility. Here the dairy-farming of Jean-Jacques Rousseau and Marie-Antoinette joined hands across the centuries with Sir Thomas More's *Utopia*, the dream of an earthly paradise where solitude and timelessness brought a man peace and inner harmony in a world he could no longer comprehend and from which he sought refuge even at the cost of reverting to existence at its most primitive.

It was no accident that some social reformers, like O'Connor and Fourier, had the idea of setting up agricultural colonies, self-supporting and on a fairly small scale, which ran directly counter to the new economic and productive methods. The back-to-the-land movement gave promise of general and unalloyed happiness as the inevitable consequence of leading a natural life.

The country became a Promised Land where all problems would be solved. Nature, seen in this light, was no longer extraneous to man but a natural extension of his being, the true habitat to which he must adapt himself.

This attitude sometimes reached the point of deliberate self-immersion in plant and animal life. This was most apparent in landscape painting, especially in England where, possibly owing to the speed of industrialization, poets and painters succumbed earliest and most ardently to the yearning for an elemental life. Their pictures were no longer of views seen afar off and virtually reconstructed by the artist. They steeped themselves in nature, which, as Wordsworth put it, "Our minds shall drink at every pore."

The artist was no longer a discovering and identifying intelligence. He gave himself up, body and soul, to his sensibilities and allowed nature to surround and engulf him. In total surrender he shared the passivity of an animal in communion with the seasons, thereby going further in his return to nature than the Fourierists or the dairymaids at the Trianon.

Constable, for instance, may be said to have experienced rather than seen what he painted, to have felt rain and sunshine as if he were an animal or a tree. At this level one encounters the obscurity of a pre-conscious vision. There can be no analyzing such tactile apprehension of nature, for it precedes any form of ratiocination.

Thus, the revolution in art at this time, and above all in landscape painting, cannot be ascribed solely to the painter's desire to break with the values of his predecessors. It also owed something to his need to find means of expressing a completely original vision. In order to make his figures melt into space he had to devise a new series of techniques, such as juxtaposed brushstrokes, the sometimes excessive use of the palette knife and the new-found fluidity of watercolor. Unity of atmosphere was obtained by softening the composition, so that objects, glimpsed but not identified, lost their definition.

Artists were trying to express a sensation so pervasive that they were groping in the dark. Earth and sky were one, and the trees could not be distinguished from the clayey soil, for they were as indivisible a part of it as the grass or rushes. Figures, too, being nothing but earth and plants, mingled with the rest. Linear perspective was, of course, done away with; but painters went further and dissolved anything that lent solidity to the composition. The earth lost its consistency and nothing was firmly rooted. Space, too, having no markers to indicate distance, was indefinite, for the artist's vision, being both comprehensive and fragmentary, could not take in any firm outline, nothing but fitful gleams and vapors or kaleidoscopic shapes, so that objects had less value than the play of light upon them.

As a result, landscape painters began to show what hitherto had been unknown to painting, the wind, humid or translucent air, changes of light according to the time of day. They dwelt on all that was most sensorial and ephemeral—moisture-laden clouds, the shimmer of pools, wet sand, sea-spray.

Those who strolled down winding lanes and grassy paths, or who, in the heart of London, followed the meandering Serpentine hoping to lose their way in that semi-wilderness—all felt at home in these deliquescent landscapes of clouds, mists rising after rain and mire dissolving into water. To melt into fog or heat, to feel instinctively by sniffing the air that rain was coming, this was to steep oneself in a world where one only had to breathe, to lead an elemental, vegetative existence, where the passing of time was marked by the seasons, where there were neither plans nor duties, for the future was no more than the silent thrust of the seed under the earth. It was to slough off all that pertained to nineteenth-century man—life in towns, industry, machines; but it meant also the abandonment of all efforts to shape the world and, in the end, of consciousness and free-will.

Exoticism did not imply self-surrender, but the desire to share the heritage of other men while preserving what one believed to be essential in one's own. The folly of pursuing the will-o'-the-wisp of country life reveals a far more serious maladjustment to contemporary changes on the part of the Western world, for in this case the alienation was deliberate and total.

THE SPECTACLE OF NATURE

The ways of interpreting nature in this period were legion. After all, if the architect or landscape gardener has not previously inserted any human element in the scheme of things, all attitudes and renderings are possible. It is natural that Man, in his discomfort at being alienated from his surroundings, should be fascinated by a reversion to nature in the wild and should seek countless ways of giving meaning to what has become unwonted. Those unwalled gardens, without plan or symmetry, while they gave a man promise of a blissful Nirvana, also confronted him, if he tried to take his bearings by the landscape, with a spectacle whose strange disorder revealed the antithesis between nature and the human mind. While a man can feel the rhythm of the universe in the filling of his lungs and the beating of his pulse, he will be at a loss if, with mind and eye alone, he beholds nature in the wild and no longer finds the order that former generations created from trees, walls and houses, from straight roads and lofty coppices. He feels himself an outcast in this inorganic, impenetrable world whose boundless mystery eludes him.

All the arts, especially that of landscape gardening, apply reason to matter and usually construct a pattern of shapes and colors scaled down to human proportions. At this time, however, the introspective Europeans made no attempt to shape their surroundings in their own image and failed to make real homes of their houses, to prune their trees or to fill and enliven their vistas with statues. Cut off from their true environment, their only options were reversion to nature in the raw or total withdrawal from the tangible world. Such human vestiges as they might still encounter were mementoes of the dead. Since they could not construct anything of their own in the present, they could only find an outer semblance of themselves in the past—in what was either varied or exotic in a world from which they had ostracized themselves by refusing that contact with reality which lays a human imprint on trees and stones.

Small wonder, then, that painters remained fearful spectators of "Nature, red in tooth and claw," producing quantities of dramatic landscapes, vast wildernesses, in which Man was swallowed up in the huge expanse of the unknown, filled with all kinds of barriers and dangers—chasms, tempests and crags, beetling cliffs and towering trees.

This view of nature became so popular that it was adopted by landscape gardeners, who developed a passion for arranging enormous rocks or cutting wild ravines in the middle of a smiling countryside. Yet man, living as a stranger to his environment, did not necessarily find it dangerous or antagonistic, but only outlandish. Having no affinity with nature, he might consider it unpredictable though not actively hostile. This entailed doubting the whole experience of the senses, as one can see from the earliest works of Corot, where not only trees and hills but even buildings belong to a world of their own, wholly unconnected with the spectator. The eye and the mind are completely at variance with each other.

The painter was an astonished witness of a world in which he had no part. Yet order of a kind emerged in the arrangement of colors, and with it space, not fluid as in Bonington or Constable, but filled with solid landmarks. Since the landscape was itself impenetrable and uninhabitable, it was perforce massive and immovable, its trees and stones firmly planted in the earth. Weight, in fact, was their essential quality, for to the painter they were anonymous objects of which he knew nothing save their color and distance.

The discovery of an elemental world may well have filled Corot with wonder. But the novelty soon wore off, and under his repeated scrutiny things took on a familiar aspect. Objects nameless at first were in time imbued with memories. The hectic treatment of his early Italian studies gave way to the gentle harmony of the views of Tivoli and

Ville-d'Avray. The immediate vision of wild nature, in which there is no place for man, is in the long run unendurable; hence the difficulty of giving an absolutely objective rendering of landscape. But the breach between man and his environment could not be healed by the direct apprehension of the senses. To understand the world and recapture the synthetic outlook required a cosmic vision, that of the poet rather than the painter. By refusing to remain earthbound and rejecting the evidence of his senses, a man might gain new awareness of the infinite; but he would have to find, as Shelley did,

> "Where the earth and ocean meet,
> And all things seem only one
> In the universal sun."

Although everything dissolves in the continuum of the elements, this is no plunge into Nirvana but rather an intelligible view of the universe where the mind, reaching beyond chaos, identifies itself with the rhythm and, especially, the unity of the world. Objects have less distinctness than ever, being now swept away in a cosmic vision.

While this was the outlook of many great Romantic poets, it was also shared by certain painters, notably Turner. They sought to express the dizziness that overcomes man on the threshold of the infinite, and this meant representing vast spaces. The vision was all-embracing. Accidents of time and place gave way to a vast synthesis obliterating the rocks and walls against which they stumble who can see only with their eyes. Moreover, a purely static vision of the world, while it gave perfect expression to the divergence between mind and sense, could not encompass what was both living and boundless. The new vision required a new dimension of unfathomable depth. Paintings were wholly dominated by movement and their essential component was light, since it is imponderable, indefinable and boundless. Their gyrations and trajectories did not signify the motion of an object through fixed space, for in that universe there were no objects, but rather the mobility of space itself.

Having swept away the obstacles constituted by direct observation, painters were left with pure movement, but also—possibly because this state of flux could have neither position nor permanence—with the feeling that nothing outside their own awareness was real. The minds of poet and painter did not impose their own order on the world but merely denied it all weight and substance, building in their own image a universe which should absorb and dissolve everything—land, sea, storms, the implements of men. The mingling of earth and water with light might well be called the very substance of consciousness; and since this appeared to be the whole of reality, there was no point in giving shape or mass to the sentient world or in setting limits to it.

This lyrical pantheism sprang from the exaltation of men who felt themselves borne along on the great cosmic tide. Unlike some of their contemporaries they felt no biological empathy with life around them, but rather a conviction that they could be spiritually at one with the universe and share in its mutations. But they did not attain this degree of contemplation without being aware of their own weakness. Instead of frustration they experienced a feeling of immensity, even of being swallowed up by the infinite. Indeed the boundlessness of Turner or Shelley is sometimes akin to the desolating belief that one is adrift in a sea of enemies.

PRIMEVAL NATURE

Mountain landscapes and desolate scenery were favorite themes with many nineteenth-century painters. But the novelty of their pictures lies more in the subject matter than in their grasp of purely pictorial problems. Each such picture expresses in its own way the solitude of man in the wilderness of nature.

Throughout the West artists tended to portray the same strange, uninhabitable places. But these were a discovery not so much of the eye as of the mind. Rocks and chasms served to express a sense of man's total estrangement from nature, his bewilderment in the face of an immense and awe-inspiring world. The choice of a wild landscape can impart the same fantastic overtones to such different paintings as the Rocking Stone, *by the English artist Thomas Girtin, and the* Geltenbach Falls in Winter *by the German artist Caspar Wolf. The sober composition of the first and the disquieting colors of the second succeed in creating an atmosphere as powerful as any to be found in the dramatic landscapes of American Romantics like Thomas Cole.*

Caspar David Friedrich had a very different aim in view. In his solitary rambles on the shores of the Baltic and through the Harz Mountains, he sought out and depicted such wild, impressive scenery as best reflected his moods, his congenital melancholy. The oppressive stillness of his landscapes is pregnant with meaning. Sometimes the object he contemplates is a tree lashed by the wind, sometimes the vast expanse of the sea. One of his most significant paintings, the Chalk Cliffs of Rügen, *shows a view over the Baltic through a gap in the trees and crags; far below the sunlight plays on the waves in a shimmer of blue flecked with purple. The sense of an ideal, inaccessible world is intensified by the attitude of the figures, only one of whom gazes at the sea, as if lost in the contemplation of infinity.*

It seems certain that the Wreck of the "Hope" *was intended neither as a representation of the far north nor as a record of an ill-fated sea voyage. The picture is, rather, a symbol of the tragic side of nature; Friedrich uses the image of the ice-floe engulfing the helpless ship to express the implacable hostility of nature, and also perhaps the futility of all human endeavor.*

CASPAR DAVID FRIEDRICH (1774-1840). THE CHALK CLIFFS OF RÜGEN, 1818. OSKAR REINHART FOUNDATION, WINTERTHUR.

THOMAS GIRTIN (1775-1802). THE ROCKING STONE, ABOUT 1797. WATERCOLOR.
BY COURTESY OF THE TRUSTEES, TATE GALLERY, LONDON.

CASPAR WOLF (1735-1798). THE GELTENBACH FALLS IN WINTER. OSKAR REINHART FOUNDATION, WINTERTHUR.

CASPAR DAVID FRIEDRICH (1774-1840). THE WRECK OF THE "HOPE," 1821. KUNSTHALLE, HAMBURG.

THOMAS COLE (1801-1848). THE OXBOW (CONNECTICUT RIVER NEAR NORTHAMPTON), 1846.
THE METROPOLITAN MUSEUM OF ART, NEW YORK. GIFT OF MRS RUSSELL SAGE, 1908.

The radical changes brought about in landscape painting, especially in England, were a matter of both subject and technique. In fact little remained of the qualities hitherto considered essential to landscape, neither the harmonious grouping of objects nor the lighting contrived to bring out the beauty of a site.

Fundamentally, Constable and Bonington painted reflections, mist and skies. A deserted shore, a meadow or a marsh were as important in their eyes as Salisbury Cathedral. Their vision changed, often radically, according to the time of day and the state of the atmosphere. Anticipating the Impressionists, Constable carefully noted the faintest variations in light caused by the height of the sun and the density of the air. The same is true of Turner between 1805 and 1810 when he painted many small pictures directly from nature in the Thames Valley. For a linear conception of space he substituted a play of luminous masses, and rejected precisely defined forms in favor of a sweeping, indistinct vision expressed with great technical freedom.

Soon, however, Turner wearied of observing light effects on the Thames and moved on to a cosmic vision. The Burning of the Houses of Parliament *(of which he made several versions) marks a decisive stage in his development. He creates a swirling image of a world composed of water, glowing light, smoke and clouds. The horizon line, burst open by a great flash of light, evokes a limitless vista of space; all objects are dissolved in the atmosphere. Going far beyond the careful observation on which it is based, the painting is like a sudden glimpse of some fantastic spectacle. Not a single form is defined and vast stretches of water and sky emerge from a welter of color.*

In Turner's later canvases, nothing distinct appears beyond the shifting pattern of the brushwork and the rapturous sweep of his increasingly transparent colors. Actually these are abstract paintings, lyrical through and through. The creation of a visionary, landscape is reduced to a fluid space that seems to be born of colored light.

RICHARD PARKES BONINGTON (1801-1828). THE NORMANDY COAST. UNDATED. LOUVRE, PARIS.

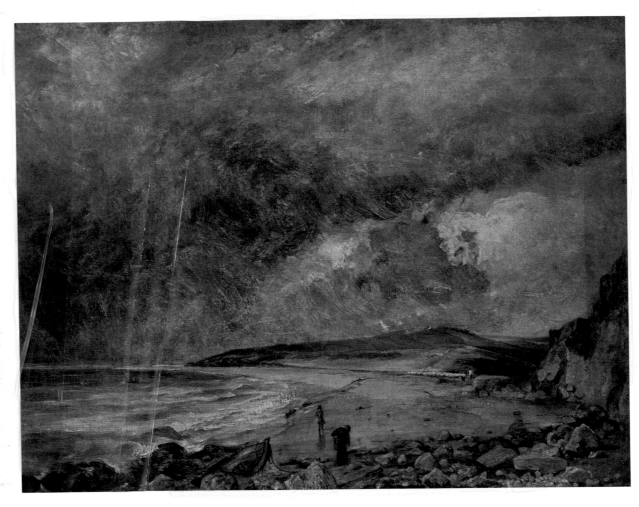

JOHN CONSTABLE (1776-1837). WEYMOUTH BAY. LOUVRE, PARIS.

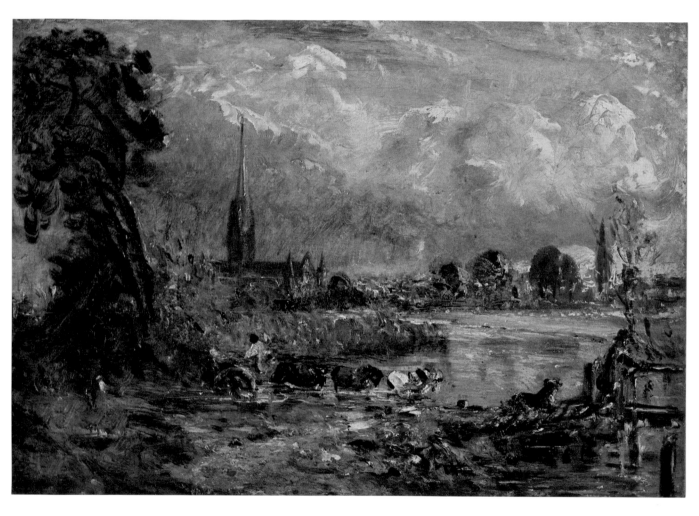

JOHN CONSTABLE (1776-1837). SALISBURY CATHEDRAL FROM THE MEADOWS, ABOUT 1829.
BY COURTESY OF THE TRUSTEES, TATE GALLERY, LONDON.

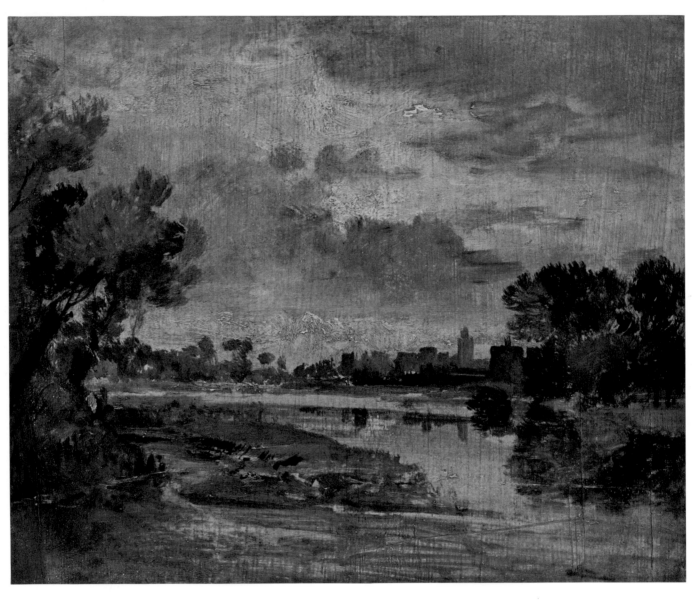

J.M.W. TURNER (1775-1851). ON THE THAMES (?), ABOUT 1805-1810. SKETCH.
BY COURTESY OF THE TRUSTEES, NATIONAL GALLERY, LONDON.

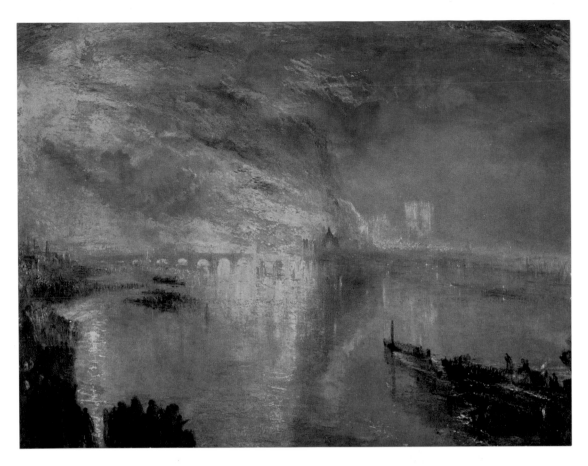

J.M.W. TURNER (1775-1851). THE BURNING OF THE HOUSES OF PARLIAMENT, 1834.
THE CLEVELAND MUSEUM OF ART, JOHN L. SEVERANCE COLLECTION.

J.M.W. TURNER (1775-1851). STORMY SEA. LATE PERIOD.
BY COURTESY OF THE TRUSTEES, TATE GALLERY, LONDON.

That art is an intellectual activity seemed self-evident to some nineteenth-century painters, not only in France but also in England, where Cotman, more than anyone else, interpreted nature in terms of a subtle geometry which was the exact and harmonious realization of his vision. His originality lies in his extreme limitation of depth. In his Landscape with Viaduct *the arches and their reflection in the water fill the whole picture space; no room is left in the narrow strips of sky and foreground for the vanishing lines that create recession. The dark masses glimpsed through the mighty piers loom up close at hand, forming a barrier that obstructs the view. Thus the whole composition rises in vertical tiers. By means of forceful contrasts the painter accentuates the sharpness of angles and the structural solidity of the viaduct. Each form is reduced to its essentials.*

Valenciennes and Granet achieve something of the same strength and solidity by building up their pictures around highly simplified architectural forms. Almost always, these provide the structural surfaces on which all effects of perspective and lighting are based.

Some of Corot's paintings, particularly the early studies made in Italy, are also built up around powerful architectural forms, and his radical simplification of volumes seems to reflect a concern for geometric equilibrium. At the same time, however, Corot always seeks to render atmosphere and takes care not to separate objects from each other. In the pictures painted from nature he records what he sees with the utmost directness and under his brush the landscape sometimes takes on a wild and disordered aspect which excludes any prearranged structure. In these paintings, colors and brushwork play a key part, and certain horizontal strokes, together with sharper and darker accents at certain points, plot out the structural framework into which volumes are fitted. Corot has no need to mark off forms with outlines or shadows; the colored masses themselves constitute buildings, mountains and trees. The pictures he painted on the site between 1825 and 1840 enable us to share intimately in an extraordinary dialogue between the painter and nature. Far from being the result of any preconceived design, their stability is worked out in the course of the execution itself and they thus reveal the underlying mold and figuration of the external world.

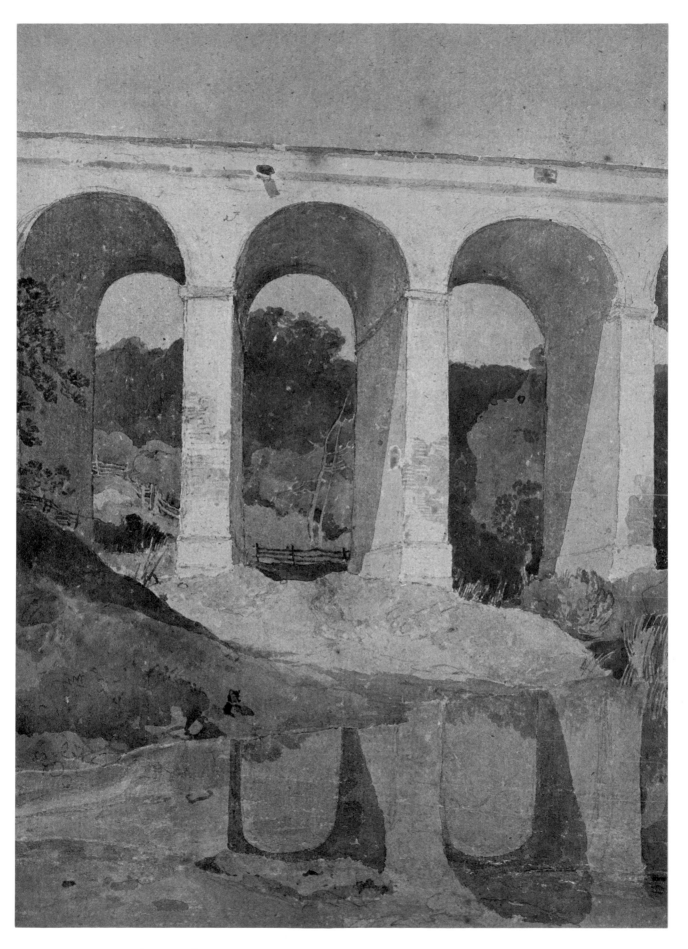

JOHN SELL COTMAN (1782-1842). LANDSCAPE WITH VIADUCT, CHIRK. UNDATED. VICTORIA AND ALBERT MUSEUM, LONDON.

PIERRE-HENRI DE VALENCIENNES (1750-1819). ON THE SLOPES OF THE QUIRINAL, ROME. UNDATED. LOUVRE, PARIS.

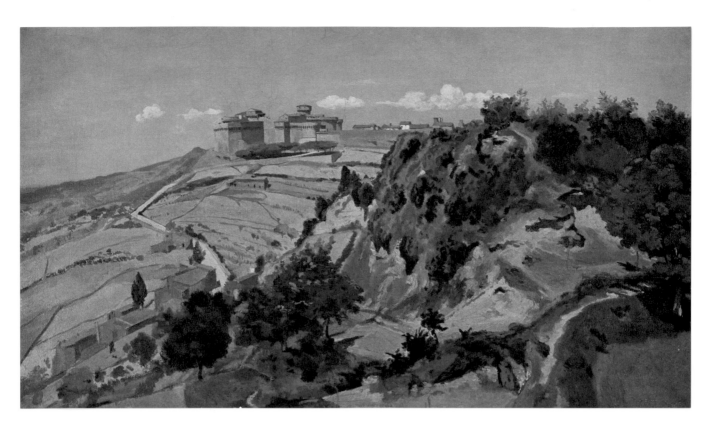

CAMILLE COROT (1796-1875). THE CITADEL AT VOLTERRA, 1834. LOUVRE, PARIS.

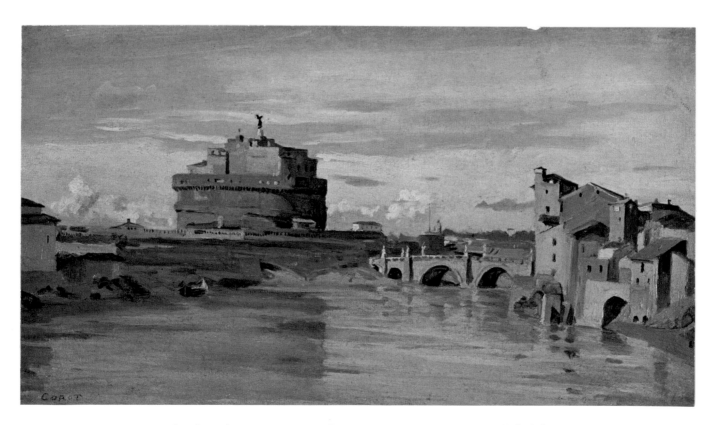

CAMILLE COROT (1796-1875). THE CASTEL SANT'ANGELO AND THE TIBER, ROME, 1826-1828. LOUVRE, PARIS.

5

LANDSCAPE

Variety was the main attraction of late eighteenth-century gardens, which offered a kind of cross-section of all the aspects of nature. They brought together in one place waterfalls and whirlpools, woods where oaks and beeches mingled with more exotic trees, and meadows traversed by placid streams. At Ermenonville or Méréville it took less than a quarter of an hour to wander from the jagged rocks of some wild gorge to the shaven lawns stretching beneath the castle windows. Along the carefully traced-out paths, surprise after surprise lay in wait; the scene changed at every step. But the gardener sought to appeal less to curiosity than to the feelings. A flutter of fear came over the visitor who ventured on to the fragile bridges thrown over chasms, and the tombs and ruins encountered in peaceful spots prompted a train of melancholy thoughts. But if he walked further on, his attention would be diverted by the rustic activities of a dairy-farm or the cheerful clatter of a windmill; or he could push off in a boat that carried him downstream through shadow-haunted glades. The eye and the mind were continually being appealed to. Without stepping outside the garden, he could experience all the sensations that nature can arouse.

Paintings, prints and drawings were also meant to touch an emotional chord. The landscape painter had turned away from the measured order of classical

JOHN CONSTABLE (1776-1837).
LONDON, WATERLOO BRIDGE AND THE THAMES,
ABOUT 1817-1820 - INDIAN INK.
VICTORIA AND ALBERT MUSEUM, LONDON.

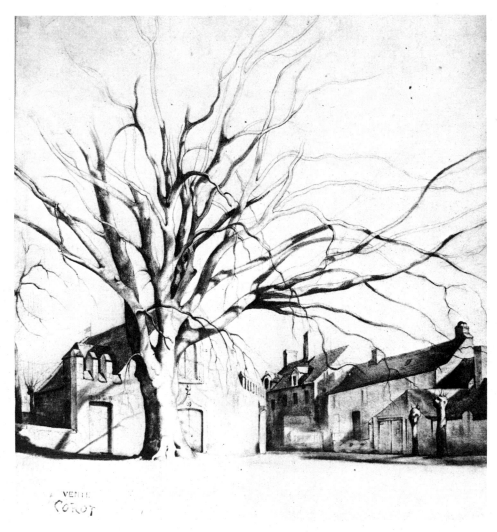

CAMILLE COROT (1796-1875). VILLAGE SQUARE. PENCIL. PRIVATE COLLECTION.

THE BYRE AT LE RAINCY.

THE GREAT CASCADE AT MÉRÉVILLE.

THE CHATEAU OF ERMENONVILLE, NORTH SIDE.

(ENGRAVINGS BY CONSTANT BOURGEOIS FROM LABORDE, "DESCRIPTION DES NOUVEAUX JARDINS DE FRANCE ET DE SES ANCIENS CHÂTEAUX," PARIS 1808).

sites; like the poet, he now "hearkened to his feelings." But it is one thing to express the emotional impact of natural scenery, another to wax lyrical over sites trimmed and formalized by human hands. For a painter, the emotion aroused by the mere act of seeing and feeling may be so strong that the actual scene before his eyes loses all importance. This presupposes a radical change in style and techniques, and in the nineteenth century such a change took place. In landscape painting the results were revolutionary. Constable in England and Corot in France suddenly broke away from classical forms, each being intent on expressing a fresh, personal and direct vision of the external world. They no longer painted just trees or rivers, but the meaning these things had for them. Theirs were subjective discoveries, and the consequence was a new variety in the painter's means of expression.

To the artist or the poet, nature appears as an extension of his own sensibility, and his contacts with her may have an immediacy denied to others. Only a technique reduced to hatchings and dark masses, like that of Constable's ink drawings, can express such a vision. Forms are so obscured by the ink wash that the spectator can no longer be sure whether he is looking at the Thames or a stretch of marshland. Trees are reduced to leafy masses that might be taken for clouds. The ambiguity of the painter's vision is revealed in the way the pen skims the paper, as if it had been dipped in the turbid river itself, the strokes gliding on then suddenly breaking off. Here Constable entered so completely into what he saw that he seems to identify himself with sky and river.

Corot felt his way wonderingly towards this new, undescribed world. He uses sharp outlines and well-defined forms to suggest the strangeness of the Civita Castellana ravine, with its gnarled roots, tangled branches and rugged boulders. There is no need to look for the small figure dwarfed by this chaotic landscape to feel, with the painter, the wildness and grandeur of the scene. Such figures are unusual in Corot's landscape sketches; here, perhaps, it denotes a certain anxiety, his need to distinguish himself from this strange world and take its measure.

In the sketches of later years Corot is at peace with nature. Judging by such a drawing as the

Village Square, one might suppose that the theme itself is enough to account for the change of attitude. But that would be to ignore his new concern for stability in balancing masses of shadow against each other and harmonizing the different elements of the design. Instead of plunging us into the midst of a chaotic world, he stands back far enough to set the tree and buildings before us, and well beyond us, in their just relation.

Constable, Corot and Turner give us none of the carefully wrought order of the landscape gardener. They looked at nature with their own eyes and recorded what they saw and felt in the most direct terms. This was a new departure, and one which the public of their time was at a loss to understand. In his old age, without seeking it, Corot achieved popularity by evoking the silvery mists of autumn in woodland scenes tinged with a melancholy which had already appeared, at the beginning of the century, in John Crome's landscape etchings. As represented by Crome, a solitary tree, battered and stripped bare by the elements, becomes a symbol of solitude. It is not meant to be seen for what it is, but rather as an invitation to reverie.

Many print collectors demanded more than this. What appealed to them was a scene illuminated in such a way as to suggest a possible drama, impending event, or mystery. A comparison of Corot's drawings or Crome's etchings with the work of Romantic engravers (Paul Huet's *Bridge in Auvergne* for example) reveals a striking difference. Neutral grays, sharp outlines and sober lighting have given way to violent contrasts which completely change the landscape. Harsh lighting throws an aura of the fantastic over the little stone bridge. The obscurity of the foreground and the ambiguity of certain forms impart a sense of mystery to familiar scenes, rural subjects and seascapes, even though these are often based on direct observation.

Here we find once more something of the pleasure afforded by gardens. The garden lover, too, was not interested in direct contact with nature; what he was after were the various, often violent emotions aroused by a succession of changing scenes and by the symbols they suggested. Painters elicited from nature the secrets of their own souls; for the public, nature was only the background against which the drama of one's own life was enacted.

PAUL HUET (1803-1869). A BRIDGE IN AUVERGNE, 1834. ETCHING.

CAMILLE COROT (1796-1875). RAVINE AT CIVITA CASTELLANA, 1826-1827. PENCIL.
CABINET DES DESSINS, LOUVRE, PARIS.

JOHN CROME (1768-1821). A SCENE IN A WOOD. ETCHING FROM "NORFOLK PICTURESQUE SCENERY," 1834.

IV

THE INNER LIFE

THE MIRRORS OF THE SOUL

When it is difficult or wearisome to apprehend the tangible world directly, one may as a last resort burke the issue and regard everything as merely the mirror of human emotions. The artist who shrinks from the contest with reality will depict places that are merely a projection of his dreams. Landscape is especially suited to serve the poet or painter as a mirror. As such it is constituted, not by a bird's-eye view of the world or by detached observation of a place, but by a number of features chosen for their emotional content. Its most perfect expression is doubtless Lamartine's *Vallon*, that sanctuary which is both his birthplace and "a refuge for a day on the road to death."

The *Vallon* was of course a solitary place, the haunt of poets fleeing human society and the life of towns. It was the refuge of Obermann, the Lake Poets and many others. Its gates, secure against intruders, lay open to those who knew the way. It was only inaccessible because, like the soul, it was a closed and private place, not easily discovered. It recalled a man's birth, occasionally his first love. It was said to be pure, inviolate, impregnable, an abode of peace. The *Vallon* signified almost undisguisedly a return to the womb. In that blessed valley there was usually untroubled water—a stream, a pool or a cool spring—which might well become milk in the manner described by Bachelard.

In many Romantic paintings one can see gentle slopes cradling the pond or the meadows where the solitary loved to dream. Yet those hills or thickets which shield the spot from profane eyes seem hardly enough to convey its essential unreality. In fact the enchanted countryside does not belong to the present but to childhood. It is looking-glass land, remembered with longing. It may once have existed; it surely does no longer. Its peace is of the past and lives only in the memory. The chosen land is not only secure but impossibly far away: an aspect that some painters conveyed either by giving only a distant glimpse of it through a screen of foliage or through the blur of mist, or else by stylizing it as it would emerge from some protracted reverie.

This landscape, with its memory and promise of repose, well reflects the dreamer lost in contemplation or repeating with ineffable languor the gestures of bygone days. In fact, the presence of figures in the landscape merely confirms the torpor of that dreamworld, which can neither change nor give proof of itself since it is only the image of self-recollection. A longed-for haven of peace, the landscape is also filled with the thought of death, the final, dimly desired return to the womb of mother earth. It is a sign of introversion, fear of life and refusal to face its vicissitudes, for death in this case is neither a fulfillment nor a cutting off, merely an escape into the warm cupboard of the womb. Poets usually put this idea into words; in paintings it appears in symbols—crosses, tombs, dead trees, but more often it is simply conveyed by grayness in coloring, by the time of day, generally nightfall, or by a slackening of rhythm.

The same mood may be seen in the fashion for embellishing secluded corners of parks with tombs and cenotaphs to encourage melancholy meditation, or in the weakness for cemeteries so conspicuous in English poetry and in French and German tales.

If nostalgic landscapes now became the favored medium for the expression of feeling, it was perhaps because portraiture lends itself less readily to subjective treatment. Many portraits of the time show tear-stained cheeks and passionate or tender gestures, but fail to move us. These looks and gestures seem artificial because they only convey the outward signs of emotion. We feel no compulsion to share the mood or memories which may have called forth the grimace that meets our eye. To enter into another's dream we must be made to share his inward vision.

Sometimes, however, the figure itself, like the looking-glass landscape, is no more than an image glimpsed in a dream or in the depths of memory, so that much the same methods may be employed to preserve its mystery. Flattened curves may throw a protective screen round it, strengthened by shadows and relaxed rhythms—anything that will frame objects or persons without wholly revealing them. By employing chiaroscuro to obscure features and outlines, effacing their objective reality, one can get the same effect as the remoteness obtained in landscapes by the use of grisaille, mists or veils of foliage. Sleep, reverie, the averted gaze—these are more effective keys to the heart than any painted tears, for they make a person, like a landscape, something that is here and not-here, the "insubstantial pageant" of a dream or a yearning.

It may seem paradoxical that a portrait, likewise, should become a means of self-expression or of projecting oneself on the outer world and denying its discreteness. After all, the portrait painter is necessarily confronted by a wholly distinct personality. His subjectivity should be dispelled or effaced by the presence of his sitter, the more so since nostalgia cannot proclaim itself in the teeth, as it were, of some other presence.

Revelation of someone else, however, may not be what it seems. The writers of that period did not make any hard-and-fast distinction between themselves and others, so that frequently their portrayal of another character became an almost neurotic obsession with their own. Their poems and romances embroidered endlessly on the theme of the identical twin, the image in the mirror. The latter might, as in Poe's William Wilson or Musset's "Etranger vêtu de noir," be a case of straightforward double identity, or it might assume many different forms, wherein identical fates or strongly cognate souls were no longer linked with similar bodies, so that the alter ego, whether angel or fiend, only betrayed its secret kinship by impregnating the mind and modifying the behavior of its double. Thus friendship, love, hatred ceased to be entirely a matter of revealing another but rather a matter of unearthing some mysterious affinity or antipathy.

The wholly detached mind cannot, of course, express these hidden depths of feeling. That is why a painter might produce a commissioned likeness of frigidly artificial sentimentality, whereas his portrait of someone he knew well would divulge a mass of subjective detail. Sitters, in fact, were no longer regarded as objects for study but solely as symbols of liking or aversion, as means of revealing oneself or elucidating some mystery or affinity. The model's psychology as evinced by the style and expressiveness of the portrait was of minor importance, as were his peculiarities of feature or gesture; nothing remained of his personality save the emotional bonds that the artist found with himself. Once more light and shadow played a predominant part, for chiaroscuro, without actually eliminating space, makes it indefinite. In this way love and hatred were not focused on some definite external object but were conveyed by a glance. Features were transformed and their fleshly, individual traits effaced by broken outlines and fragmented planes, so that they became floating apparitions expressive of all that is most volatile, fluctuating and ambiguous in the feelings of one person for another. Portraits no longer sought to give a likeness in the strict sense but to convey the artist's speechless amazement at comparing, if not identifying, himself with someone else. Perhaps they also propounded a question which has never been answered and which is that of Narcissus rather than Pygmalion. It has been said that the Romantics portrayed the soul, which is true if by that is meant the artist's soul and not the model's.

SYMBOLS AND CHIMERAS

When Taglioni, clad in filmy tulle, first flitted across the stage on her toes, ethereal and fairy-like as a dream, she may have embodied something of the subjectivity expressed in mist-shrouded landscapes, but she was also a vision whose phantom presence gave greater promise of Nirvana than did the moody ecstasies of the solitary dreamer.

Weightlessness, soaring and transparency, which characterized the Romantic ballet, recur in various ways in portraits and illustrations. To choreographers and painters, as to poets like Nerval or the German story-tellers, a woman became a wood-nymph. She may have been a memory, an unattainable ideal, but she was also Titania. To the here and not-here of nostalgia and to the fear of life was added a mythology whose only appeal, as often as not, was that of a nursery tale, yet another road back to the bliss of childhood.

This gave rise to an inane, contemptible infantilism, exemplified by the illustrations to romances, with their wan, childlike faces and their weak, fuzzy drawing, whose flabby affectation appears again and again in genre paintings or portraits. The real purpose of all this gossamer art is to tempt us into a never-never land without the ecstasy or agony of plunging into the unconscious. It is as if one were to relate a dream without experiencing it, for unreality is all that remains of a dream whose horror or enchantment has been forgotten. This comfortable world of the nursery had its counterpart in those gushingly sentimental albums of prayers and ballads which appeared in every drawing-room and seemed to be echoing, after twenty or thirty years, Blake's *Songs of Innocence*, but without recapturing anything of their magic.

The revival of the fable was certainly bound up with this trend. Thanks to the researches of Herder, Brentano and the brothers Grimm a number of old tales were put back into circulation, giving rise to

many works of fantasy which did little more than travesty the conceits and marvels of their prototypes. Nodier and Hans Andersen did not embark on a painstaking study of folklore or try to follow old-established tradition; they merely made use of material that suited their purpose. Nineteenth-century tales, unlike those of former times, were intended for readers who did not believe in sprites or fairies. If a writer allowed himself to be carried away by his fantasy, he knew or assumed that it had no reality and he was only indulging his fondness for this extravaganza which provided such convenient symbols for irony, tenderness and disappointment. Nothing was left of the original idea except the magic of spells and transformations; the mystery was gone, for the myth had lost its meaning in the counterfeit.

These products of whimsy rather than imagination found their appeal in naïveté. There was something restful about the straightforward goodness or wickedness of the protagonists, and their make-believe provided welcome solutions to the vexatious problem of real life. Flowers spoke, fountains shed tears, nightingales were princes in disguise and doors were unlocked by those who knew the Open Sesame. This dreamlike equation of man with nature caused more amusement than harm. Like the angels that appear to little girls in cemeteries, it was wholly the work of imagination, shutting out all reality since it embodied neither the tangible nor the unseen. The symbols used in these tales were so obvious and soothing that their artistic expression was inevitably fatuous or grotesque.

The trivial make-believe that so effectively masks the anguish of self-discovery may well result from the anomalous condition of middle-class women. For all their importance in fashionable society, they were never really allowed to grow up. They owned nothing, neither themselves, nor their property, nor their children; yet they queened it at galas and

exhibitions, they attended first nights and sang drawing-room ballads. They were prepared for a lifetime of playing second fiddle by a confined, sheltered and abysmally infantile upbringing, calculated to stunt their minds, sweeten their characters and make them incapable of assuming adult responsibilities. No wonder there was such a spate of fairy-tales, such a vogue for saccharine sentiment in the shape of the silly, doting, dim-witted child-wife, the idol of Monsieur Prud'homme and the darling of David Copperfield.

This sentimental bilge largely concealed the more serious attempts of Blake, Hoffmann or Baudelaire to use fantasy as a means of expressing the mysterious, extrasensory links between man and nature. While the storyteller made a game of magical transformations, the visionary saw deeper meanings beyond them. He, too, did away with outward appearances and "shuffled off this mortal coil"; but instead of weaving fancies, he sought the essence that lay behind matter. Unlike Nodier, Hoffmann believed in the mystery he showed us. Unlike Johannot or Runge, Blake was convinced that the world he painted was more real than the one we see.

They regarded the tangible world as no more than the symbol of man's destiny, in which objects were shown in barest outline. Substance and space werc an impediment to spiritual expression. Ideally, the artist should strive to create a series of allusive symbols whereby each object, stripped of all sentient accretions, should express the innumerable associations men had gradually bestowed on it throughout the ages. Thus, a concept such as tree—connoting growth, protection, separateness, strength—should not designate any one tree or any one place. This usually meant abandoning the third dimension, since shapes were always defined as thoughts or symbols, never as parts of the tangible world. Sometimes, however, and especially in the case of Blake, spatial relationships might be dynamic and could not be adequately expressed in two dimensions. A meaningful gesture might then give an effect of depth, but without creating a material setting for the action, which remained purely symbolic. The siting of objects in an autonomous, objective space would have implied the existence of a place foreign to the creative idea, thus causing needless confusion. The trajectory was accordingly developed in the void, or else it swept up the entire composition in a movement which could not possibly be confused with an objective representation.

Men like Palmer or Blake, Hoffmann or Nerval, could close their eyes to their surroundings and make their relation to it wholly abstract. They did not travesty the world; indeed they penetrated the myths which the writers of fairy-tales had forgotten. Yet, like those who yearned for the Happy Valley, they could not break free from their dreams and build a bridge to the world of living men.

HAPPINESS

Far from the busy centers where new social and economic structures were taking form, a thoughtful, serious-minded society lived on in country towns. For that society the little masters of the early nineteenth century pictured a calm and luminous world where happy moments seem to be held captive and secure forever.

The striking thing about these scenes is their utter tranquillity. A sense of arrested time seems to emanate naturally enough from the halo of light in which Kersting's reader sits dreaming over his book, but it comes as a surprise to find something of the same stillness in an apparently lively scene like Agasse's Playground. *The precise but simplified forms and slow-motion gestures fail to suggest movement, the more so as each of the slender, delicate figures is divided from the rest by taut, finely drawn outlines. It is obvious, for example, that the little girl on the swing is not moving, nor is the equally charming and unreal little boy who is pulling the swing. Each group is balanced by another, and each forms a self-contained unit. Moreover the figures looking out over a distant landscape tacitly invite us, like those of Caspar David Friedrich, to share a mood of meditation whose effect can only be to bring all movement to a standstill.*

The people and objects in these pictures are as spellbound as Sleeping Beauty, and the delicate, often symbolic details combine to create an atmosphere of unreality. The same atmosphere, but subtler and more haunting, pervades Von Kobell's riding scenes. The long cast shadows lend a new fascination to these carefully modeled forms; though they are too schematic and prettified to have anything of a supernatural character, they still convey an impression of timelessness.

The fear of life that transpires so often in the writings and paintings of this period reappears here in the subtle form of a self-contained world where all change is impossible, all intrusion sacrilege—an untroubled world whose image has the nostalgic serenity of childhood memories, but a world continually threatened, for everything it brings before us, youth, affection, happiness, is as fleeting as a dream.

Mysterious, fleeting, infinitely precarious, hard to capture and harder to hold—this was the image of happiness evoked by poets on both sides of the Atlantic. And this is how Canova interpreted it in most of his sketches. The rough model for the Death of Adonis *suggests all that is spontaneous, irrational and vulnerable in unfulfilled love. It is not surprising that in his marbles Canova never attained the fervor and sensitivity which he expressed so naturally in clay. Though a modeler of the highest powers, he was never able to retain in his finished works the rich and expressive ambiguity of his sketches. Immobility must be shattered and forms contorted if the artist is to convey something of the poignant evanescence of love and happiness.*

French, English and Italian artists repeatedly sought to express what the Swiss and German little masters seemed to shrink from exploring—the secrets of being and the mysterious flux of time. When Bonington painted costume pieces, showing ladies of old and odalisques, he was concerned above all with rendering the play of light, with dissolving forms and creating a dreamworld. He realized that if it was drawn with precision his picture would be no more than a social document. But handled as they are, with a diffuse, transparent light glowing on clothes and half blotting out the lines of a face, his sketches acquire an indefinable grace and charm.

Though working with more vigor and emphasis, Turner sought by similar means to record his impressions of life at Petworth House, in Sussex, where he often stayed as the guest of Lord Egremont. There he produced a series of over a hundred watercolors, all painted on blue paper. The female figures hazily conjured up in these sketches are more like apparitions than women. Like the company which, in certain scenes, is shown assembled in the drawing room at Petworth, the young lady seated at her dressing table, wholly wrapped up in herself and unconscious that she is observed, has all the remoteness of a vision or a dream.

Prud'hon, on the other hand, in his Happy Mother, *evokes an image of happiness in all its plenitude. Yet this figure is as dreamy and self-absorbed as any of Turner's. The soft, luminous circle formed by the mother's arms and the child's body seems to catch and focus all the light at the center of the picture. Its glow obliterates the features of the figures and evokes a plaintive sense of the mystery and brevity of life. The flickering lights that consume or soften forms can only express joy and happiness at the moment they are passing away.*

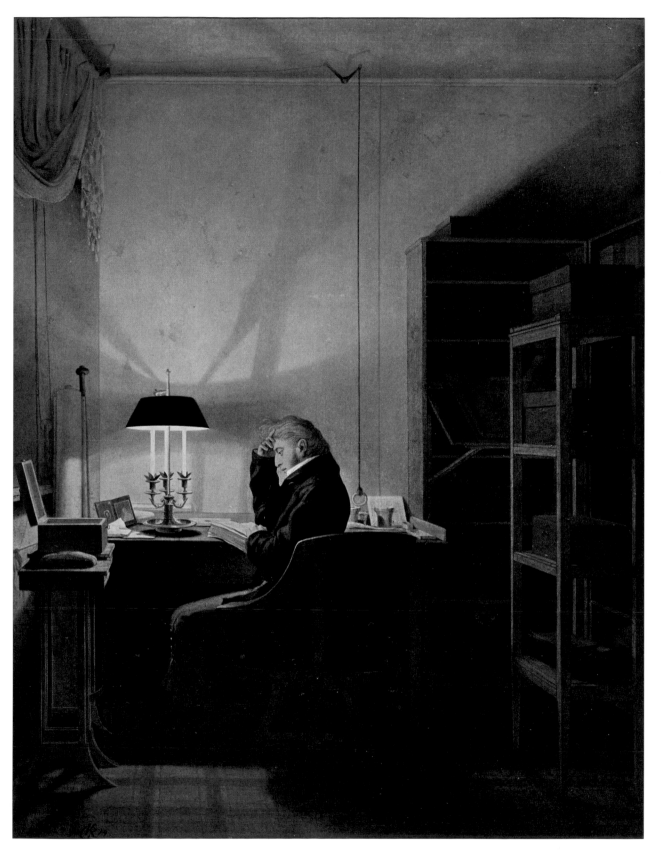

GEORG FRIEDRICH KERSTING (1785-1847). MAN READING BY LAMPLIGHT, 1814. OSKAR REINHART FOUNDATION, WINTERTHUR.

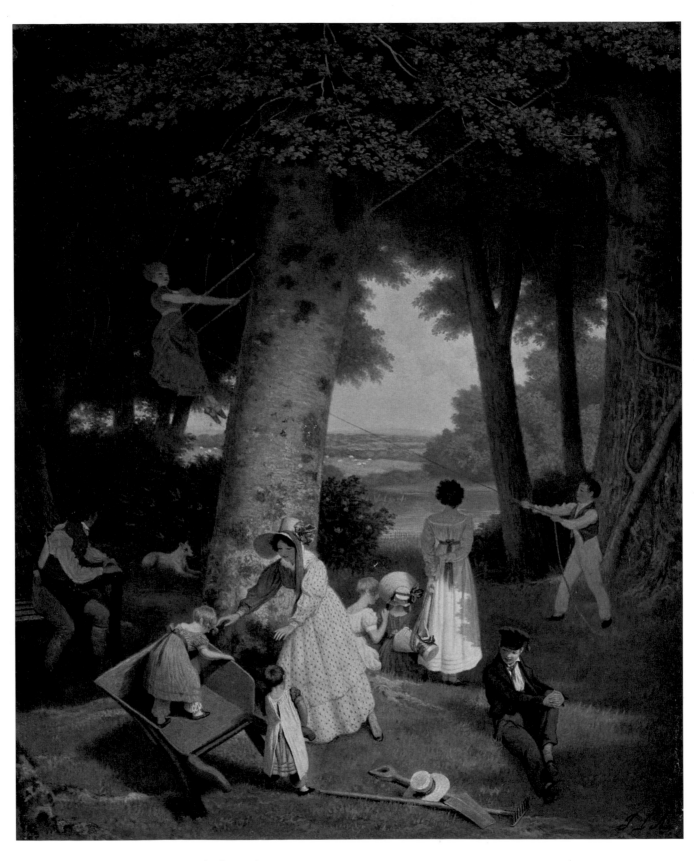

JACQUES-LAURENT AGASSE (1767-1849). THE PLAYGROUND, 1830. OSKAR REINHART FOUNDATION, WINTERTHUR.

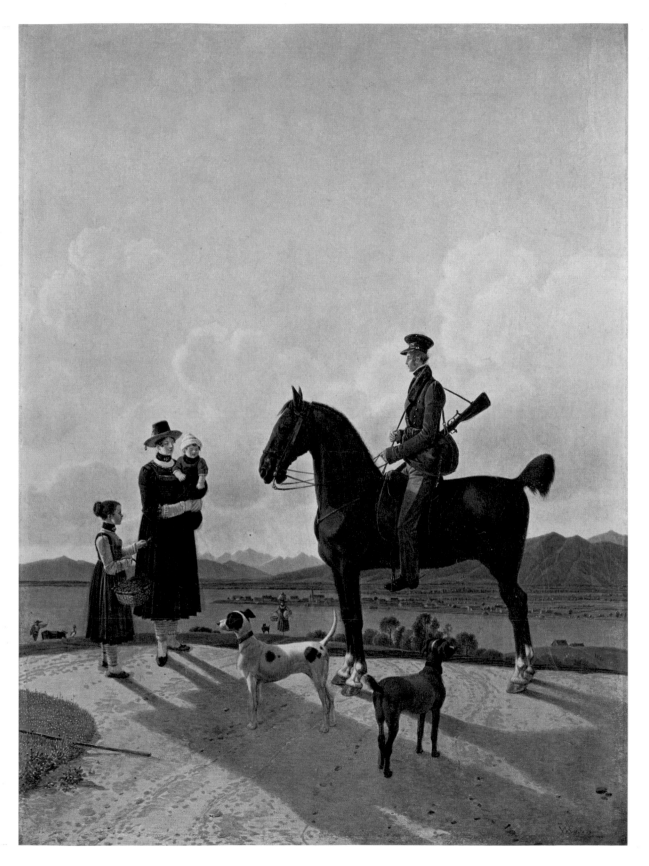

WILHELM VON KOBELL (1766-1855). RIDER NEAR TEGERNSEE, 1825. OSKAR REINHART FOUNDATION, WINTERTHUR.

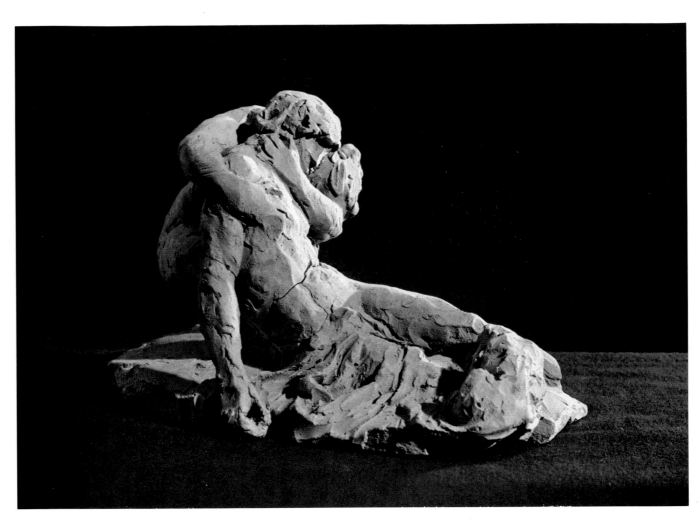

ANTONIO CANOVA (1757-1822). THE DEATH OF ADONIS, ABOUT 1797. GIPSOTECA CANOVA, POSSAGNO, NEAR TREVISO.

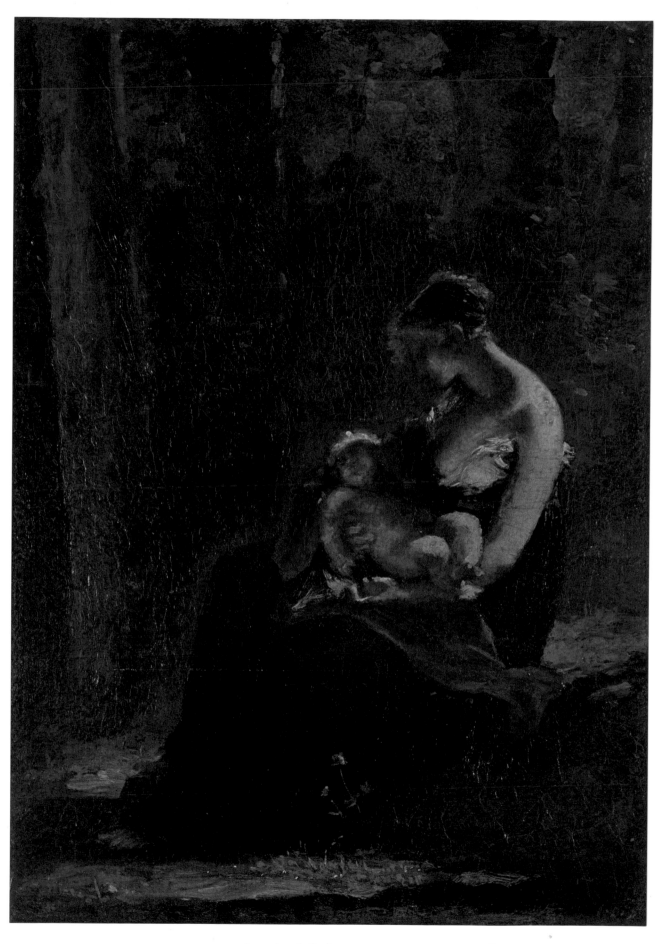

PIERRE-PAUL PRUD'HON (1758-1823). THE HAPPY MOTHER, ABOUT 1810.
WALLACE COLLECTION, LONDON. (SLIGHTLY ENLARGED IN REPRODUCTION)

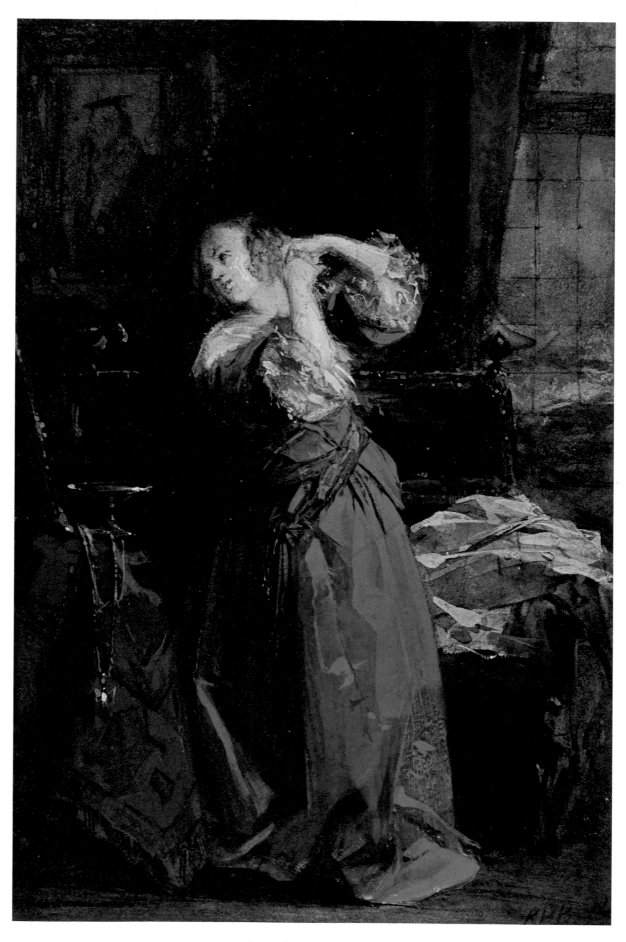

RICHARD PARKES BONINGTON (1801-1828). LADY AT HER TOILET, 1827. WATERCOLOR.
WALLACE COLLECTION, LONDON. (SLIGHTLY ENLARGED IN REPRODUCTION)

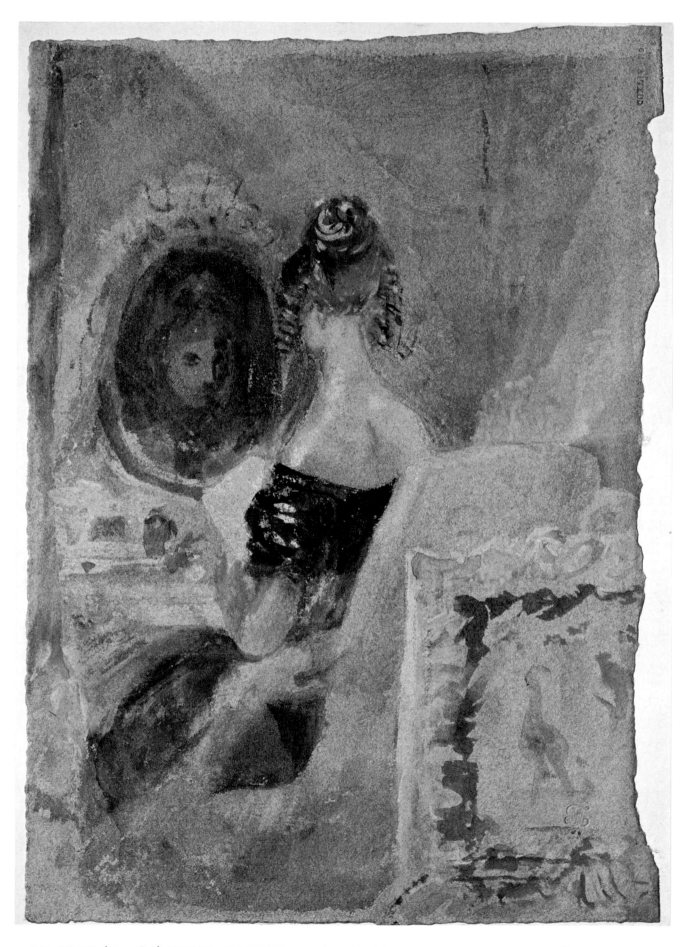

J.M.W. TURNER (1775-1851). INTERIOR AT PETWORTH: LADY IN A BLACK DRESS AT HER TOILET, ABOUT 1830. WATERCOLOR. BRITISH MUSEUM, LONDON. (SLIGHTLY ENLARGED IN REPRODUCTION)

Corot's figure paintings have an originality no less distinctive than that of the studies he made from nature on his journeys through France and Italy. He had always been eager to record his vision of people and things as directly and truthfully as possible. But after 1845 there crept into his portraits and landscapes a sentimental note that differentiates them from his earlier work. He seemed to have fallen a prey to the melancholy expressed by so many artists of this period. His landscapes and trees became increasingly blurred, nostalgic, almost unreal, shimmering through silvery mists and soft gray tones. Though his figures reflect the same emotional response, their full-bodied forms set them apart from the dreamlike images of Diaz and Bonington.

A study like the Girl at her Toilet, *with the shadowy face, the languid gestures and the dimness of certain contours, enables us to measure the depth of Corot's insight into the mysteries of the human personality. Everything about the picture is suggestive of reticence and secrecy, from the girl's dreamy, downcast gaze to the thick dark hair about to fall over her lowered face—only to be held back by a gesture that Degas was to take up more vehemently later. But for all its evocative languor this figure is a compelling presence, thrown into prominence by the background lighting; her movements create a sense of space as she seems to turn towards us.*

Corot's penetrating analysis of the visible world to some extent neutralizes the melancholy of the theme. For the artist, of course, that analysis is part of a process of self-discovery which tends to estrange him from the world, but to the end Corot looked at the things around him with undiminished wonder and delight. Unlike most painters of his time, he does not analyze surfaces in order to express volume; he builds up his picture by means of simple masses that unfold and develop as if impelled by a vital impulse of their own, thus enabling light to play over forms without destroying them and to bring out the subtlest harmonies of whites and ochres. No stroke of the brush but is essential to the construction of the picture. Aloof and unapproachable, but a privileged object of the world of the senses, Corot's Girl at her Toilet *is one of the most complex and tantalizing works of its time.*

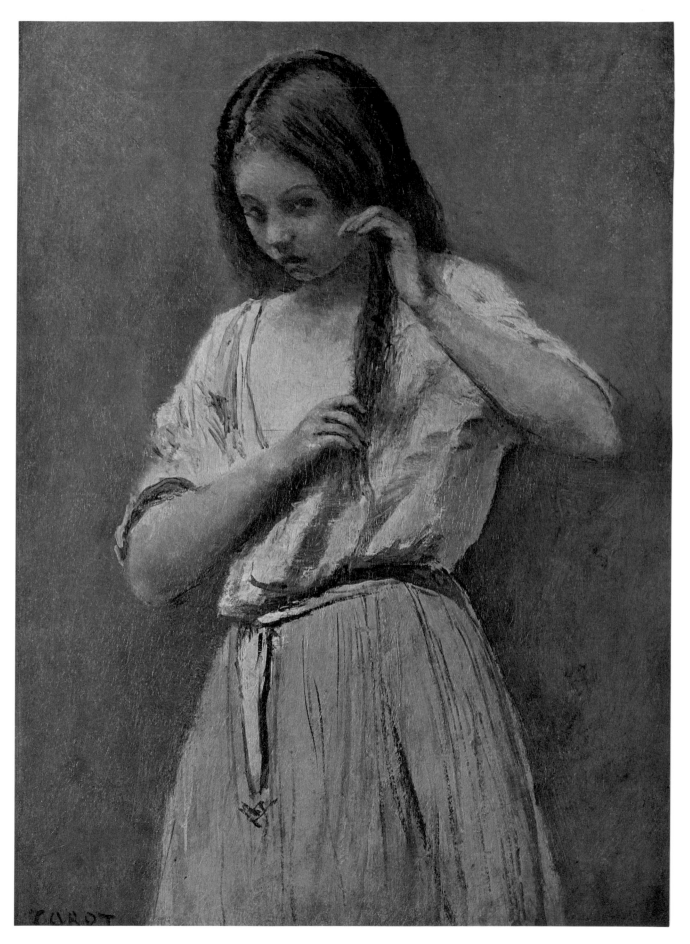

CAMILLE COROT (1796-1875). GIRL AT HER TOILET, ABOUT 1860-1865. LOUVRE, PARIS.

V

MAN IN SEARCH
OF HIMSELF

VIOLENCE

Cataclysms of all kinds—war, riot, revolution—marked with violence the years between the American War of Independence and the social and political upheavals of 1848, which convulsed Europe from end to end.

During this period the actual violence of bloody conflicts and disturbances was magnified by the press and the increasing speed with which news was disseminated. It was almost as thrilling to read reports and articles on campaigns while they were still being fought as to witness the battles themselves, especially for those who had experienced similar convulsions in their own streets.

Meanwhile there was a growing awareness of confusion as the futility of all this commotion became apparent. For nearly always the forces of reaction won the day; the successive uprisings flared up and died away incapable, for all their destruction and bloodshed, of changing the established order.

The ensuing disillusionment largely accounts for the introverted character of the age. It also explains why painters and poets, balked of their reforming crusade, found an outlet in symbolic violence, much as a prisoner in impotent fury might batter the door of his cell with his fists. They found some consolation in an escapist art whose works gave voice to unbridled emotion and glorified human energy.

They did so, however, in terms of Promethean passion, not of effective action. They made no distinction between the hero who sacrifices himself and the egotist who sacrifices others; for both could be portrayed in the same manner and could give a man, however briefly, the sense of wielding power.

The art of the "Sturm und Drang" era is characterized by this explosive and seemingly aimless quality in its themes, a feature that can only be understood by comparing Romantic myths with historical reality and also by examining the doctrines of certain contemporary thinkers, especially the French philosopher Maine de Biran. These men, reacting against idealism and sensualism, exalted self-assertion as the prerogative of the Ego. They insisted on will, action and, above all, the proof of being a free agent.

In their view, however, action was not creative but a means of asserting the permanence and reality of self-consciousness. While Maine de Biran admitted that internal action was not divorced from external, he maintained that the latter function was subsidiary. When he sought to demonstrate what he called the "original fact of consciousness" the whole aim of his inquiry was to ignore all the external consequences of an act and to maintain that its essence was "the awareness of instruments combined with the power of a free agent setting them in motion."

This awareness of power, therefore, exists regardless of its actions, which need be neither effective nor lasting. Moreover, the action, far from changing the world or affecting anyone else, impinges only on the agent, for he is trying not to do anything but to be aware of himself as the doer. Violence, as portrayed in the art of the period, was just like this—brutal, spasmodic, nearly always destructive—for it was confined to practising a freedom whose be-all and end-all was the impassioned, ineffective expression of the Ego. This was almost the only way in which artists sought to invade and dominate the outer world.

This sort of violence was also apparent in music, whose range was greatly extended by the massing of singers and a steady increase in the number and variety of instruments. The German caricaturists who showed Berlioz using artillery in his orchestra

were not altogether mistaken in believing that contemporary composers intended their music to be a bombardment of the audience.

The change, however, was seen at its most striking in the theater. In place of the statuesque figures of classical tragedy, declaiming their emotions one at a time, there appeared characters who made their impact by sheer animal vigor. The spoken word was reinforced by immensely lavish scenery, costumes and direction, and the most violent deeds were enacted on the stage. The severe classical setting gave way to crowd scenes and elaborate props, requiring much bigger stages and drawing larger audiences. The placid spectator of Raynouard's stilted tragedies received short shrift at the hands of Victor Hugo or Alexandre Dumas, who preferred scandal to silence and expected their plays not merely to fill larger theaters but to overwhelm the audience.

Painting displayed not only the stock-in-trade of the so-called *frénétiques*—murder, rape, duels to the death, pitched battles, headlong gallops, wild pursuits—but also methods similar to those employed on the stage. Scenes of violence were usually enlivened and made more tumultuous by the presence of a crowd. The hidden, contradictory, explosive elements in a painting emerged most readily and, as it were, overflowed the canvas, in the form of people attending bullfights or executions, taking part in riots or looking on at assassinations or abductions. Sometimes the amorphous, gesticulating mob would flow away into the middle distance; sometimes it would surge forward as if about to leap out of the frame.

These deliberately violent irruptions into space were reflected in the extravagance both of the paintings themselves and especially of the characters depicted, who were often so massive that the canvas seemed barely to contain them. This effect could be obtained by drawing people larger than life, but better still by making them excessively stalwart, with a generous display of muscle and bare flesh which emphasized the physical, instinctive and often bestial nature of the action.

One might well suppose that sculpture, being three-dimensional, would hold pride of place in this genre. It should be remembered, however, that there was something unreal about all the huffing and puffing, and that the violence, as often as not, was imaginary. The action was not a genuine assault so much as a demonstration of its feasibility. The power to act was there, and the exhilarating sense of begetting it, but no more than that. There was never any allusion to the permanence or effectiveness of the action, which was, indeed, bound to be ephemeral, since it produced nothing new and was merely a vehicle of self-expression. The Romantic flame burned brightly enough but it gave a fitful and flickering light.

The artistic expression of violence was, in fact, temporal rather than spatial. It always took the form of a paroxysm, furious but short-lived. Most significant in this respect was the new school of dramatists, deliberately setting out to startle. They were always introducing situations for which there was no plausibility in the characters or previous action of the play. Innocent victims are stabbed in the dark; an accident or blunder gives a sudden twist to the plot; people appear out of the blue, as unexpectedly as Don César de Bazan, in Victor Hugo's *Ruy Blas*, coming down the chimney in the mysterious house where Don Salluste is lying in wait for his prey. The hero, whether his name be Don Carlos or Ruy Blas, plays his part blindfold, striking out at random and going benighted to his doom. There is no inherent logic about the climax of the action, nor any moral significance in it, for its violence does not imply a consummation, however terrible, merely the abrupt, preposterous interruption of a plot. Even liberty, the central theme of the play, is mocked, since it only asserts itself by an act of aimless destruction.

In poetry and music the desultoriness of time, always fragmentary and unfinished, could be conveyed by meter and rhythm. Pictorially its expression was equally graphic and almost as direct, being embodied in the convulsive violence of the action. Never, perhaps, had artists been so obsessed with rearing horses and figures leaping out of the canvas, with the vaulting, soaring and falling of man and beast, with imminent blows and gestures frozen in their most vehement motion.

The impression of sudden blaze and extinction is still more apparent in the artists' use of light to break up their surfaces, in the contrasting colors,

166

the vibrancy of the brushwork and the writing, often flame-like shapes, giving the picture an apocalyptic effulgence. Sometimes the entire composition is torn asunder, lending incomparable pathos, far exceeding the histrionics of the Romantic drama, to the tragic futility of the violent action, in which man's desperate assertion of his strength ends in swift annihilation.

These scenes of violence and brutality, although they contain an admission of failure, symbolize a quest for truth. In a mood of self-inquiry Man cannot believe himself wholly rational, yet refuses to be a mere puppet or fugitive. The frenzy of these paintings is that of stumbling blindly through the wilderness in a forlorn attempt to find a meaning for himself in action and space.

Artists showed a combative spirit in their deliberately harrowing treatment of violent themes, in which twisted features, gaping wounds and clinical observation of the dead and dying were calculated not merely to affect the beholder but to make his flesh crawl. To achieve this effect, they either filled the foreground with scenes of horror or caused figures in the distance to bear down on the spectator as if about to hurl themselves at his throat.

Incongruous gestures and strident contrasts in the composition gave a further turn of the screw. In the Massacre at Chios *no piling on of barbarities could impart such violence to the tragedy as do Delacroix's two groups of figures with a wide expanse between them. The heap of writhing bodies on the* Raft of the "Medusa" *are themselves a stark definition of tragedy, as is the streak of light dividing the living from the dead in Goya's* Execution of the Rebels. *This deliberate confusion is profoundly tragic, but it also shows that violence is ineffectual.*

The feeling that Man is doomed to shake his puny fists at remorseless Fate appears still more clearly in another antithesis, that of two masses, one motionless, the other in frenzied action. This idea, admirably expressed by the firing squad in the Execution of the Rebels, *may also be seen in the way Delacroix contrasts the huddle of the defeated with the violence of their conquerors. In this case the imagery is contradicted by ineffectual movement. In the* Massacre at Chios *the group of animated figures is isolated by the rearing horse, while the soldier turns away from his victims. The same distribution appears even more strikingly in Daumier's* Ecce Homo, *where the winding throng of scowling faces keep their distance from the still figure of Christ. They are forever beating the air, getting nowhere. Their rage strikes blindly and has no object but itself. In evil it has no meaning, in righteousness no hope. Always it reveals the futility of the human predicament.*

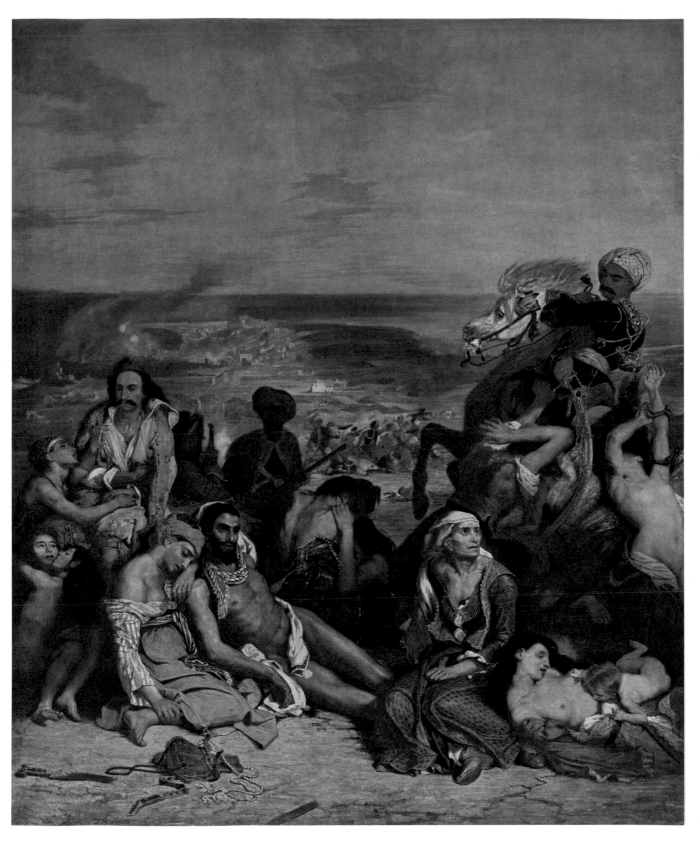

EUGÈNE DELACROIX (1798-1863). SCENES OF THE MASSACRE AT CHIOS, 1824. LOUVRE, PARIS.

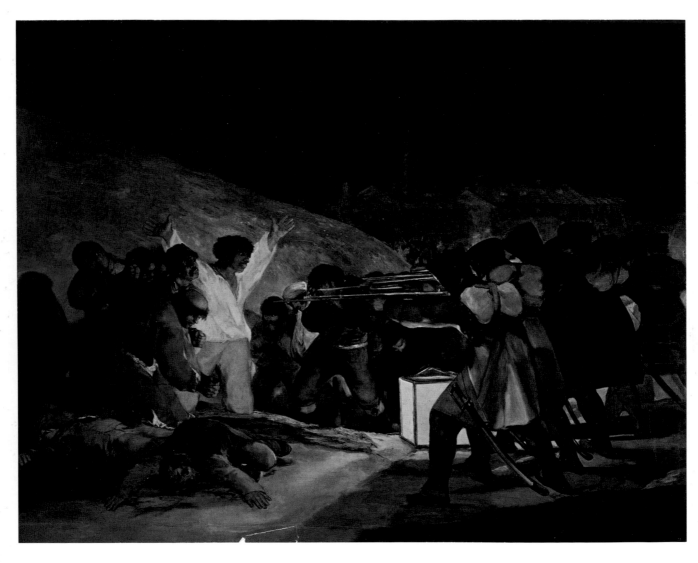

FRANCISCO DE GOYA (1746-1828). THE EXECUTION OF THE REBELS ON MAY 3, 1808. PAINTED IN 1814. PRADO, MADRID.

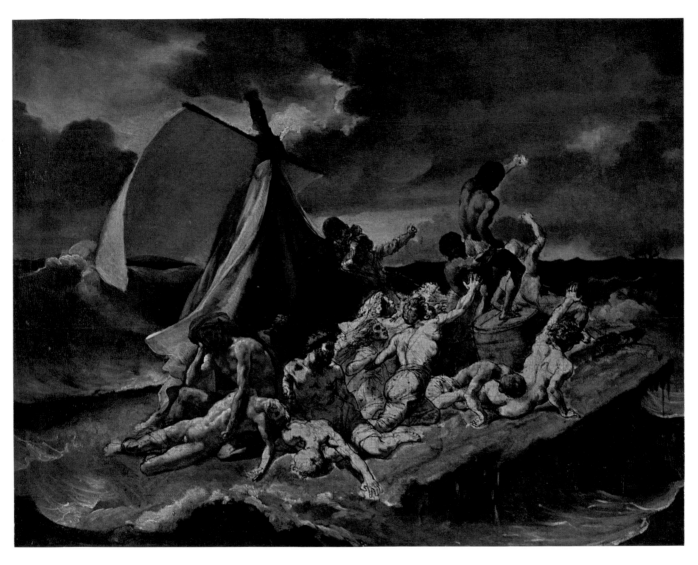

THÉODORE GÉRICAULT (1791-1824). THE RAFT OF THE "MEDUSA," 1818. UNFINISHED SKETCH. LOUVRE, PARIS.

HONORÉ DAUMIER (1808-1879). ECCE HOMO, ABOUT 1850. FOLKWANG MUSEUM, ESSEN.

THE FALLEN ANGEL

Artists, like poets and composers, knew quite well what they were doing when they arbitrarily revolutionized the treatment of space, color and texture. In the emphasis on expression at the expense of form, in the rejection of rules and contempt for traditional standards, the cloven hoof was apparent in every artistic activity.

As early as 1790 Kant had remarked the artist's power of creating works to which he could assign no fixed principles. This, however, Kant attributed solely to genius, whose mystery and singularity consisted in the fact that the artist could neither analyze the creative process nor explain his methods to others, and that his ideas were not of his own volition and came he knew not whence.

The Romantic school went much further than this. In the first place, they held that every work of art must possess the Kantian attributes, that it behooved the artist to violate existing rules, to invent new forms of expression, to insist on being untrammeled by any preordained definition. Moreover, they laid much greater stress on the mystery of inspiration and the impossibility of delivering a final verdict on any work of art. Thereafter the poet and painter, walking in the void towards an unknown destination, appeared both dedicated and doomed.

The artist's inability, despite his vision of the ideal, to make himself understood was vividly described in books like Balzac's *Chef-d'œuvre inconnu*, where a painter devoted his life to a single work which, for all his efforts, remained inarticulate and obscure. In the view of a Romantic, a genius could not explain what he was doing and his work was always liable to remain inchoate. He was not, as Kant saw him, a man whose work, created by some impenetrable process, would become a standard and model for future generations; to the Romantics he was only its potential creator. This attitude was bound up with the tendency of the period to despise the material side of art, the actual handwork that goes into it, and all that determines space. New significance was thus given to the creative act, as such, and the work itself could remain in the rough, a mere sketch or project, without losing any of its value.

The purpose of this amorphism in art was not merely to convey depth of emotion or the inaccessibility of nature, but to enable the spectator to share in the creative process, the irrepressible upsurge of image, melody and color. Artistic creation acquired an aura of sanctity. The poet communed with himself and by the jarring discordance of words and sounds revealed the sibylline forces that swept him along. Hölderlin compared him to Semele, consumed by fire when she gave birth to "the fruit of the storm," but also to Prometheus. The artist was both a brand for burning and a bearer of light. He received the gift of tongues, that he might disclose mysteries of great moment; but he was not wholly master of the gift, for it spoke through him and its utterances haunted and unhinged him. Others saw him as herald or prophet, as priest or sorcerer. Whether deified or damned, possessing the secrets of the world yet obeying a master whose features were often veiled, he resembled the priestess at Delphi, mumbling broken syllables whose true meaning was hidden from her.

Thus the poet's muse forced him to blaspheme God and nature, to trespass rashly on forbidden ground and to surrender his soul. But he experienced one moment of grace. The Romantic poem, painting or Lied was not the product of slow ripening or patient toil; it was a sudden insight, a lightning-flash of revelation. For an instant, but no more, the artist was almost God. Part of his doom lay in the vanity of his attempts—and his own awareness of their vanity—to retain the fleeting rapture of his vision. He was doomed to failure because the tangible outline of his work could never be completed in the sublime moment of revelation. Therein lay yet another reason for extolling perfection and the unsullied vision.

Artists tried, however, to give their finished works the inevitably confused, meteoric quality of the original, truth-revealing vision: for they perceived the evidential value of the rough sketch that crystallized the instant when an inexpressible truth was discovered. In this sense artistic achievement lay wholly in the creative act, which might be as fugitive as the inspiration itself. Since the value of a work of art no longer depended on the finished state, it derived all its vitality from the painter's gesture or the poet's vagary. There was eloquence in strident metaphors, harsh discords, vibrant clashes of color, for they enabled people to witness the actual genesis of art.

When art grows introspective, however, it becomes inaccessible, especially to a public imbued with tradition, conventional in outlook and hostile to anything newfangled. The Romantic view of inspiration, therefore, was a factor in the ostracism of artists —a process which was accentuated by the fact that they were out of place in a society built on cash and credit. They were considered eccentric, mad or incorrigibly uncouth. Their works might be admired, but for a son to demean himself by becoming a poet or painter was a blot on the family escutcheon. Art had ceased to be an honorable trade since its divorce from craftsmanship, and the eclipse of the patron had deprived artists of their place in society. The more firmly they repudiated minor requirements that might have restored them to favor, the more isolated they became. Their work was neither picturesque nor engaging and it contained no message: it merely gave utterance to freedom and destiny.

No wonder poets were both touched with Pentecostal fire and pursued by the Furies. The tragic destiny of Hölderlin, Nerval, Kleist and Gros shows how closely inspiration is linked with madness, grief, loneliness and death. No one heeded them. If they were obscure, it was not only because their inspiration was fitful but because they spoke to themselves alone. In their disdain for the uncomprehending public they might, like Constable or Corot, exhibit works that bore little resemblance to the real paintings they did in private, or they might follow the example of Goethe when he left his second *Faust* unpublished.

Yet this segregation was an agony to them, for words that are spoken in a void lose their meaning even for him who utters them. The artist broke away from his public just at the moment when he knew himself to be filled with a mysterious power, and this helped to give his generation the air of men bereft and groping in the dark.

6

THE TRAGIC MOMENT

The suddenness and irreversibility of an act of violence cannot be conveyed by clearly defined forms and firm outlines. Classical techniques of drawing and painting impose an order and fixity which run counter to the one essential element of dramatic action: the break in time.

More perhaps than any other painter, Géricault was alive to this problem. His favorite themes —aggression, rape, death, rearing or galloping horses—allow of no coherent time sequence; but the style and composition of his pen drawings, as of most of his finished paintings, impose on them a sense of finality. Only the swelling muscles and bulky forms suggest the blind compulsion of straining bodies. In the *Man grappling with a Bull*, the very theme is one of instability and movement, but the massive forms are as motionless as a piece of sculpture. Some of his gouaches, however, like the *Nymph carried off by a Centaur*, express to perfection what the artist was never able to render with such intensity in his paintings: the instantaneity of action and the immediacy of his vision. It is not so much the posture of the figures as the astonishing fragmentation of the picture space by means of flickering brushstrokes which suggests the swift and sudden onrush of figures in movement. Yet, in these drawings, the speed and volatility of his touch are not the result of a flash of inspiration.

THÉODORE GÉRICAULT (1791-1824). NYMPH CARRIED OFF BY A CENTAUR. GOUACHE.
CABINET DES DESSINS, LOUVRE, PARIS.

FRANCISCO DE GOYA (1746-1828).
MEN FIGHTING, ABOUT 1809-1810.
INK WASH. PRADO, MADRID.

EUGÈNE DELACROIX (1798-1863). STUDY FOR ONE OF THE CEILING PANELS IN THE SALON DU ROI OF THE PALAIS-BOURBON, ABOUT 1833. PEN AND INK. CABINET DES DESSINS, LOUVRE, PARIS.

ANTOINE-JEAN GROS (1771-1835).
STUDY FOR "TIMOLEON AND TIMOPHANES," 1798.
PEN AND INK. PRIVATE COLLECTION.

Always in complete control of himself, Géricault hardly betrays the movement of his hand. Most draftsmen worked quite differently when they sought to portray a world torn by violence. For them, direct expression often took precedence over pictorial or dramatic considerations; they seemed to feel that the essential drama lay in the surge of tragic movement, not in its communicable image.

This approach is best exemplified in the work of Goya. In his drawings, and even in his etchings, despite the difficulties of the medium, he tried to seize and arrest the passing moment. Like Géricault, he achieves this by breaking up the surface, by unbalanced forms and disjoined bodies, but such precision as necessarily remains in the forms and outlines of figures keeps us from sharing directly in the artist's emotion. The event he conjures up before us—in terms as brutal as those of Picasso's *Guernica* which he foreshadows—rivets our attention, so that we fail to notice how the forms take shape. On the other hand, in some of his wash drawings, the ferocity of hand-to-hand fighting and the passionate intensity of the rendering are such that the whole scene is reduced to a tangle of obscure masses shot with sudden lights; all that remains is an overwhelming impression of the artist's fiery spirit.

In some drawings, Goya achieves graphic expression at its purest. His hand conveys his feelings directly, and we can follow all his impassioned outbursts and hesitations. Here and there a more emphatic accent reveals a pause in the unfolding outline or, on the contrary, a barely contained uprush of violence. Nothing seems to stand between us and the artist; it is as if we were given a privileged glimpse into the workings of his mind.

Handled in this way, the pen and pencil can free the painter from the limitations of precisely defined images. Thus Fuseli, in his later years, was able to work out a looser, more violent style which gave his figures a hallucinatory quality that more than made up for what they lost in mere prettiness. Its most perfect expression is not to be found in his chiaroscuro paintings but in those drawings where

the nervous energy of his line renders dramatic movement with such intensity that we are indifferent to the subject and aware only of the suggestive power of his ambiguous lines and forms. Ingres and Corot, like all painters who aimed at pure form, avoided these crisscrossing lines, these splashes and streaks which confuse the eye. For them, line alone could capture and define the essentials of an object so as to bring it home to the mind. But when line is enlisted in the service of creative movement, it ceases to delineate objects and becomes instead the vehicle of an instinctive violence which gives rise to dramatic expression.

Paralyzed by academic formulas and painstaking techniques, this impetuous spirit is best expressed in drawings. None of Gros's paintings suggest any of the passion and inner drive revealed by the jerky movements of his pen scratching at the paper or the heavy impress of his ink-charged brush. Even static figures here take on a violence which springs wholly from the artist's passionate investigation of form.

The same is true of Delacroix, whose large compositions are almost always disappointing. These frozen forms are a far cry from the turbulence of the initial conception as recorded in the drawings. In his pencil sketches, as powerful and striking as Géricault's, not only the line but even the volumes have a sweep and boldness which fail to come through in the finished painting. The massive air-borne figures and vibrant accents of the sketches for the Palais-Bourbon ceiling are untranslatable into other techniques, as is the impassioned spirit of Goya's wash drawings. Such forms as these, the fruit of pure research, point to the artist's cruelest dilemma: the insuperable difficulties of transposing the discoveries of a purely subjective vision into finished paintings. Only the then unsuspected possibilities of abstract art might have enabled Gros, and above all Delacroix, to preserve the purity of what to them was little more than an unformulated prompting, irreducible to any definite image. Instead they felt bound to respect the accepted limits of vision and keep to readily intelligible forms.

HENRY FUSELI (1741-1825). CLASSICAL SCENE, 1790. BY COURTESY OF THE ASHMOLEAN MUSEUM, OXFORD.

THÉODORE GÉRICAULT (1791-1824). MAN GRAPPLING WITH A BULL. PEN AND INK.
CABINET DES DESSINS, LOUVRE, PARIS.

FRANCISCO DE GOYA (1746-1828).
THE DISASTERS OF WAR, NO. 30:
LOS ESTRAGOS DE LA GUERRA
(THE TRAGEDY OF WAR),
ABOUT 1810. ETCHING.

ANGUISH

"Every human life is but another dream, dreamed for a moment by the infinite spirit of Nature and by the stubborn, persistent will to live: it is but a picture, hastily scrawled on her limitless page of space and time, which she leaves for an imperceptibly fleeting instant and then rubs out to make way for another." In these profoundly pessimistic lines, Schopenhauer denied the idealism of Hegel and every concept of historical progress; yet they accorded with the note of despair in the most impassioned outbursts of the Romantics and the obsession with death that ran throughout their art. Its constant refrain was the futility of life and the tragic irony of man's fate.

Death was everywhere, fascinating and horrible. Not only did it provide the obligatory climax to plays and novels, the inevitable background to scenes of battle, but it often constituted the pith and marrow of adventure. One might suppose works like De Quincey's *Murder considered as one of the Fine Arts* to be mere conceits, were it not for the writings of Poe and many others. Moreover the Romantics' obsession with death is apparent in their own favorite authors. Never had Dante's *Inferno* been so widely read outside Italy; never had Europe devoted such eager attention to *Hamlet* and *Macbeth*. The preference was not simply for works of violence but for those dealing with the mysteries of crime and death. Yorick's skull in the hands of the Prince of Denmark became virtually the symbol of Romanticism; for here, as in Poe's *Tales of Mystery and Imagination*, death appeared not as a consummation but in the form of Hamlet's anguished conjecture: "To die, to sleep... to sleep: perchance to dream..." It recurs throughout the poems, tales and paintings of the age. It is reflected in all the men buried alive or living in the shadow of death who people Poe's stories and Goya's etchings. The anguish is the same, whether one surmises that consciousness is blotted out or that some vestigial life subsists. It accounts, too, for Géricault's meticulous preoccupation with

corpses and for the way Gros, Delacroix and occasionally even Turner were fascinated by lifeless flesh.

The death motif may also be seen in artists' predilection for storms and chasms, as if to emphasize all that is puny and contemptible in man, a sentient but ephemeral being, embodied in a handful of dust. Moreover, this connection between man's anguish at his fate and the hostility of nature is more than allegorical, for his divorce from the tangible world lies at the root of the so-called "Mal du siècle."

Although Schopenhauer shared Hegel's attitude to aesthetics in so far as he advocated abstract forms, he did so in order to eliminate the illusory will to live, regarding it as the origin of all sorrow. Art that made it possible to contemplate action while remaining aloof from it provided one of the keys to utter detachment, to that annihilation of self which was the only remedy for the misfortune of being born.

Nonetheless the will to live is, as Schopenhauer admitted, "stubborn and persistent." To anyone who has not achieved total release from self, art that no longer represents physical reality is itself a source of anguish. For we feel diminished if our body or its substantiality is set at naught. Denied stability, we should lose our bearings. Torn up by the roots, bereft of sight, touch, physical obstacles, we should be severed from our flesh and cast adrift in a hostile, chaotic, incomprehensible world. Had we no fixed abode we should be confounded far more decisively than by plunging into the unknown, for our very being would be lost to us. The artist, therefore, having discarded walls, roofs and windows, had to paint mountain ranges; no longer a stonecutter, he found himself scaling cliffs and crags.

Those who dwelt in unwalled gardens felt no freer on that account, but grew uneasy and longed for caves, tunnels, outlandish dens where they would be captive and forlorn. In German fairy stories, in

Poe's tales and Hugo's novels, the characters frequent jails and vaults, the mines of Falun or mysterious caverns at the end of hidden valleys. They are seeking the keys to life and wealth, but they find only death and terror. Painters, too, were obsessed with the narrow confinement of lairs and dungeons, in which men languished—prisoners, madmen, lepers—their sufferings only less grim than their unspeakable place of captivity.

"When the sky is low as a heavy lid," wrote Baudelaire, long after Goya had confronted us with "a day sadder than any night." And yet, although man's despair was not due to an unfamiliarity with his environment but to a divorce from it that struck at the root of his being, he could not turn in upon himself without feeling the same anguish. It appears in another form, but with a similar origin, in those pilgrims of eternity, René and Childe Harold. For all their seemingly extrovert vigor, they suffered from a profound disillusionment whose cause they could not identify. Life, for no apparent reason, was a weariness of the flesh. René's thoughts of suicide were inspired, he said, by the fact that "disgust with life, which I had felt since childhood, returned with renewed force. Soon my heart no longer nourished my thoughts and I was only aware of my existence through an abysmal tedium."

There is a paradox in the attitude of Chateaubriand's hero, for his disgust with life is coupled with the need to "be aware of his existence." René's nostalgia, like Baudelaire's in *Spleen*, is a yearning for identity. Tedium shows him his inadequacy. He longs to be himself, but he recognizes that, unsupported and rootless, he is a broken reed.

While the Romantic hero admits his destitution, he will adopt any expedient that makes it bearable—love, addiction to drugs or drink, violent escapades, bizarre spectacles. He may be a seafarer, a Don Juan, even a bandit, but never a hermit. He is not afraid of death, so long as it is a dreamless sleep, but he cannot endure a life of ease, for that would confront him with his own limitations and bewilderment. Willing to try any means of escape, he often wears foreign or antique dress. He adopts real or imaginary disguises. Carnivals and fancy-dress balls give him a momentary respite from his own appearance and allow him to be the "man next door"—a concept that Fantasio-Musset made real.

The frills and furbelows beloved by Byron or Dumas, Hugo or Delacroix are apparent in their works. Hugo's flourishes, Delacroix's flowing robes, Byron's asperities, Rude's fiery gestures—these were symptoms of impetuosity, but they also concealed an emptiness that lay deep within them and filled them with terror. As the aging and anguished Hugo described it:

"*O citerne de l'ombre! O profondeurs livides!
Les plénitudes sont pareilles à des vides.
Où donc est le soutien?*"

Man's introspection showed him that he was nothing and could do nothing: that even if he attempted anything he was bound to fail. Progress, the watchword of 1789, gradually gave way to a sense of utter failure. The emptiness in men's hearts was transferred to the future and made all their enterprises futile. Besides *William Tell*, Schiller wrote *Don Carlos*; but even Don Carlos was not aware of his own impotence. A better example is Musset's Lorenzaccio—a second Brutus who hoped to free Florence by killing Alexander de' Medici. He knew the murder was futile even before he committed it, and when it was done he died wretchedly, spent, degraded, helpless. Never has the myth of the hero, the man of action, the liberator of his country, been more cruelly exposed. Schopenhauer's definition constantly recurs: the will to live is evil and perverse, bringing only sorrow in its train. Witness Lorenzaccio; witness Hoffmann when he repeats in various guises the legend of the maiden to whom physical love is denied, for whom even singing means death, but who can safely listen to her own voice imitated by a violin. In other words, she can contemplate the act she is forbidden to perform, that of uniting herself, body and soul, with the physical world. Thus was reborn the legend of Narcissus, of the nymph Echo, of all those to whom death comes from watching themselves live.

A man who cannot escape from himself is doomed to shipwreck, as in Friedrich's painting of the boat caught in pack-ice, or like the character in Chamisso's *Fable of Adelbert* who is overtaken by winter and trapped in a cavern of ice. Like the heroes in German story-books he can only find refuge in dreams, in that sleep which cloys time and arrests the flow of events. Michelet described it as a baneful spell, but Jean Paul Richter proclaimed it a higher form of life, precisely because it enables us to

"shuffle off this mortal coil." To the Romantics, the old myth of winter's sleep became a symbol of man's refusal to live, because life is vanity and travail.

But escape, too, whether by dream or adventure, was futile. There was no evading the anguish that, like violence and death, so deeply marked the Romantic era. Sometimes it took the form of causeless dread, as in Hugo's *Les Djinns*, or in most of Poe's tales, such as *The Fall of the House of Usher*, or in the ghost stories of the English writers, or in the hallucinations of Gérard de Nerval.

Painters, too, tried to reflect nameless apparitions in the features they portrayed. It was difficult, though, to give precise shape to anguish born of nothingness. So definite is the presence of a real flesh-and-blood portrait that it leaves no room for the meaning beyond words of a Lied by Schumann or a poem by Nerval or Baudelaire. Once the image took shape and every detail fell into place the most hideous nightmares were reduced to make-believe. Artists, therefore, tried to eliminate the fleshy substance of their figures by using a tenuous, fluid line that adumbrated but did not define them, and by employing color-wash and blurred stippling to dissolve distances instead of putting them in focus.

A further consequence was the Romantics' weakness for the grotesque and the importance they gave to caricature, with its pessimistic outlook. To Rowlandson, Daumier or Grandville physical appearances were misshapen, preposterous, unreal, and they regarded them as objects of mockery or obloquy. Yet these caricatures and illustrations were only approximative; they compared rather than identified. Their subjects were to some extent dissociated from the horror or absurdity that was adventitiously thrust upon them. Usually the image had less reality and cogency than the actual person. But this was not necessarily true, for sometimes, as in the case of Goya, the repulsiveness of the image only heightened its reality. In *Los Espejos*, when the dandy sees his collar in the glass as either a cravat or a garrotte, the reality is the garrotte. The mask has become real because it has more vitality than the commonplace features behind it. The grinning skulls and bestial faces in *Los Caprichos* are more real than their entourage of men in frock-coats and girls with shapely ankles.

In such surroundings the mind begins to reel from terror and bewilderment. When every landmark is swept away, "great wits are sure to madness near allied." The Romantics were fascinated by madness for, like death, it was desolate and unknown. Painters did not feel wholly detached from the demented faces they studied. The curse laid on Prometheus may be seen in the tragic destiny of Hölderlin, Schumann, Gérard de Nerval; but they, too, may be said to exemplify the derangement that afflicts a man when he is cut adrift from that persistent, illusory will to live, which obtains utterance even from those who seek to deny it.

THÉODORE GÉRICAULT (1791-1824). PORTRAIT OF DELACROIX, ABOUT 1818. MUSÉE DES BEAUX-ARTS, ROUEN.

THE FORCES OF DARKNESS

Well before Romanticism had reached its climax painters had begun to fill their canvases with darkness; for by veiling their subjects in subfusc anonymity they could best express a world that had lost its bearings. Reason, of which so much had been hoped, was found woefully incapable of seeing into men's hearts and powerless against the vagaries of impulse. When Man had lost his grip on life, what was the use of painting objects with the definition given by clear light and sharp perspective? When his own self-questioning went unanswered, how could he pretend to fathom the world about him?

Géricault's amazing Portrait of Delacroix *seeks to acquaint us not so much with another man as with his own horror of the unknown. His friend's familiar countenance has become a specter of darkness. Shadows obliterate every feature save the tight-set mouth and haunting eyes that transfix us. We can find no certainty in the inchoate design, for Géricault's own self-questioning, as he faces his model, leaves him baffled.*

The inner turmoil revealed in a portrait such as this destroys all tangible reality. The visual image gives way to dreams and bugbears. Formerly there was nothing fearsome about a carnival, whose fancy dress was a pleasure to behold; yet Goya gives it an almost tragic twist in his Burial of the Sardine. *We wonder whether the masks have any faces behind them. Nothing is quite what it seems, neither the grotesque bystanders, a mass of grays and blacks, nor the lumpish dancers joylessly jigging in a garish light, nor those weird and frightening figures in the foreground, sitting with their backs turned between us and the scene.*

Darkness, the harbinger of woe, later became a stock-in-trade of Romantic painters. It was generally used to signify hell let loose, as in Delacroix's Death of Valentin. *This scene from* Faust *depicts not only violence but the dread of what is beyond our ken and yet of great moment to us. Objects lose their identity in the moving shadows and stabbing light; as in the* Burial of the Sardine *they are no longer things seen but obsessions, the incubi of our dreams.*

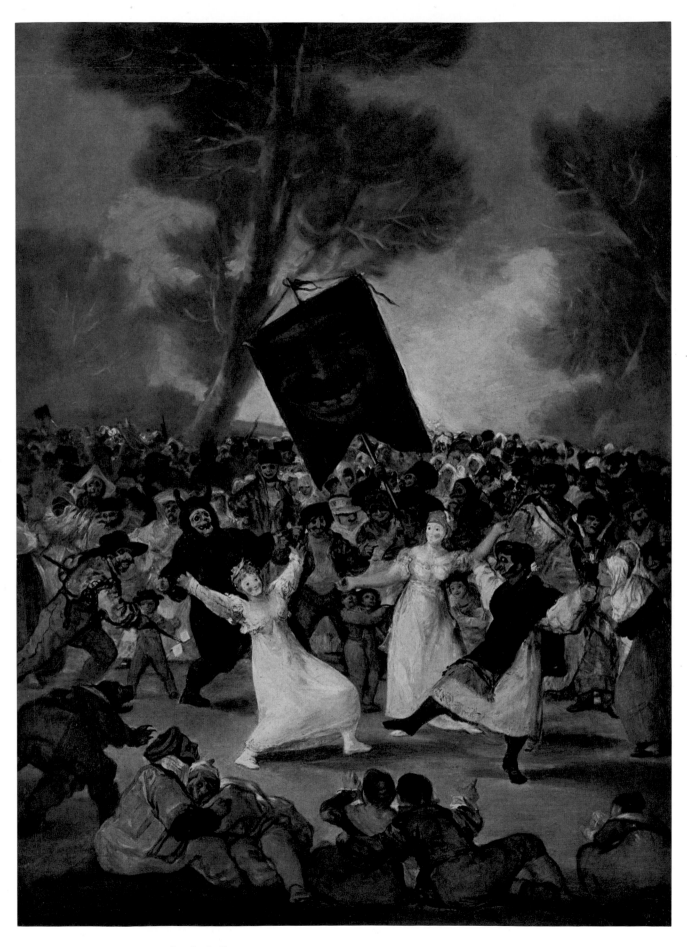

FRANCISCO DE GOYA (1746-1828). THE BURIAL OF THE SARDINE, 1793. ACADEMIA DE SAN FERNANDO, MADRID.

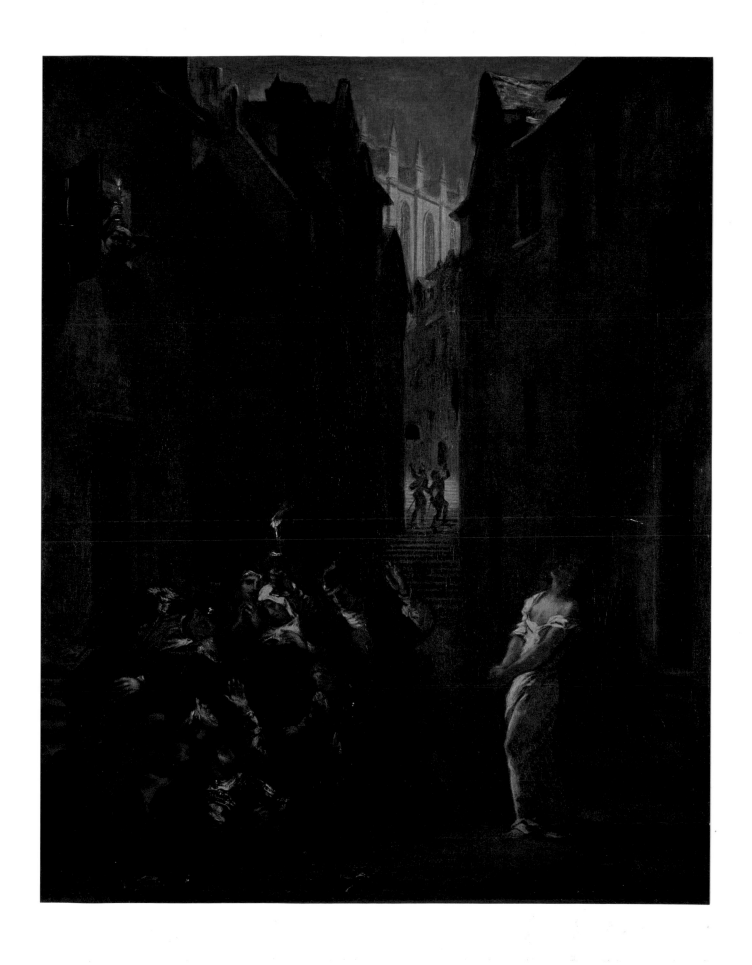

EUGÈNE DELACROIX (1798-1863). THE DEATH OF VALENTIN, 1847. KUNSTHALLE, BREMEN.

7

THE SLEEP OF REASON

By the end of the eighteenth century, painters and engravers were discovering a new vein of inspiration in the weird and fantastic shapes that appeared to them in their dreams, and the mixture of grim humor and frenzied imagination which we find in these works anticipates Surrealism. The same object, if it baffles the reasoning mind and startles the senses, can either terrify us or make us laugh, as the case may be. We enjoy the masquerades of carnival time and the antics of clowns even though their outlandish figures remind us of the denizens of our nightmares. In reality, they disarm our fears by the flagrance of their artifices; monsters are merely comic if they are obviously made of painted cardboard and cheap finery. If it is to amuse us, a picture too must reveal the elements that went to its making. Grandville never meant to frighten us, and that is why he set out to show us in detail how a monster is concocted. He obligingly delineates the metamorphoses of his figures. Thus in *Another World*, we see the cravats of the audience at the Opera transformed into eyelids, their hair into eyelashes, and their faces into a large eye. The effect is comic because the artist's touch is so deft and ingenious. Yet if we take in the picture at a glance, without lingering over details, the artifice of it all is momentarily lost on us and we find ourselves confronted with the stark, undisguised expression of desire. Then the monstrous side of

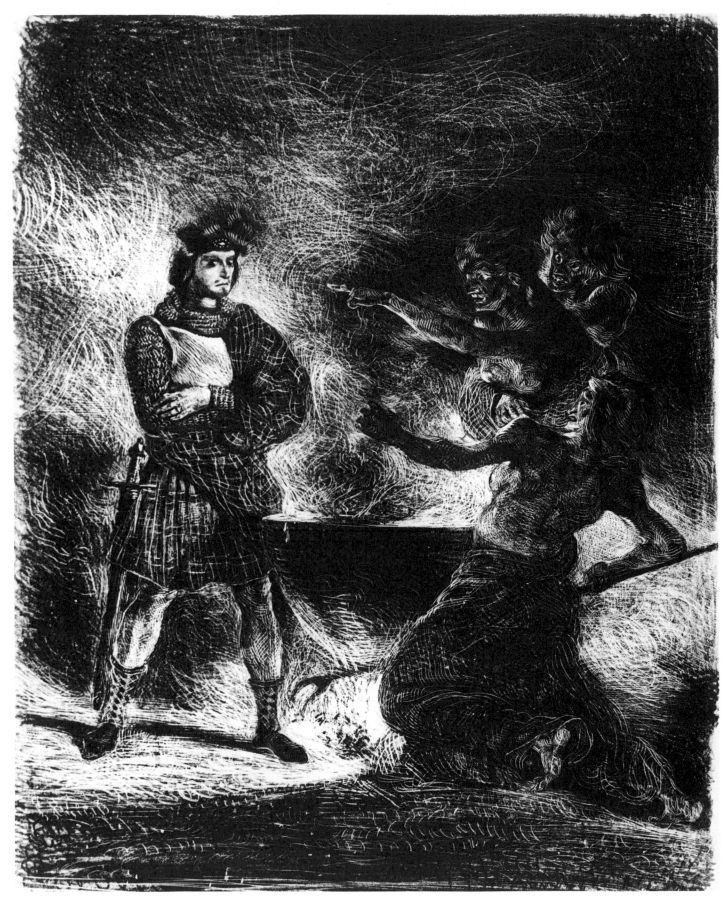

EUGÈNE DELACROIX (1798-1863). MACBETH CONSULTING THE WITCHES, 1825. LITHOGRAPH.

◄ FRANCISCO DE GOYA (1746-1828). LOS CAPRICHOS, NO. 77: UNOS A OTROS (ONE TO THE OTHER), 1797. ETCHING.

GRANDVILLE (1803-1847).
LES AMOURS. ILLUSTRATION FROM "UN AUTRE MONDE" (PARIS 1843). WOOD ENGRAVING.
▼

these figures produces a disturbing effect. What was amusing before, when we followed the play of the artist's fancy, ceases to be acceptable when we realize its underlying implications.

The ambiguity of a humorous sketch no longer has any *raison d'être* when the artist's vision brings home to us a recognizable reality in compelling terms. When their metamorphoses are no longer meant to entertain, these imaginary beings fail to raise a laugh; their portentous presence may even change the meaning of a print. In Goya's *Caprichos*, social satire and the whimsical pretexts which conceal it are usually swept away by the violence of the images. Granted that the print entitled *Unos a otros* is meant to satirize a decadent society in terms of a popular game—the mock bullfight known in Spain as *la vaquilla*; nevertheless, all it now conveys is a terrible vision of the dead riding the dying and bearing down, not on a straw bull, but on us. The figures are so compellingly real that they haunt us like bad dreams.

When the engraver tries to communicate his anguish, to the exclusion of any other concern, he is careful to avoid well-defined forms, thus preventing any analysis that might release us from the rankling sense of uncertainty he has aroused. The figures hovering round the sleeper in the *Disparates* are doubtless less horrible than the eyes imagined by Grandville or the apparitions in *Los Caprichos*, but they are children of the night and recede into its depths to assume other forms. The sleeper himself, of whom it is difficult to say whether he is walking or hanging in mid-air, is part and parcel of the nightmare. Not a single object is distinct or definable; and it is this very ambiguity, running through the whole series of the *Disparates*, which so effectively conveys the anguish of this vision. Far worse indeed than ghastly phantoms is the unknown, the nightside of things, all that the senses divine but cannot grasp, all that the imagination spawns but never quite reveals in name or form. Precision of outline must be avoided if the artist is to perplex us with intimations of the unnamable. Thus it was the abiding concern of the Romantics to evoke, by every possible means, the mystery of what cannot be completely disclosed or delineated. Delacroix resorted to eerie effects of light and shadow in order

to throw an aura of mystery round the characters from Goethe and Shakespeare that figure in his lithographs. He creates an atmosphere of the supernatural in this scene from *Macbeth* in which, by means of white streaks, the witches are made to appear as dark shapes looming up against the light, elusive phantoms born of the smoke or of dreams.

It might be supposed that only strange or outlandish figures are able to arouse anxiety. Actually any ambiguous form is capable of plunging us into the disturbing atmosphere of visions which we cannot come to terms with. The massacres of the *Disasters of War* are terrible enough, but they are not more horrifying than a plate from the same series showing bodies wrapped in shrouds; we are left in suspense as to whether they are dead or asleep. Nothing is made explicit, and yet the scene is fraught with fear, desolation, an overwhelming sense of ineluctable fate. The same is true of Victor Hugo's hallucinating castles; dim, unsubstantial shapes looming out of the shadows, they are as disquieting as phantoms. We know that in many cases they were sketched from nature, but nothing remains that might suggest a building of stone. They are visionary, almost nightmarish creations—ghostly towers and belfries which, we feel, may at any moment turn into something else. Victor Hugo's landscapes too, whether imaginary or real, are shrouded in the same haze, which blurs and dissolves forms.

It is not the tower that awakens fear and dread, nor the bodies wrapped in shrouds; it is all that lurks in the night, all that, being ephemeral and formless, reminds us of the precarious foundations on which our own existence rests. In these tremulous shapes about to be swallowed up in darkness, we recognize all that in ourselves is unformed and unfathomable.

Hence the underlying unity of all the dream-figures that haunted the artists of the early nineteenth century. Monsters and phantasms, figures born of smoke and those in the grip of some awful metamorphosis, are all of the same brood. They are not apparitions, nor even the denizens of "another world," as Grandville seems to suggest. They spring to the fore from the depths of the human mind when Man, faced by a world on which he can secure no purchase, feels his reason fail him.

VICTOR HUGO (1802-1885). LA TOURGUE IN 1835. PAINTED IN 1876. INDIAN INK AND SEPIA.
MAISON DE VICTOR HUGO, PARIS.

FRANCISCO DE GOYA (1746-1828). LOS DISPARATES, NO. 18: THE NIGHTMARE, 1810-1819. ETCHING.

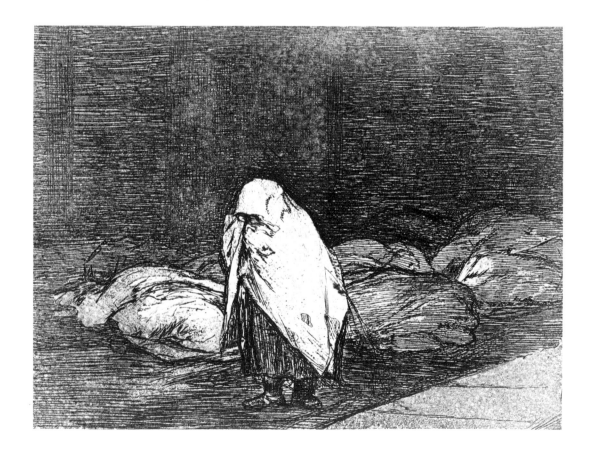

FRANCISCO DE GOYA (1746-1828).
THE DISASTERS OF WAR, NO. 62:
LAS CAMAS DE LA MUERTE
(THE DEATHBEDS),
ABOUT 1810. ETCHING.

195

THE MASKS

Romantic art found its most genuine and fruitful expression in anguish, violence and flight. This was the reality behind the gimcrack buildings of the fashionable districts, whose gaping façades, like the crumbling, cloud-borne castles drawn by Victor Hugo, concealed emptiness. Likewise, behind the display of strength and finery, one can detect the failure of an age which shied away from reality and was afraid to dree its weird.

The inability of architects and sculptors to come to grips with space was seemingly offset by concepts of a quasi-spatial nature. Where there was no intrinsic necessity for spatial transformation, artists went in search of forms which at that time were unattainable. They did not get much beyond allegory and fantasy, but they clearly felt the need to impinge on the tangible world. It would seem, then, that the Romantics' failure to achieve spatial reality was due to helplessness rather than to deliberate rejection of their own corporeal nature. In their music, painting and literature they could only create and conjure up a potential reality. Their aim was not to build a harmonious relationship with the physical world and thus recapture the departed sense of order, but rather to absorb the physical world into their own consciousness.

The third dimension, therefore, was used mainly to produce dramatic effects or to impose the painter's vision. Not even Turner or Delacroix tried to resurrect a rational universe where men would be at one with their environment.

Literature, too, reflected this attempt to absorb the physical world. Verse without allusions to nature was unthinkable. Not content with describing what they saw or remembered, poets imagined themselves flying over the earth and being granted a cosmic revelation of the universe. Yet in making these conquests and trying to renew them in words, they were merely projecting their own subjective mood.

Description became an essential ingredient of the novel because of its psychological value. Since Adolphe's feelings were unaffected by his surroundings, Benjamin Constant could make him travel round Europe without once describing the scenery. It was quite another matter for Stendhal or Balzac, who meticulously described streets, houses and furniture, not simply as a setting for Fabrice or Rastignac, but because these things were synonymous with their manner of existence and enabled the reader to enter into their consciousness. Hence, just when it seemed as if the physical world of bodies, dimensions and objects had become meaningless, writers began to describe it. Instead of the architect it was the novelist who built cities and tried to disguise the chaos on which men could no longer impose their own laws and standards. This putative space, whether literary or pictorial, was of course fictitious. In real life man had been cut off from his environment, and no amount of descriptive effort or painstaking accumulation of detail could hide that bitter truth.

This hankering for an external and unattainable reality reveals the inconsistency of an attitude whose idealism was only ostensible; for there was nothing Platonic about the Romantics' contempt for manual skill or their obliviousness of man's physical condition. On the contrary, theirs was an age when natural energy was being harnessed and the manufacturing process perfected, when there was a growing demand for consumer goods and creature comforts. Far from spurning the physical world, the men of the early nineteenth century made the most of it. What they objected to was themselves, or rather the madding crowd. It may be that they shrank from grappling with an entirely new situation and, like aboriginals, could not find their place in a scheme of things whose meaning was still a mystery to them; it may be that they were nonplussed by the energy at their command and by the responsibilities it entailed. The fact remains, they had lost their bearings and could not

construct anything outside themselves. Moreover they failed to establish any but the most tangible and perfunctory sense of values, such as the sophistry of credit or the narrow materialism of getting and spending. Their very existence therefore became meaningless and empty. As a result they confined themselves to appearances—the show of strength, the illusion of virtue; but these could never be truly creative, and in the long run, if there was nothing behind them but a chaotic void, they became unbearable. The Romantics resorted to every kind of expedient and wore every conceivable mask in order to keep up their rickety but reassuring façade. They turned back the pages of history or made believe they were somebody else; they sought oblivion or adventure far from their fellow-men; they took refuge among the beasts of the field. Yet whenever these yearnings found artistic expression as poems or paintings, the truth they had tried to veil was starkly revealed: anguish, emptiness, the denial of life.

For this reason Romantic art often masked itself in allegory or genre. To avoid the embarrassment of coming face to face with truth it resorted to blatant images and symbols, which could be easily identified and adapted.

Art is born of discernment and must, indeed, coincide with man's awareness of the world or of his destiny. It cannot be analyzed and it perishes if men tamper with it for fear of what it may reveal. Since every undiminished art is a revelation of fact, it follows that a society which fears self-knowledge is always iconoclastic.

The bourgeois had no use for art; he wanted everything to be show and make-believe, as comfortable and luscious as possible. When Delacroix and Turner ventured to paint real pictures they fell from favor. Distinction in art was the signal for cat-calls—and for the ostracism of the artist. The poet was afraid to publish, the painter locked away his authentic works. Since he could not be content with appearances but saw the cracks and rust and gaps behind the smart stucco house-fronts; since he painted the essential barrenness of what he saw, the artist was the Anarch, to be thrust beyond the pale. He retorted to banishment by setting himself above society; but he, too, had lost his roots. No longer did he utter the unspoken thoughts of his fellow-men; no longer was he honored among their gods. He spoke in solitude and anguish.

But the ostracism of artists solves nothing. A man cannot change his face by breaking the mirror, nor can he prevent those who see it from recording what they have seen. Those who were lords of the Western world in the age of optimism were recreated in the works of Schumann, Shelley or Hoffmann, of Goya, Turner or Delacroix. They emerged as men of appearances, finding themselves forlorn in an unstable universe, recoiling from their vital tasks, their age, their City, and at last from themselves.

THE ABYSS

The portrayal of anguish gave rise to a spatial problem, usually solved by depicting scenes of mystery or cruelty within the narrow confines of prisons, caverns or vaults. Among the most remarkable were those composed by Goya in the early years of the nineteenth century. His paintings of down-and-outs huddled under massive arches are profoundly eloquent in their plain statement of outline and shadow. There is a literalness in the agony of his figures, a damnation that is not eternal, which may be seen in the chained men in Interior of a Prison. *We can at least describe the scene and grasp its meaning. There is something reassuring about the fact that, once the vision has "a local habitation and a name," we can bring our reason to bear on it. A precinct, even though it imprisons us, allows a measure of detachment. Walls and arches, however oppressive, offer solid support.*

It is when we become aware of being nothing, of being unable to comprehend anything around us that anguish begins to stalk abroad. That is what Goya perceived some years later when he painted the walls of the "Deaf Man's House." Now there is neither rhyme nor reason. The scenes no longer have any familiar setting but emerge sickeningly from the abyss. The most astonishing is that of the Dog buried in the Sand. *The foreground is filled by an amorphous shadow; beyond it there are watery streaks of light, signifying who knows what? A waterfall perhaps? All one can make out is a number of brushstrokes. And then, in violent and shocking contrast to the rest of the picture, the dog's head sticks out starkly from the shadow. The feeling of horror is too nebulous to be associated with the poor beast's predicament. In a world without shape or distance, forlornly adrift in a void that has neither name nor meaning for us, the dog is the very image of the bleak, unbearable nothingness that we call anguish.*

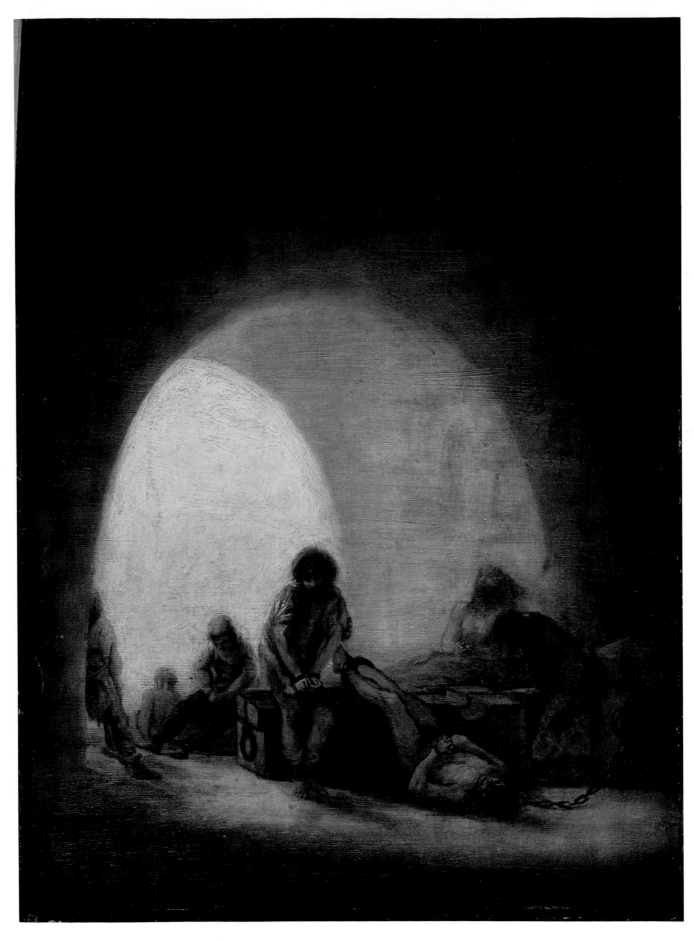

FRANCISCO DE GOYA (1746-1828). INTERIOR OF A PRISON, 1801. BOWES MUSEUM, BARNARD CASTLE, DURHAM.

FRANCISCO DE GOYA (1746-1828). DOG BURIED IN SAND, ABOUT 1820. PRADO, MADRID.

INDEX OF NAMES

LIST OF ILLUSTRATIONS

PRINTED ON THE PRESSES OF
EDITIONS D'ART ALBERT SKIRA
15 FEBRUARY 1965

PHOTOGRAPHS BY

Maurice Babey, Basel (pages 12, 14, 17, 29, 37, 39, 41, 53 bottom, 55, 61, 62 bottom, 63, 65, 66, 102, 109, 110, 111, 115, 121, 122, 123, 127, 128, 129, 130, 131 bottom, 133, 134, 135 top and bottom, 153, 154, 155, 157, 158, 159, 161, 169, 171, 202), Archives Photographiques Paris (page 30 bottom), Arnott Rogers Batten, Ltd., Montreal (page 83 bottom), Raymond Asseo, Geneva (page 104), Joachim Blauel, Munich (pages 67 and 186), Lee Boltin, New York (page 125), Bulloz, Paris (pages 30 top, 54 top and bottom, 75, 196), Camera Center, Charlottesville, Va. (page 28 top), Focco, Madrid (pages 82 and 203), John R. Freeman & Co, Ltd., London (pages 105 and 112), Giraudon, Paris (pages 56 and 142 bottom, pages 177, 178, 179 top), Grafic Photo, Paris (pages 40, 62 top), Carlfred Halbach, Ratingen (page 172), Hans Hinz, Basel (pages 170, 188), Institutet för Färgfoto, Lund (page 114), A. F. Kersting, London (page 42), Walter Klein, Düsseldorf-Gerresheim (page 103), Ralph Kleinhempel, Hamburg (page 124), Raymond Laniepce, Paris (pages 83 top, 113), Louis Loose, Brussels (pages 95, 96 top and bottom, 139, 193 bottom), Jochen Remmer, Lübeck (pages 38, 189), Umberto Rossi, Venice (page 156), Oscar Savio, Rome (page 43), and the photographic services of the following museums: Brussels, Bibliothèque Royale (pages 76 top and bottom, 93 bottom, 94, 179 bottom, 193 top, 195 top and bottom) and Musées Royaux des Beaux-Arts (page 15), Cambridge (Mass.), Fine Arts Library, Fogg Art Museum, Harvard University (page 27 top), The Cleveland Museum of Art (page 131 top), London, British Museum (page 28 bottom, 141) and Victoria and Albert Museum (page 140 top), Madrid, Prado (pages 73, 178 bottom), Oxford, Ashmolean Museum (page 180), Paris, Bibliothèque Nationale (pages 56 top, 93 top, 142 top, 194), Providence, Rhode Island School of Design (page 140 bottom), Sèvres, Archives de la Manufacture Nationale (page 53 top), Washington, D.C., Library of Congress (page 27 bottom and 74).

COLOR PLATES ENGRAVED BY GUEZELLE & RENOUARD, PARIS

BLACK AND WHITE PLATES BY IMPRIMERIES RÉUNIES, LAUSANNE

PRINTED IN SWITZERLAND